BUS PHOTOGRAPHY
FOR THE
DIGITAL AGE

BUS PHOTOGRAPHY
FOR THE
DIGITAL AGE

Mark Lyons

Ian Allan
PUBLISHING

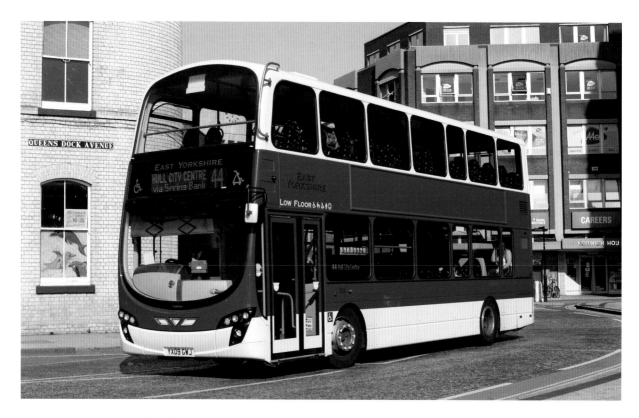

above One of the joys of bus photography is capturing the changing scene. Although recent years have seen a rapid growth in the big groups, which has made their corporate liveries a common sight across the country, an exception is East Yorkshire, which is still recognisably the same company sold to its management team by the National Bus Company in 1987. Its burgundy and cream-liveried buses share the streets of Hull, where Wright Eclipse Gemini 2-bodied Volvo B9TL 763 is seen in Queen's Dock Road, with those of Stagecoach, which bought out the former local authority-owned bus operation in 1989.

Bus Photography for the Digital Age
Mark Lyons

First published 2010

ISBN 978 0 7110 3420 4

Published by Ian Allan Publishing

an imprint of Ian Allan Publishing Ltd, Hersham, Surrey KT12 4RG. Printed in England by Ian Allan Printing Ltd, Hersham, Surrey KT12 4RG.

Visit the Ian Allan Publishing website at www.ianallanpublishing.com

Distributed in the United States of America and Canada by BookMasters Distribution Services.

Mixed Sources
Product group from well-managed forests and other controlled sources
www.fsc.org Cert no. SGS-COC-005526
© 1996 Forest Stewardship Council
FSC

CONTENTS

Introduction

This book is about digital photography with a particular focus on road transport. But it is also, I hope, far more than that. In the pages that follow I hope not just to provide an insight into how the still relatively new medium of digital photography can be exploited to its full potential but also to give some useful hints on selecting a camera, composition and image processing. My focus is very much on the equipment and techniques that are most appropriate for the photographer of buses and coaches, an aspect of photography that has not been particularly well covered previously – as a consequence there is no mention of red eye removal, for example. The book is set out in such a way that the reader is taken through all of the stages of digital photography in logical fashion so it can be read from start to finish in order to guide a newcomer to the hobby. Alternatively, it serves as a reference work where the reader selects the section most relevant to his immediate needs. I have also included five themed galleries looking at particular locations that provide the photographer with either a wide range of subject matter or a particularly attractive setting. These carry detailed captions covering both subject matter and exposure information.

The advent of digital cameras probably represents the greatest advance in image capture since the advent of 35mm cameras in the 1930s. Whether you are already a digital photographer or are still questioning whether digital photography is the Guy Wulfrunian of the consumer electronics world, this book is for you.

But first a piece of background. I am often asked what first made me interested in buses. The honest answer is that I don't really know, since most of my early memories involve childhood trips to various relatives that seemed to involve passing bus garages. The fact that a detour via Godstone, Chelsham or Catford, which, on a Sunday, housed rows of well-turned-out buses, seemed to make me a more compliant passenger encouraged my parents to indulge me more. Family holidays to the south west would introduce me to the delights of Southern National, Hants & Dorset and Bournemouth's municipal fleet. That these buses were different from those with which I was familiar merely increased my fascination. At the age of seven a family move to north Hampshire introduced me to Wilts & Dorset – this somewhat confused approach to geography helped to occupy my mind, although just as I seemed close to cracking the conundrum the Hants & Dorset fleetname began to appear. This was, however, accompanied by the creation of a geographical feature unique to the NBC in the shape of 'Alder Valley'!

I began to buy books and magazines on buses and was drawn to the photographs that they contained. The die was set and I persuaded my father to let me take control of an elderly Kodak folding camera that had lain in a drawer for many years. Most of the early results were, frankly, disappointing and have long since been thrown away. Added to which, the cost of film and processing stretched my meagre pocket money somewhat.

By my early teens I had moved on to my first SLR and, having obtained part-time work in a local photographic shop, bringing with it both a regular income and access to discounted equipment, my activities really began to take off. One thing led to another and I soon found myself building a darkroom in which I would (mis)spend many of my youthful hours.

In the early days I would photograph anything – it soon became clear that in order to avoid amassing a vast collection of

snapshots, most of which would end up in boxes never to be seen or simply thrown away, a degree of discipline was needed.

The message was clear – it had to be buses. The industry is in a continual state of change – not only do the vehicles change, but also liveries, fleetnames and, of course, the environment in which they operate. That environment itself is a challenge to the photographer – not for us the easily controlled environment of a studio or the stationary landscape where one can sit for hours waiting for the perfect lighting. The bus photographer must cater for many variables over which he (sadly it is still a largely male preserve) has little control. Traffic, people and unpredictable weather can all conspire to frustrate, but we persevere. In its own way each photograph is a little piece of history – preserving the street scene at that moment in time, not just for the photographer or those who enjoy looking at photographs of buses but for anyone with interest in our way of life. This, for me, is the great draw.

To return to digital photography, it is easy to see what attracts people: instant results, no more buying film or spending money on developing and processing, and the ability to share pictures with friends and relatives are all strong arguments for taking the plunge. What's more, it's immediate – you know whether the photograph is good and, if not, you can take another. Once you have made your initial investment in a digital camera the running costs are much lower – there are no film and processing costs since a digital camera saves its images onto memory cards that can be reused. Indeed, it is highly likely that within a few years film will become a specialist product available only from a few sources. Finally, photographs can be saved on your computer and edited easily to improve them.

Digital has made it easier to take photographs than ever before, and the market is saturated with cameras ranging from a simple camera phone costing a few pounds to a medium-format SLR requiring an outlay of many thousands. While it is simple to take photographs, the true challenge is to take *good* photographs – this requires just as much skill and thought today as it did for early photographers.

The ease of digital photography means you will probably take more bad photos than you've ever taken before. Without the price of film and developing to worry about, a digital camera encourages experimentation, and with experimentation come failed experiments. It also allows for practice which, in turn, brings perfection.

A NOTE ON PRESENTATION

A volume of this sort can end up littered with italics, quotation marks and other typography. With this in mind, when a particular command, as employed by a computer program, is applied, that term appears in quotation marks. I have used the American spelling of program where it relates to a piece of computer software or a camera function and of color when it appears so written within a command. The UK English spelling of disc, when used in the context of computer memory, appears to have come back into favour.

ACKNOWLEDGEMENTS

Finally, all of the photographs used in this book have been taken by me with the exception of one wintry photograph kindly provided by Richard Walter. Images from Bus Map are used with the kind permission of Mike Harris (www.busmap.org). Windows and Windows XP are trademarks of Microsoft Corporation. Photoshop and Photoshop Elements are trademarks of Adobe Systems, Corel Paintshop Pro is a trademark of the Corel Corporation, and Macintosh is a trademark of Apple Computers. Images from Google Earth are ©Google Imagery 2008, © DigitalGlobe, Infoterra Ltd 2009 & Bluesky, and © TeleAtlas Ltd.

Particular thanks are also due to those whose photographs have served as my inspiration and to those close to me who have tolerated and, occasionally, encouraged my activities, particularly my parents and, for the last two decades, the long-suffering Linda. Without them this volume would not have been possible.

DIGITAL PHOTOGRAPHY BASICS

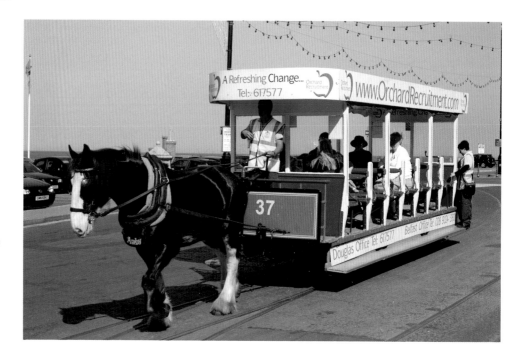

right **This is probably the transport equivalent of an old plate camera – Douglas Corporation 37 is seen on the town's Promenade in May 2008.**

■ How it differs from film

Before we start looking at digital photography in any great detail it makes sense to address the basics. All cameras, digital or film, share a common purpose of capturing and preserving moments of time for the photographer. The desire to achieve results with quality, speed and ease has driven the photographic industry for a century and a half – this has seen photography evolve from the cumbersome plate cameras of the 19th century to today's sophisticated digital offerings. In technical terms it is like comparing a horse tram to a modern hybrid bus.

Looking at a camera from the outside, there are no ways to tell how a digital camera differs from a film-based (or 'analogue') camera, since most digital cameras have been built to recreate the look and feel of traditional analogue models. Indeed, many of

the fundamentals of digital photography do not differ greatly from film. In both cases light is passed though a lens onto a surface that captures details of the image. However, they take distinctly different paths to reach a final destination of a picture that the photographer can use, share and enjoy. In the case of an analogue camera, that surface is a gelatin film coated with light-sensitive chemicals, whereas in a digital camera the surface is contained on a light-sensitive computer chip that converts light into electrical patterns that the camera stores as digital data.

On the inside, there are many differences. The following describes how traditional photography has been transformed for the world of bits and bytes.

Film cameras are largely mechanical affairs, constructed with assemblies that open and close shutters and apertures and wind and rewind film.

When the shutter release button is pressed on an analogue camera, a series of mechanical linkages opens the shutter for a period of time. Light hitting the film causes the chemicals on the film to react. The longer the film is exposed to light the greater the reaction. Crucially, however, in order to see the photograph the film needs to be developed. For a negative film this is a two-stage process – the film itself is subjected to a chemical process that causes the image to appear on the film and fix it. The parts with the least exposure are the most transparent, and the parts that were most exposed to light are black or opaque. The negatives are then projected onto a light-sensitive paper to produce positive prints of the scene. Colour transparency (or 'reversal') film differs somewhat in that the image on the film is a positive one that can be seen by holding it up to the light. This simpler development process explains why slides represent a truer image than prints. Colour film has three emulsion layers, each one reacting to a primary colour of red, green or blue light. Coupler dyes mix to

approximate the actual colour of the light that first hit the film.

Most photographers using film take or send their rolls of film to a developing lab, which processes the film and produces prints or mounted slides. These days many labs will convert your film shots to digital images, placing them on a photo CD. There are a number of online photo-sharing sites to which you can send your film that will perform the same task. These sites will also post your digital images to a web page that you can share with others.

Digital cameras, by contrast, are largely electronic – they contain wires, processors, and few, if any, moving parts.

At the heart of a digital camera is the image sensor. Often referred to as a CCD, or charge-coupled device (although strictly speaking this is only one type of sensor available), this is a light-sensitive chip that forms the image-sensing device for all digital cameras. The camera lens focuses an image onto the CCD, which is covered with tiny light sensors, each of which converts light into an electric charge. Each of its

below **Modern hybrid buses represent the ultimate contrast with the horse tram – East London 29001, the first Optare Tempo Hybrid bus to enter service, is seen near Bow Flyover in early 2009.**

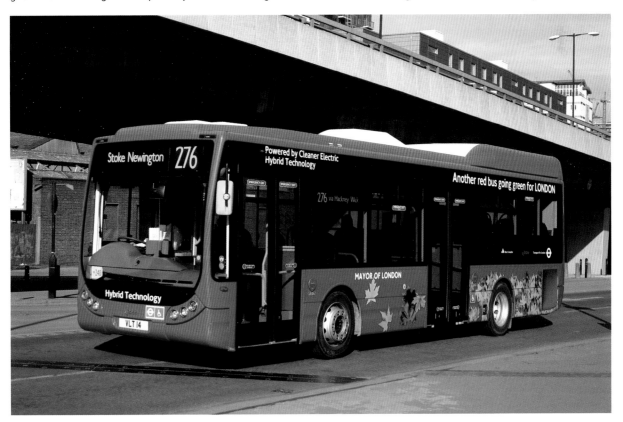

pixels registers the amount of light that falls on it in a similar way to the changes caused to silver halide crystals in film by light falling on them. Each pixel is defined by a set of numbers that represent its colour in the RGB (red, green, blue) spectrum. A white pixel is 255, 255, 255 and a black one 0,0,0. All other colours are expressed by a combination of these values that, taken together, represent both the colour and brightness of the final image. When the array is scanned, the charge from it is read off and converted into a number. The end result is an array of numbers inside the camera's microprocessor that corresponds to the intensity of light at each point on the array. This information is stored, either in the camera's own memory or in a separate memory card, from which it can be transferred to view the images. One of the crucial differences between film and digital imaging is the relative ease with which the colour and brightness of an image can be altered by changing the values of the pixels. This is something that will be looked at in more detail in later sections.

The camera itself is just one link in a three-stage process: the original scene captured by the camera; the processing of the image either through traditional film developing or as a digital image on a computer; and an image that is capable of being shared with others.

Photography can be viewed as a three-stage process.

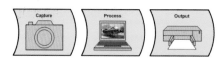

STAGE 1: Capture

The first step in digital photography is to get a digital image, and there is more than one way to do this:

- Digital still cameras capture photographs in a digital format.
- Film cameras capture photographs on slides, negatives or prints, which you can then scan to convert them to digital photographs.
- Video cameras capture images in a video format. You can then use a frame grabber to isolate individual frames and save them as still images.
- Digital video cameras are sometimes able to capture still images just like a digital still camera. You can also use a video-editing program to extract individual frames from the digital video.

In this book we are going to focus on digital still cameras, although we will also look at scanning slides and photographs as a means of digitising old photographs. We will examine all aspects of image capture to ensure that the photographs you take are of the highest quality possible.

STAGE 2: Process

Once a photograph is in digital form, you can store it on a computer and, if you wish, edit it with a photo-editing program. The things you can do to a digital image are almost endless. In some cases you can improve an image by eliminating or reducing its flaws. In other cases you can adjust an image for other purposes, perhaps to make it smaller for emailing or posting on a website. Finally, you might take an image to a new place, making it something it never was. Here are some ways you can process images:

- Crop the photograph to emphasise the key part.
- Remove irritating distractions.
- Convert it to black and white.
- Reduce the size of the photograph to make it smaller for posting on the web or emailing.
- Use filters to sharpen it.
- Stitch together multiple images to create panoramas.
- Change brightness and contrast or expand the tonal range to improve the image.
- Convert the photograph to another format.

These are just a few suggestions – you will quickly begin to experiment with the possibilities that digital editing allows.

STAGE 3: Output

Once an image is the way you want it, you'll find that there are a number of ways to display and share it:

- Print the image on a colour printer.
- Send the photo to a photo finisher for prints, or to have the images printed as a bound book or onto T-shirts, posters, etc.
- Insert the photograph into a word processing or desktop publishing document.
- Email the photograph to friends or family members.
- Store the photograph on your system for later use.
- Post the photograph on the internet.
- Create slide shows that play on a DVD player connected to a TV or a DVD drive in a computer.
- Write a book!

Finally, put aside any concerns about image quality. For most applications, digital images are equal to, and often better than, film images. The real reason to switch lies elsewhere, in the fact that the immediacy of digital photography will encourage you to be far bolder in taking photographs – and this will encourage you to experiment with all of the camera's settings and to try new angles, secure in the knowledge that you are not wasting money on film and processing. As with all things, the more you try it the better you will become!

below While London has seen the introduction of hybrid buses, Reading Buses reacted to growing environmental concerns by investing in ethanol-powered Scania double-deckers, although their high cost of operation has led to conversion to bio diesel. One is seen here in Wokingham Road in October 2008. As with many modern buses the electronic destination displays are a challenge to the photographer, and this stationary bus was photographed using a shutter speed of 1/60th second to capture the destination details in full.

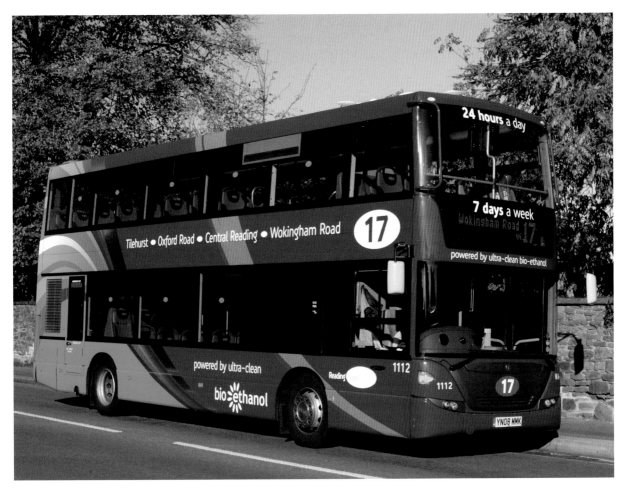

EQUIPMENT

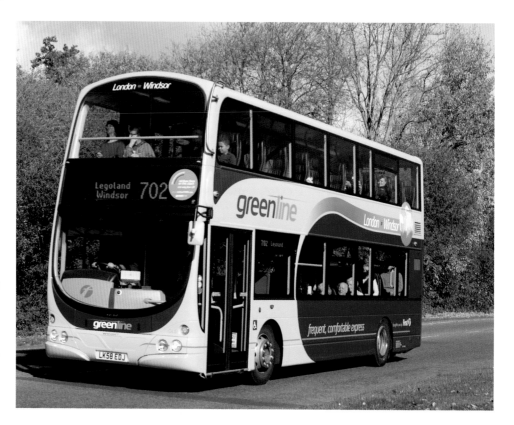

right When buying a digital camera it is important to ensure that you make your requirements clear. To capture fast-moving subjects such as Green Line-liveried First Beeline 37275, seen here heading along Winkfield Road, Windsor, it is essential to have a camera with minimal shutter lag and a suitably fast shutter speed.

In order to start taking digital photographs it is, of course, necessary to get a digital camera. There is also a wide range of other accessories, some more useful than others, which the intending digital photographer might want to consider buying. It is not within the scope of this book to endorse particular brands or models (in any event the life-cycle of modern consumer electronics is such that any advice would be obsolete within a very short period), but what I hope to do is provide enough of an overview to allow you to make an informed choice on what sort of equipment is right for you to get started with. For detailed product advice and comparisons it is worth consulting any of the specialist magazines available.

■ Camera types explained

As with any consumer electronic item the intending purchaser of a digital camera is faced with a bewildering array of choice and often conflicting advice from a range of publications, friends and sales staff. The decision-making process is not made any easier by the fact that manufacturers are constantly upgrading models and adding new features, some of which may be of more use than others. In this section we will take a look at the types of camera on the market and weigh up their pros and cons.

PHONE CAMERAS

In the modern age it seems that every piece of equipment needs to multi-task,

and it is no longer sufficient for a phone to be a phone, a camera just that, or a bus merely something to travel to work on.

These days digital cameras are found in a variety of other gadgets – including cell phones. In fact, camera phones are one of the fastest growing segments of the digital camera market, and with the improvements in the quality of what is being offered in some phones, many believe that they are beginning to win a market share away from the low-end offerings of many digital camera manufacturers. Personally, I am yet to be convinced and mention them for the sake of completeness. By all means buy a phone with a camera facility, but do not expect it to provide high-quality results. At best, view it as something to carry at all times just in case you see something truly unusual on the way to work!

COMPACT

Sometimes referred to as 'point and shoot', these cameras often have a limited range of controls and are therefore somewhat limited in their creative applications. In addition, some of the more basic models have very wide-angle lenses that not only force the user to stand fairly close to the subject but can cause some pretty weird effects! That said, they are very compact, and even budget models are capable of producing reasonable-quality prints of up to A4 size. From the point of view of transport photography, their main limitation is that some models suffer from shutter lag, where there is a delay between pressing the shutter release and the photograph actually being taken. This is clearly a problem when taking photographs of moving subjects as the photographer has to anticipate the distance that the subject will have travelled before the shutter fires. This is easier said than done!

PROSUMER

These are sometimes referred to as 'bridge' cameras. They feature a wide range of automatic functions supplemented by the facility to control settings manually. They tend to have sophisticated electronics that allows them to process images quickly, thus avoiding problems like shutter lag. Lenses are often of a high quality and have a useful zoom range, which, allied to decent-sized image sensors, makes them highly versatile. Their only major drawback is that they do not have interchangeable lenses.

RANGEFINDER

A rangefinder is a device for measuring distance, but it has also become the generic name for a genre of cameras using a separate viewfinder instead of the through-the-lens viewing of a single-lens reflex (SLR) camera. Instead of seeing a direct image projected by the lens onto a focusing screen, as is done in an SLR camera, most modern rangefinder cameras employ a coupled rangefinder system that shows a double image of the scene being photographed in a viewing window. As the lens is focused the two images align. Rangefinder cameras represent a small and specialised area of the market and they are unlikely to appeal to the transport photographer.

DIGITAL SLRS

SLR stands for single-lens reflex camera. This means that there is only one lens in the camera, whereas compact cameras usually have two lenses – one for the viewfinder and one for the sensor to take the picture. SLRs

below **Digital compact cameras are relatively cheap and small enough to fit into a pocket. Although they lack the flexibility of more advanced models, they are capable of producing reasonable results.**

can be digital or film, but both have a mechanical mechanism to move the mirror up and open the shutter to take the picture. Because they only have one lens, when you look through the viewfinder you see exactly what will be in the picture.

They represent the most versatile family of cameras and, as digital photography has taken off, a large number of models are available to suit most budgets. They combine a range of automatic functions with the option of full manual control of both exposure and focusing. This, combined with the ability to choose from a wide range of lenses and other accessories, means that an SLR forms the platform for a system that is capable of developing with the user. This flexibility, combined with recent falls in prices, means that they are probably the best choice for the transport photographer and we will now look in more detail at the issues to be addressed when making a choice.

below **For most keen photographers the best choice of camera is an SLR. It allows the user to change lenses and add other accessories such as filters and external flash guns.**

The most important thing to decide when buying a new camera, as with any other investment, is how much can you afford. Once you have undertaken some basic research into what's available, set a budget and stick to it. Bear in mind that you will almost certainly need to buy additional items such as memory cards, spare batteries, camera bags and maybe additional lenses.

Among the most important considerations are:

- Size: digital SLRs vary considerably in both size and weight. Some have plastic bodies that, although not as rugged, are less of a strain to lug around. Don't overlook the potential impact of having to carry several kilograms of gear in the course of a day's photography – you are clearly more likely to take a lightweight camera than a heavy one. That said, if you are used to using a medium-format camera this is less of an issue.

- What features do you actually need? Make a list, then do your homework – research which cameras fit your requirements and budget, read the reviews in the magazines and on the web, and arrive at a shortlist of maybe three different models.

- Will you want to use your existing accessories? Most manufacturers have unique mounts for attaching lenses and you may be able to use existing equipment bought for an old film camera. That said, advances in lens design mean that it may be just as well to start afresh.

- Don't become too obsessed about pixel count. The more pixels that are squeezed onto an image sensor, the smaller they have to be. This can lead to increased 'noise', which manifests itself as a grainy appearance to the picture.

- What sort of photography are you interested in? As this is a book about road transport, it is reasonable to assume that you will be photographing buses and coaches – these move, so a fast shutter speed (with no lag) will be useful, as will the ability to fire off shots in quick succession (the 'burst rate'). If you are interested in night photography, go for a camera that has a high ISO setting.

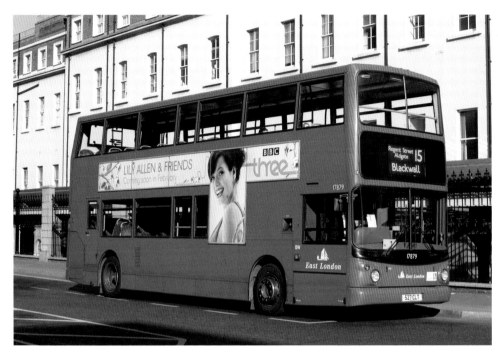

■ Be wary of 'bundled' kits. While these can appear to offer good value for money, they often include items that you do not want.

Armed with your shortlist, go to a good (preferably independent) camera shop and ask to handle the models in which you are interested. If they haven't got a particular model in stock, get them to order it so that you can compare them side-by-side – any decent shop will be willing to do this. Choose the camera that feels right, sits comfortably in your hands and whose controls fall readily to hand. Trust your instincts – if it doesn't feel right, you'll struggle to get good pictures with it.

Once you have made up your mind, buy from the shop that has helped you. By all means negotiate the price down by quoting internet prices, but be prepared to pay around 10% more than you would on the internet – in my opinion it is well worth it for the simple reason that if something goes wrong you can walk back in and get something done about it there and then. Remember that under UK law it is the retailer with whom you have contracted, not the manufacturer. If the bargain that you ordered from a website in Timbuktu

needs warranty attention (or worse still fails even to arrive!), your avenues of recourse are limited. Added to which is a real risk of having to pay excise duties on a personal import before it will be delivered.

Additionally, and speaking as someone who used to work in a photographic store, you'll be supporting your local photographic retail specialist and these days they need all the support they can get – if they go down the pan, there'll be nowhere to 'try before you buy'!

Finally, by all means seek advice from fellow photographers but ignore anyone who is too dogmatic in claiming that this make is best or that make is better – those people are biased because they own one of that brand, and brand loyalty among photographers is very strong. All current DSLRs are fine cameras, capable of producing decent pictures in the right hands. At the end of the day, regardless of how much you spend on a camera it is only a tool to capture an image – it's the nut behind the shutter release that creates the picture!

SENSOR SIZE

The sensor is arguably the most important component of a digital camera, crucial as it

right This image simulates the difference in field of view obtained from a 50mm lens fitted to a full-frame camera with that from the same lens fitted to a camera with an APS-C sensor. Courtney Coaches KX08HMD is seen in Alençon Link, Basingstoke, when new.

is to converting light entering the camera into a digital image.

Just as film comes in a number of formats, there are differing sizes of sensors, although most are smaller than 35mm film. Film formats and film grain are in a way comparable to sensor size and number of pixels, and it is generally fair to say that, as with film, larger sensors require less magnification at the printing stage, thus ensuring better image quality than a smaller format.

For digital sensors, there is a direct relationship between the size of the CCD, the number of megapixels (Mp) it supports and individual pixel size. The larger the pixel, the more light energy it accumulates during exposure. This means that sensors with larger pixels are more sensitive to light than those with smaller pixels, and produce less image 'noise'. For this reason a larger sensor with fewer pixels will give a better-quality image than a small sensor with more pixels.

When comparing the relative size of the sensor used in a digital camera, many photographers use the reference point of film sizes and refer to a full-frame sensor to describe anything that approximates to the size of a 35mm film image (nominally 24mm x 36mm).

There are several reasons why many digital cameras do not have sensors that are at the larger end of the scale. The first is financial – although the cost of producing CCDs is coming down, they remain significantly more expensive than smaller versions. Second, like film formats, a larger sensor tends to require larger and better-quality optics. Finally, the camera itself needs to be bigger (and therefore heavier), something that is not always seen as desirable for most users.

Most digital cameras therefore use an image sensor that is approximately 25mm x 15mm and equates roughly to the format of the Advanced Photo System (APS) 'classic' film format launched in the 1980s. For this reason such sensors are often referred to as APS-C.

An important dependency on sensor size is the type of lens needed to capture a given angle of view. Most film photographers will be familiar with the concept that a 50mm lens provides a field of view roughly the same as that of a human eye and is therefore regarded as a 'standard' lens. Each variant of an APS-C sensor results in a slightly different angle of view from lenses at the same focal length and overall a much narrower angle of view compared to 35mm film. As a result

a 50mm lens used on such a camera will cause parts of the image to be cropped when compared to that obtained when used on a camera with a full-frame sensor.

The widespread understanding of 35mm film terminology means that manufacturers have tended to quote this crop factor (sometimes referred to as a multiplication factor). Most digital SLRs have sensors with a crop factor of about 1.6. This means that to get the same field of view obtained from a 50mm lens the owner of a camera with an APS-C sensor will need a lens with a focal length of about 31mm. The nearest widely available lenses have focal lengths of 28mm or 35mm, so these have become the de-facto standard lens for many digital photographers.

■ Lenses

Although many SLR cameras come packaged with a lens (normally a zoom) of some sort, it is usually not long before your thoughts will turn to buying an additional lens or two.

LENS CHOICE

The concept of a 'standard' lens with a field of view corresponding roughly to that of the human eye has already been mentioned. Lenses with a wider field of view are referred to, not surprisingly, as 'wide angle', while those with a narrower view are 'telephoto'. Lenses have an obvious affect on composition – the shorter the focal length, the wider the view, and the longer the focal length, the narrower the view. But this is only part of the story when it comes to composition. The other (and in many ways more powerful) tool you have to hand is the ability to use your viewpoint and lens choice to alter the perspective of your images. Using a wide-angle lens from close to the subject will make the background appear further away. By contrast, using a longer lens from further away makes the distance between the subject and background appears to become compressed. From the point of view of transport photography, particularly in narrow streets, the wide field of view

afforded by a wide-angle lens is useful, although care is needed to avoid the image becoming distorted – this is a particular issue with horizontal and vertical lines. A telephoto lens is useful for allowing the photographer to compose an image that avoids much of the foreground clutter prevalent in the urban scene. As with wide-angle lenses, however, the road transport photographer is unlikely to have much use for ultra-telephoto lenses.

FOCAL LENGTH EXPLAINED

As has already been touched upon, the focal length of a lens is measured in millimetres (mm). Although there is a mathematical formula to explain the focal length of a lens in absolute terms, this is rather more information than we need for this book. Rather we simply need to establish the focal length of the 'standard' lens for a given camera. Once we know this, any lens with a longer focal length (ie, a larger number) will be a telephoto lens, and anything with a short focal length will be a wide-angle lens.

Any lens that has a fixed focal length rather than a zoom is called a prime lens. These have become much less common over the last ten years or so as the quality of zoom lenses has increased and the cost fallen. However, they do have one major advantage over most zoom lenses – the maximum aperture of a prime lens is usually wide (f/2.8) so they are great for lowlight shots, which is important if you want to capture moving buses, for example. They also tend to be smaller and lighter than many zoom lenses.

That said, a zoom lens, which can be set to any focal length within a given range, will obviously prove more versatile than a prime, and reduces the weight penalty of one zoom lens compared to two or three primes. Ultimately, the choice is a finely balanced one that often comes down to little more than personal preference.

Many manufacturers offer professional lenses with added features that make it possible to take pictures in the most demanding conditions. These include

right The first of three views of Reading Buses 1018, all taken from the same spot in Market Place, Reading. The first is with a 'standard' lens, in this case with a 55mm focal length, which equates pretty much to the normal field of vision of the human eye. When using a camera with an APS-C sensor, the standard lens has a focal length of about 35mm.

right This view is taken with a 24mm lens. Note how the wide-angle field of view has distorted the vertical perspective of the buildings, making them appear bowed, an effect known as barrel distortion. The level of distortion is such that wide-angle lenses are not generally suited to transport photography. To reproduce this effect with an APS-C camera would require a lens with a 15mm focal length.

right The final view is taken using a short telephoto lens with a 105mm focal length (equivalent to 160mm with APS-C). This has made the bus appear somewhat foreshortened. Used with care, telephoto lenses of this focal length allow for impressive compositions, especially in urban areas where the perspective of buildings in the background is compressed.

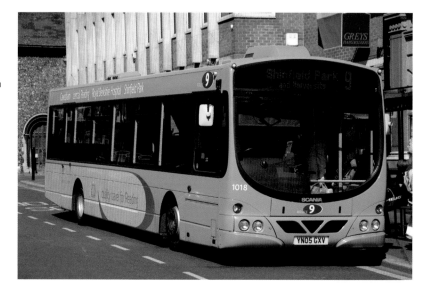

extra-wide maximum apertures and image stabilisers, a mechanism inside the lens that helps compensate for movement while a picture is being taken and thus mitigates the effect of camera shake. They are also often made with better-quality glass and finished to more exacting standards than cheaper lenses. Their more robust construction also means that they can withstand heavier use, although this often brings a weight penalty.

Before buying any lens, try one on your camera body to ensure that you are comfortable with it. It is also worth taking a couple of shots to see what they look like. Remember that lenses made specifically for a camera with APS-C sensors will not function properly on cameras with full-frame sensors.

It is worth noting, however, that just because a lens has a 'professional' price-tag, it is not necessarily the best option for you. If your pictures are purely for your own enjoyment and you can't afford expensive professional lenses, just buy the best you can afford. If you are thinking of selling your work or need the extra facilities to tackle more demanding subjects, then it is time to start saving those pennies.

■ Additional items

Although it is possible to buy a camera, head straight out of the shop and snap the first bus that comes past, is likely that you will want to obtain some additional accessories to enhance your photographic activities.

MEMORY CARDS

The most important item, and earliest additional purchase, is likely to be a memory card or two. Memory cards are the removable device on which the camera stores images; they are sometimes referred to as 'digital film'. Although some cameras have an internal storage capability, this will often be very limited. Just as there are a number of different film sizes on the market, so memory cards vary in both format and capacity. Although your choice of format is largely dictated by the camera you have bought, so is not explored further in this book, cards come in a wide range of memory sizes and speeds.

The size of a memory card is expressed in terms of the number of megabytes (MB) or gigabytes (GB) of data it will hold – a 512KB card will hold twice as much data as a 256KB, one but only half as much as a card of 1GB. The number of images you can fit onto a card will depend on the card's capacity and the size of images you are taking. Image size and format is covered in more detail in a later section; however, as a general rule a high-resolution JPEG image from a digital SLR is about 6MB in size. Using this as a guide, a 1GB card will hold about 170 shots. The other variable quoted on memory cards is speed. They will carry reference to '133x' or '266x'. This relates to the rate at which data can be transferred to or from the card. A higher-speed card is likely to be of particular use to those shooting both RAW and JPEG files simultaneously. Memory cards are relatively cheap these days and, because they can very occasionally fail, it is worth having two or three spares with you on an outing to avoid being left in the position of not having the means of storing photographs. It is also worth noting that there have been instances of counterfeit memory cards being sold, which are of an inferior quality – this can be avoided by buying only from a reputable dealer.

Memory cards have electrical contacts that allow them to be 'read' by both camera and computer. These can be affected by dirt, so it is worth investing in a case to given them some protection.

In addition to keeping them clean, the likelihood of having a memory card fail can be reduced by storing them in a protective case, avoiding extremes of heat and switching off your camera before inserting or removing them. If you find that a card has failed, it may be that the data has become corrupted, in which case it is possible to recover it using one of a number of proprietary software programs.

right Spring flowers provide some foreground interest to this view of preserved TD95 heading out of Esher on 22 March 2009, taken from a wide grass verge. Composition techniques are explored in detail in Section 5.

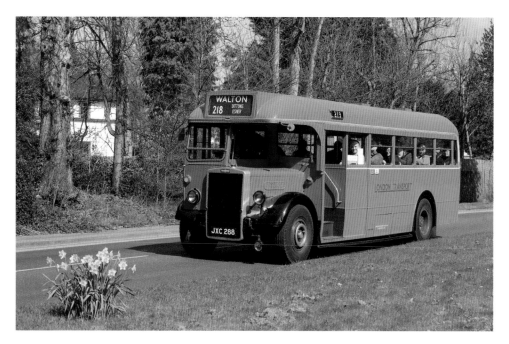

Once images have been transferred from the camera to a computer, and back-up copies made, images can be deleted from the card. This can either be done via a computer or while the card is in the camera. The latter reformats the card, thus wiping it clean of any stray data. Over time simply deleting files can result in data becoming fragmented, which will slow operation. It is good practice to transfer images and reformat cards regularly if only to avoid the risk of inserting a full card into the camera just as an unrepeatable shot presents itself.

BATTERIES

Unlike some older manual models, a digital camera is wholly depended on electrical power to work. It is easy to underestimate just how great these demands are – the camera is basically a small computer with other features, such as a motor added on to power the autofocus. If the batteries run out the camera will not work – period! The frustration that this will cause if it coincides with an unrepeatable event, such as the last normal Routemaster working, is obvious.

Some cameras use widely available batteries such as 'AA' or 'AAA' cells, which have the advantage of being easily obtainable but they are expensive to buy. If your camera is one of these it might be worth investing in some rechargeable batteries and a charger. Other models use rechargeable batteries of a type specific to a particular model. If this is the case the appropriate charger will have been supplied with the camera. It is worth buying at least one spare battery (and making sure it is fully charged) to avoid being stranded.

The amount of use it is possible to get between charges will depend on a number of factors including whether you use features such as autofocus and flash as well as the weather (batteries don't like cold conditions!). In addition, even rechargeable batteries do not last for ever and, with extended use, their ability to hold a charge will diminish. If you find that they are only lasting for a short time it will be worth buying new ones.

Finally, even if your camera uses a bespoke battery type it is possible that generic alternatives are available that will be significantly cheaper and provide comparable performance to that sold by the camera manufacturer.

CAMERA BAGS

Regardless of what camera you have bought it, and its various accessories, it will represent a significant investment. The reality of transport photography is

that you are going to be using your camera outdoors and will need to protect it from the elements and the odd knock and scrape. It is worth investing in a camera bag that allows easy access to all of your equipment without having to remove all of its contents, and one that is easy to carry. Depending on where you plan to take photographs it might also be worth having something that does not scream 'camera bag' to a would-be street robber. As a final consideration, try to ensure that your bag is able to hold a bottle of water and a snack!

LENS HOOD

A lens hood is usually made from strong plastic material and is fitted onto the front of a lens, shielding it from sun flare. The geometry of a lens hood can vary between different lenses and the more complex 'tulip hoods' are generally used on telephoto lenses to prevent the hood from blocking the field of view. Wide-angle lens hoods are much smaller – any larger and they would foul the wide viewing angle.

Lens hoods are particularly useful in wet conditions as they prevent water from hitting the front of the lens.

FILTERS

The term 'filter' has two meanings in the context of digital photography. Traditionally they are pieces of optical glass in a mount that can be fixed to a lens. Although users of black and white film will be familiar with the use of coloured filters to enhance parts of an image (usually the sky), the most common filter used is a colourless 'Skylight' or 'UV' filter. Although this removes some of the haze often present in the middle distance of a photograph, its primary purpose is to protect the lens from damage. A scratched filter costs a few pounds to replace rather than several hundred for a new lens! For bus and coach photography a polarising filter is very useful and its effects will be explored when we examine taking the photograph.

'Filter' is also used to describe some aspects of image processing software – this is covered in a later section.

OTHER ACCESSORIES

Other accessories that may be of use for some types of photography, especially low-light and night work, are tripods and flash guns. A tripod provides a secure platform for the camera when using long shutter speeds, while a flashgun provides additional illumination. The practical considerations of setting up a tripod in a busy urban area are such that I have rarely used one for bus photography. While flash photography may be useful in garages or at exhibitions, it should never be used to take photographs of moving vehicles without first alerting the driver as the flash could cause temporary blindness with potentially serious consequences.

CAMERA CARE

Your camera is a complex piece of equipment that, properly looked after, should give years of good service. There are a number of basic care techniques that will help ensure that you get the best quality photographs possible.

Knowing how to clean a camera lens is a top priority. Just a little bit of dust or grime on your optics can cause all sorts of problems – strong light will show up dust and dirt in your pictures, while general grime will affect image sharpness, so it is essential you keep the lens clean.

A camera lens should be cleaned with either a proper lens-cleaning cloth or lens-cleaning tissues. Paper tissues or the corner of your shirt have rough fibres that

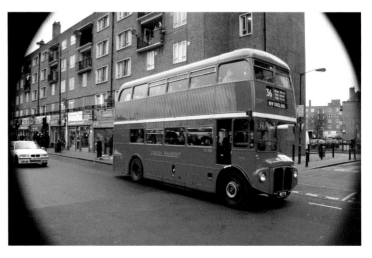

below A lens hood is useful for both keeping rain off the lens and preventing flare. When using wide-angle lenses, however, it is important to ensure that the hood does not cause 'vignetting'. London Central RM9 is seen in a rather wet Peckham High Street on 28 January 2005, the last day of Routemaster operation on route 36.

right The angle of the sun in the sky varies greatly throughout the year, something that is examined in detail later. The noonday sun in midsummer is very high in the sky, which, while throwing very short shadows, can create rather flat images. Transdev Yellow Buses 153 is seen in Gervis Place, Bournemouth, shortly after 1pm on 24 June 2006, when the sun is at its highest point in the sky.

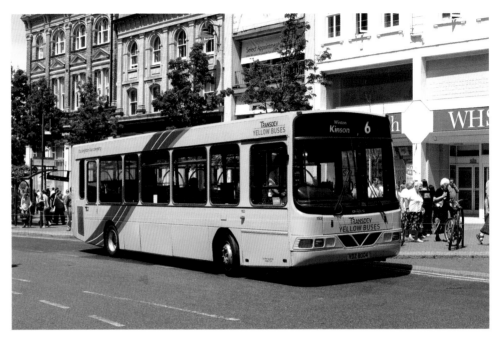

below In midwinter long shadows on sunny days are a challenge to the photographer. At midday on 1 December 2007 Ensignbus RT624 is seen skirting the Thames Estuary at Gravesend.

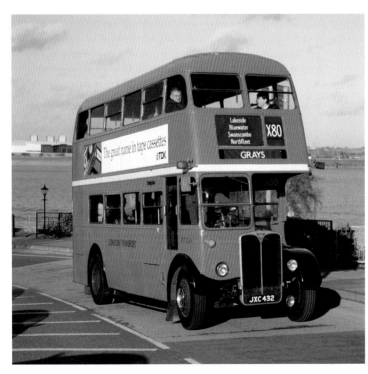

will scratch the surface of the lens. Lens cloths should be replaced regularly, while tissues are only for a single use.

Before you wipe the front of your lens, get rid of any dust or grit that will scratch the glass. A good-quality soft brush or air blower is perfect. Clean the whole of the lens regularly, ensuring that the external moving parts are free from dust and dirt,

particularly sand, which can cause lots of problems and scratches.

When you take a lens off your camera always replace the front and rear lens caps immediately to prevent knocks and scratches and to keep dust off the optics.

One of the biggest potential problems for a digital SLR user is dust on the image sensor, which manifests itself as small specks on your photographs. Some cameras have functions that try to prevent dust, and although it is not possible to avoid altogether, here are some suggestions to minimise the problem:

- Try to avoid changing lenses too much outdoors – city centres in particular are dirty environments! Put the lens that you are most likely to use on the camera before you go out and try to get the shots with this lens.
- Always turn off the camera before changing the lens. When the camera is switched on the sensor has an electrical charge that attracts dust, so by turning it off it is less likely that the dust will attach to the sensor.
- When changing lenses find somewhere out of any wind or dust. Use your camera bag or a shelter to keep you and the camera out of the breeze.

■ Before you take the lens off the camera make sure the new lens is close to hand to minimise the time that the camera is open to the elements.

■ Make sure that the back of the new lens you are about to attach is clean by blowing it with compressed air or a blower before you swap lenses.

If you do find dust on the sensor there are several DIY sensor-cleaning products on the market. Be extremely careful when using any of these products and follow the instructions closely – it is very easy to cause irreparable damage to the sensor.

Finally, be careful of rushing straight out of the cold into a warm place, as it could cause the internal lens elements to fog. Try to slowly acclimatise your kit; at the very least open your camera bag, and keep it away from extremes of heat and cold.

■ Computers

Strictly speaking a computer is not a necessary adjunct to digital photography but, as we will see later, one of the great advantages of the new medium is the ability to improve images using a computer.

The range of computers on the market and the speed with which the technology develops makes buying one a daunting prospect for many. In many respects the approach to take is similar to that when buying a new camera. You are going to be forking out a significant amount of cash so you want to make sure you make the right decision and purchase something that will serve you well for years to come. Manipulating digital photographs places great demands on a computer's processor and, if your existing machine is more than a few years old, it may not really be up to the task.

In this section we will look at some of the more important aspects to be considered before purchasing a computer.

WHERE WILL YOU USE IT?

Which type of computer is best suited to your needs? If you are on the move and fancy using your computer on a train or in

different rooms of your house with wireless internet, a laptop is the obvious choice. If you prefer to sit down in a comfortable swivel chair in an office environment, or computer room in front of a large monitor, a desktop computer will be more comfortable as well as having greater scope to update its specification. If funds permit it may be worth buying a desktop for home use and a relatively inexpensive laptop to use on the move.

HOW MUCH MEMORY WILL YOU NEED?

Processing photographs uses greater reserves of a computer's processing power than just about any other activity in a domestic environment.

There are two types of memory within a computer: random access memory (RAM) – the part that is used for actually carrying out tasks – and the hard disc, on which data is stored. The more functions you carry out at the same time – processing an image, printing another while listening to the radio on the internet – the more quickly the RAM gets used up. Although the computer will not actually 'crash' if the RAM is exhausted, it will slow down, which makes life very frustrating. Computer memory is measured in gigabytes (GB) these days and, as a very rough guide, you should be looking to have a RAM of at least 4GB.

HOW FAST WILL IT BE?

The central processing unit (CPU or 'processor') is the most valuable component that affects the running speed

above **A laptop computer is useful for working 'on the move' although it will neither have the processing power nor the capacity of a desk-top to be expanded.**

of your computer. Nobody wants a slow or sluggish computer, so ensure that you buy a computer with a fast processor. Most common laptops and desktop PCs are fitted with dual-core processors, so you can run multiple demanding applications at the same time. Double-check your processor speed with your purchase. Processor speed is measured in gigahertz (GHz), and the latest models have an extremely fast 2.8Ghz processor. This is ideal if you are going to be working with contemporary software and want any adjustments you make to images to be implemented quickly.

WHICH OPERATING SYSTEM?

Regardless of whether you buy a laptop or desktop computer it will use a specific operating system – this is no more than a computer program designed to make the machine run.

The two most common operating systems are Microsoft Windows and Apple's Mac OS. Windows has by far the largest market share (more than 95%), and as a result a wide range of software is available. Machines running Windows are generally referred to as 'PCs' with those using Mac OS as 'Macs'. Although slightly more expensive than a similar PC, a Mac comes loaded with sufficient proprietary software to get going straight away and tends to be the first choice of professionals. That said, it is likely that you will be more familiar with a PC, as will those to whom you are likely to turn for advice. For these reasons all of the guidance given in this book assumes that the reader is using a PC. Ultimately, though, the choice of PC or Mac is a very personal one; however, as the Macintosh operating system is visually quite different from Windows, if you are thinking of making the jump from a PC it makes sense to try it first.

WHAT SORT OF MONITOR?

Although many stores sell 'bundled' computer packages containing a particular model of monitor, it is not necessary to be restricted by the choice offered. Having the right monitor will make or break your photo-editing sessions. It needs to be capable of showing a good-quality image, both in terms of image size and resolution, as well as being capable of being positioned in a way that allows you to adopt a confortable position while using it. Most contemporary monitors are of the flat-screen type, which offers the twin benefits of taking up less space and producing an

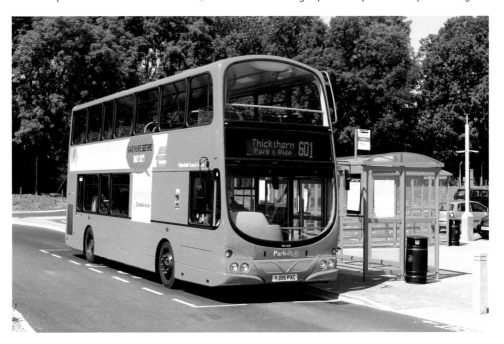

right **Although often overlooked, streetside infrastructure can often be made into an integral part of the photograph. Each of the park-and-ride sites in Norwich is colour-coded to match the branded buses serving it. Sitting next to a matching bus shelter is Konectbus 502, seen at the Thickthorn P&R site on 27 June 2005.**

image that is less distorted than a traditional cathode ray monitor. As an added bonus it consumes less power!

If you intend to spend significant amounts of time editing digital photographs, and if space permits, it is probably wise to get the largest monitor you can afford. A large monitor is easier to work with as the image is larger, making fine adjustments easier to control, and less scrolling up and down is needed to find the piece of the image you want to work on. As with all significant purchases, test the monitor before buying it – this will allow you to check things such as image brightness and clarity.

WHAT ELSE TO LOOK FOR?

There are a number of apparently minor aspects that are often overlooked when buying a new PC. Although easily rectified, a moment's consideration at the purchase stage can save considerable frustration and unnecessary expense later on.

The essential tool for navigating a modern computer is the mouse, and it is worth taking some time to find one that is comfortable to use. The decision as to whether to go for a wireless mouse or one that is connected to the computer by wires is a personal one; I tend to favour the former as it avoids the cables getting in the way.

You are almost certainly going to want to connect accessories to your computer, whether it is a printer, scanner or card-reading device. Most of these are plugged in to a Universal Serial Bus (USB) socket on the computer. While it is possible to obtain a USB hub, which provides additional sockets in much the same way as a multi power socket, these require additional power and can slow down the machine. It is therefore preferable to have as many sockets on the computer itself to ensure maximum flexibility.

HOW MUCH TO SPEND?

Even more so than with cameras it is impossible to be prescriptive about this. Some of the best computer prices can be found on the internet, so make sure you shop around to find the best price.

Although it is not practicable to try the computer as you can in a shop, many online retailers offer the ability to upgrade RAM, processor and hard disc drives with your purchase, so you come away with a tailor-made PC or Mac that is suitable for your requirements rather than the standard products offered by many high-street retailers. That said, if you have a specialist computer store in your area, it will offer this service as well as providing specialist advice and support, which, in terms of saving aggravation, more than outweighs the internet price-saving.

SETTING IT UP

It is important to ensure that the computer is set up correctly to ensure comfort when using it. Important considerations include ensuring that the monitor is free from reflections, there is sufficient desk space to allow free operation of the mouse, and that any accessories are within easy reach. A purpose-designed computer table is clearly the best choice – those with a separate keyboard tray free up space on the desk itself.

EDITING SOFTWARE

Before you can start processing digital images with a computer it is essential to have some suitable editing software. Your camera will have been supplied with a CD-ROM containing a number of programs. The exact nature of the software will depend on the camera, but it will provide you with the

below **The author's workstation. A large (24-inch) monitor ensures that the image being worked on is bright and clear. From left to right on the clear working space of the desk are a wireless mouse, film inserts for a flat-bed scanner, a card reader and scanner. The keyboard is on a shelf beneath the main workspace, while the printer and external hard drive are out of view but within easy reach. Also readily accessible are maps, used for planning photographic expeditions!**

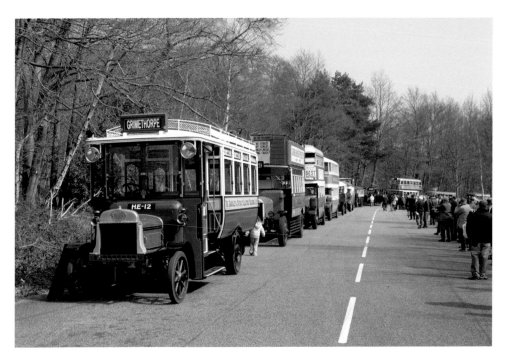

tools to save images onto a computer, sort them and undertake basic editing functions. It is also likely that your computer itself will have been supplied with some photo-editing software. The Microsoft Vista operating system, for example, includes a program called Photo Gallery, which is adequate for basic editing functions.

There are, as you would expect, numerous software packages on the market from which to choose. The gold standard remains Adobe Photoshop CS, which is the choice of most image-editing professionals. It will allow you to undertake every conceivable editing function and offers the scope to add even more features should you wish. That said, it is relatively expensive, most of its functions will be of limited use to the majority of amateur users, and it is not the most user-friendly of programs to use, at least to begin with.

If you do not feel able to justify the several hundred pounds that Photoshop CS will cost, there are a number of alternatives available, some of which can even be downloaded for free from the internet. A good all-round choice, though, is Adobe Photoshop Elements. This is in effect a slightly less highly specced version of Photoshop CS packaged in a more intuitive format, which makes it ideal for the enthusiastic amateur. All of the examples shown in this book have been achieved using this software.

ADDITIONAL HARDWARE

As with almost any large item of consumer equipment there are numerous add-ons and accessories available, although whether these are actually necessary or not will depend on what you are planning to do. In this section we will take a brief look at those likely to be of most use to the aspiring transport photographer.

As already noted, the hard disc drive stores all your data – images, text documents and programs – but every computer comes with a limited hard drive capacity. If you're taking the occasional set of images on a small 5Mp compact camera, it will take you quite a while to fill up even a modest computer's internal 120GB hard drive; if you're shooting lots of large files you will fill this up rapidly. It may be worth buying an additional external hard drive for storing and backing up your images. These have dropped rapidly in price in the last couple of years and connect to the computer via a USB cable.

CARD READERS

Your camera will store the images taken on a memory card, but clearly if you are to edit these on a computer there needs to be some way of transferring them. While it is possible to physically connect the two, the transfer rate is slow and it consumes significant amounts of the camera's battery power. Some computers come with a memory card slot (or slots – there are a number of formats, as we have seen). If yours does not, it is possible to buy a relatively inexpensive reader, which is usually capable of taking a number of different types of memory card and plugs into one of your computer's USB sockets. Images stored on the memory card can then be swiftly transferred to your computer for storage or editing.

GRAPHICS PAD

Although most digital photographers are quite comfortable using the mouse to carry out image editing tasks, it is possible to obtain a graphics pad (sometimes referred to as a tablet), which makes things both easier and more precise. The pad itself is a touch-sensitive screen attached to the computer on which images and selections are 'drawn' using a digital pen. Most pads are able to interpret the drawing style of the user so, for example, greater pressure will result in a wider stroke being made or more colour being added.

■ Scanners

Although I have not used film cameras for several years, I have accumulated several thousand slides, prints and negatives over the years. By investing in a scanner it is possible to digitise these images and process them on a computer in the same way as a photograph taken on a digital camera. There are three types of scanner available:

■ Flatbed: these are the easiest and cheapest option and are sometimes referred to as 'reflective scanners' as they capture light reflected off the original image. Photographs are placed on a glass plate and the lid closed. A scanner moves across the image and captures it digitally. Some flatbed scanners have adapters to hold film strips or mounted transparencies.

■ Film scanner: these use a film holder, which usually holds a single strip of film or a number of transparencies. They

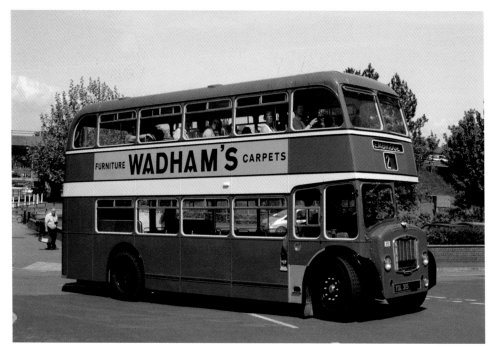

left For those photographers who prefer to see vintage vehicles in action, there are a number of events organised throughout the year in all parts of the county. These vary from low-key events to well-organised undertakings, such as the Isle of Wight Bus Museum's island vehicle running day, for which timetables and vehicle running graphs are available. On 11 May 2007 Southern Vectis 563 pulls away from Newport Quay.

tend to provide better quality than flatbed scanners and often have some form of dust-removal software supplied.

■ Drum scanner: these are the professionals' choice and provide excellent quality from negatives and slides. The film is wrapped around a glass drum, which is rotated at high speed and the image scanned at high resolution. They are, however, expensive pieces of equipment.

The scanning process is, in many ways, analogous to that of image capture in a digital camera, although the picture is taken in lots of small slivers rather than in one go as the scanner's sensor passes across the image. The image is then 'rebuilt' using the scanning software. The resolution depends upon both the number of pixels in the sensor and the number of slivers into which it breaks the image while scanning it.

As with almost everything else, buying a scanner brings with it a whole new set of jargon. The most important things to bear in mind are:

■ Resolution: most manufacturers describe their product, incorrectly, in terms of dots per inch (dpi). The correct label is point per inch (ppi), and the higher the figure the greater the definition offered. Where optical and maximum resolutions are described ignore the latter as it will be produced through a process known as interpolation, which reduces image quality. As a general rule a reasonable-quality scan of a print requires around 600–1200ppi, medium format film about 2400ppi, and a 35mm frame up to 4000ppi.

■ Bit depth: this determines the number of colours that the scanner can reproduce. Most scanners will capture 8 bits, which will provide just over 16 million colours. Some higher-specified scanners offer 36-, 42- or even 48-bit colour, which can produce billions of colours, albeit giving very large file

sizes. That said, they will usually need to be reduced to 8-bit for printing.

■ Dynamic range: the density of an image is measured, from pure white to very black, using a scale of 0 to 5. The ability to capture a truly dark image is described as a DMax factor. Most scanners have a DMax factor of about 4, with only high-end drum scanners delivering a rating of 5. Scanners with a lower dynamic range will not be able to capture dark areas of the image properly.

Scanners will usually come supplied with suitable image-editing software, although many photo-editing programs can also import images from a scanner.

Flatbed and film scanners give perfectly acceptable results, but they will probably not do justice to your original slides, and images scanned in such a way are unlikely to be acceptable for publication. That said, they are useful tools to have and can be obtained relatively inexpensively. If you do want high-quality scans from slides it is probably more cost-effective to send them to a professional lab for scanning than to invest in a drum scanner.

■ Printers

Although all of the processing of a digital image takes place on a computer screen, you are almost certain to want the ability to print your photographs. I look at the practicalities of printing in a later section – for now the aim is to give some idea of what to look for when choosing a printer.

There are three types of printer readily available:

LASER PRINTERS
These work in a similar fashion to photocopiers by electrostatically charging a sheet of paper, which allows a coloured powder (the toner) to attach itself to the paper. The toner is then fixed to the paper by a heating process. Although laser printers have a number of advantages, notably speed, they are not able to

reproduce a wide range of colours. For this reason their use as photo-printers is limited.

DYE SUBLIMATION PRINTERS

These are designed specifically for printing photographs. They work by heating a film coated with coloured dyes, which are vaporised and transferred to a specially coated paper. This means that they are capable of producing very high-quality images with a full range of colours and, because the dyes are infused within the paper, they are less prone to fading. Their main disadvantages are that they come in a relatively limited range of sizes and are not able to be used for general printing tasks. There are a number of small dye sublimation printers on the market that can be connected directly to a camera to produce prints.

INKJET PRINTERS

For all-round flexibility most users gravitate towards an inkjet printer. It offers good print quality, is multi-purpose and, unless you want to print hundreds of images in one go, offers a reasonable speed at a price within most people's budgets. Inkjet printers work by spraying microscopic drops of ink onto the paper, which make up the image. If you look closely it is possible to see these. When choosing an inkjet printer the most important considerations are:

- Print size: most printers will take paper up to A4 size, which is more than adequate for the majority of users. If you want to produce really large prints, make sure you buy a printer capable of taking A3 or even A2 paper. Remember, however, that you will need to have high-resolution images to do justice to this format.
- Number of colours: inkjet printers use variable amounts of coloured ink to reproduce the many tones contained within an image. The better-quality printers will use five or more colours plus black to make up the picture.

- Separate ink-tanks: it is worth buying a printer that has separate cartridges for each colour. This avoids having to replace all the inks at once simply because one colour has run low – a particular consideration if you print lots of photographs of London buses!

Although you will usually print images that have been processed in some way on a computer, it is possible to insert a memory card into many printers and print photographs directly from it. Finally, some printers come with added features such as scanners or a fax capability. While these may be useful it is clearly preferable to make your choice on the basis of printing capability.

■ The upgrade race

In common with other consumer items, photographic equipment and computers seem to have ever shorter life-cycles, which leads many users to continually question whether they need to have the latest offering simply because it promises a few extra pixels or a faster processing time. The simple truth is that the evolutionary curve of digital photographic equipment has begun to slow down and future developments are likely to be incremental. A camera is not obsolete simply because the model has been replaced – if it does what is required of it, that's all that matters.

below Wilts & Dorset 4426 was captured passing through Corfe Castle using a Canon 300D SLR, fitted with a 35mm lens, on 1 July 2006. Although now superseded several times, the camera still produces acceptable results and there is little reason to spend money on replacing it simply because a newer version is available. The bus, however, has long since made its last journey to Swanage.

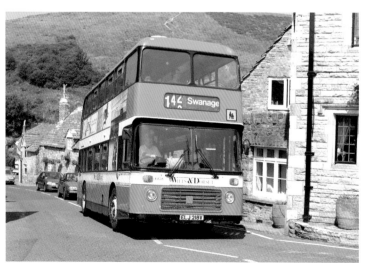

SECTION 3

DIGITAL
TERMINOLOGY

If you have survived this far you will have acquired a new digital camera and computer together with a number of other accessories. Even a cursory perusal of the instruction manuals will have shown that there is a whole new vocabulary to learn associated with digital photography. In this section I will explain some of the terms that will appear most often as we start to take photographs and process them on a computer. In addition, we will consider some of the issues to be addressed before taking that all-important first photograph. It is important to note that the guidance given is just that – guidance. If the instructions provided for any of your equipment suggest an alternative, that must take precedence over anything said here.

First, we will look at file formats, image quality and why these are important to obtain the best results from your camera.

■ File formats

Before you take a picture with a digital SLR the camera will offer you a choice of formats that the image file can be saved as. There are two main options: JPEG (Joint Picture Experts Group) and RAW. Each has its advantages and disadvantages, and each is more suited to certain situations. Some cameras allow you to save both a RAW and a JPEG file simultaneously. In addition there is a third format in widespread use: TIFF (Tagged Image File Format).

The JPEG is the most widely used digital file type. It takes all the information from a digital picture and compresses it into a relatively small file. The compression allows the file to use less memory, but it also loses a certain amount of quality in the process. The compression process works by identifying which pieces of information can be discarded without adversely affecting the image – as an example, a photograph of a red London bus will contain large numbers of adjacent identical pixels. The compression process will get rid of large numbers of these by, effectively, telling the program that the next so many pixels are similar.

As such it is sometimes known as a 'lossy' file format. Every time you save a JPEG it gets more compressed, which means that the picture is losing more image detail each time it is saved. Eventually this results in your picture suffering from horrible jagged edges. Digital cameras allow you to choose the quality of JPEGs, while picture-editing programs also allow you to select the amount of compression.

If your images are suffering from jagged edges it may be necessary to increase the quality settings on the camera. Lower-quality JPEGs are suitable for small prints and the web, but you will need to increase the JPEG quality in your camera for larger prints, or even select another file type for higher-quality use. You will probably have a choice of both image size and compression settings on your camera – it is always preferable to select the largest image size and lowest level of compression in order to capture the best-quality images. Remember – while files can be made smaller for particular purposes, it is not possible to increase the quality of a JPEG once it has been shot. JPEG files can be recognised by the '.jpg' file extension.

RAW is a digital image file where the data is taken directly from the camera sensor. Unlike other formats, no processing is performed on the images in-camera, so

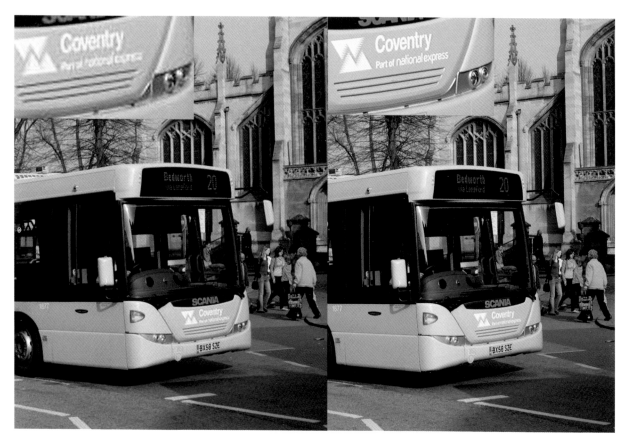

you have to process them once they are downloaded to your computer and convert them into a widely recognised file type.

This makes RAW files much more versatile than their JPEG counterparts, as you can change the settings from those chosen when you shot the image without any loss of quality. The downsides are that it takes time to process the images and the images cannot be successfully printed directly from the camera.

This format is available on all digital SLRs, and many creative digital compacts and SLR-style cameras. Each manufacturer has its own standard for the format, however, so the RAW files from a camera can only be recognised by certain types of software. This is not a problem for most people, but even different cameras within each manufacturer's range can have different RAW file formats. This is worth looking out for if you are buying a second camera or upgrading from one model to the next – do not assume you will be able to use the same software. The file extension

used by a RAW file varies between camera manufacturers. We will look at RAW files in more detail in Section 8.

TIFF is an extremely versatile file format, and is popular among both photographers and designers. This is because it is supported by nearly all image-editing and desktop publishing applications and can also be inserted into word processing documents.

Unlike JPEGs, TIFF files, recognised by their '.tif' file extension, are a lossless format, so no matter how many times you save or copy them, your image will not degrade. This comes at the expense of a file size that is considerably larger than a JPEG.

Other common file formats include bitmap (BMP), which is no longer widely used, and Graphics Interchange Format (GIF), which has a limited ability to handle colours and is used mainly for web applications.

Photoshop is the 'native' file format used by Photoshop and means that any of the features added during the editing

above **A comparison between low- and high-resolution images. The view on the left is 1000 x 667 pixels, producing an image size of 150KB, while that on the right is 3000 x 2000 pixels and produces an image size of just under 5MB. The loss of detail and 'pixilation' is clearly visible in the smaller image. Although this is an extreme example, if your photographs exhibit these features the file size on the camera should be increased. Travel West Midlands 1877 is seen passing Saturday shoppers in Trinity Street, Coventry, on 21 March 2009.**

process are retained and can be further edited at a later date. Photoshop files carry a '.psd' file extension.

■ File extensions

All files have what is referred to as an 'extension' made up of three or four letters separated from the file name by a full stop. As we have already seen, the file name itself can be almost anything that describes the contents of the file and is for the benefit of the user. By contrast, the extension tells the computer what kind of data is within the file and therefore what program is required to open it. In addition to the file extensions used by image formats, described above, you may have come across the following:

.doc – word processing document
.xls – spreadsheet
.htm – web page

■ Resolution, image size and pixel count

These are some of the most frequently used, yet least understood, terms in the world of digital photography.

Resolution refers purely to the number of pixels that are contained within a digital image – in general, the more pixels, the more detail the image can contain. It is usual to use pixels as a measurement unit when describing the size of a digital image, so, for example, an image that is 3000 x 2000 pixels will be described as a 6 million (or 6 megapixel) image. The image size refers simply to the physical dimensions of the image.

Image resolution is usually described in terms of the number of pixels per inch (or ppi), and the optimum level of resolution will depend to a large extent on how the image is going to be displayed.

Pixel count, resolution and image size combine to affect how an image will look when displayed. For display on a web page it is common to use a resolution of 72ppi, which means that fewer pixels are required

to fill the monitor. This in turn means that the pixels appear larger and, because there is less information, the file size is smaller. A high-quality printed image will usually have a resolution of at least 300ppi to give the required level of detail in an image reproduced to the same size.

The following formulas provide information about how to view the relationship between the physical size, resolution, and pixel dimensions of an image:

Physical size = resolution x pixel dimensions
Resolution = physical size/pixel dimensions
Pixel dimensions = physical size/ resolution

For example, you have an image that has a width and height of 400 x 400 pixels, has a physical size of 4 x 4 inches, and has a resolution of 100 pixels per inch. If you want to reduce the physical size of the image by half without resampling, you set the physical size to 2 x 2 inches, and Photoshop increases the resolution to 200 pixels per inch. Resizing the image this way keeps the total number of pixels constant – 200ppi x (2 x 2 inches) = 400 x 400 pixels. If you double the physical size (to 8 x 8 inches), the resolution will decrease to 50 pixels per inch, because adding more inches to the image's size means that there can only be half as many pixels in each inch. If you want to change the image resolution, the physical size will change in response.

Finally, it is worth noting that ppi (pixels per inch) is different from dpi (dots per inch). Pixels per inch is the number of pixels in each inch of the image (as described in this section), while dpi relates only to printers, and varies from printer to printer. Generally there are 2.5–3 dots of ink per pixel. For example, a 600dpi printer only requires a 150–300ppi image for best-quality printing. Images of 300ppi or more can sometimes show pixilation when viewed on screen – this is not a cause of concern as they will be fine when printed.

■ White balance

The type of light falling on your subject makes a massive difference to the colour of the scene. The light in the middle of the day is much more blue than it is at sunrise or sunset, while a cloudy day or artificial light will produce a different cast. This is due to what is known as the colour temperature of the light source. While our eyes and brains adjust to these changes automatically, this is not the case with a camera, which will faithfully record what is actually there. Every digital SLR has a white balance (WB) setting to adjust the way it records colours, so to get the most out of your camera you need to know when to use the settings available. While for the

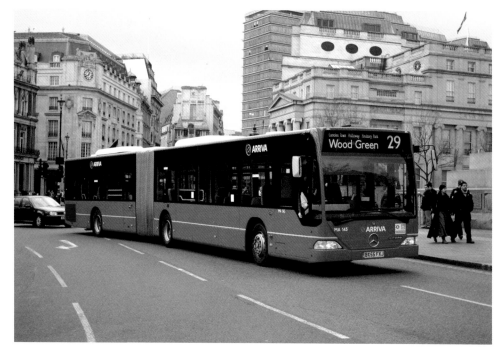

left Although the auto white balance usually works reasonably well, it is possible to obtain greater control by setting it manually. This view was taken in a rather cloudy Trafalgar Square on 22 January 2006 using the auto white balance setting ...

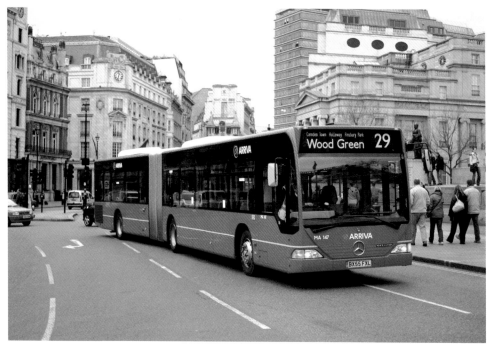

left ... while this was taken a few minutes later using the pre-set for cloudy conditions.

vast majority of cases the 'auto' setting will give a reasonably faithful reproduction, it us worth understanding how to change the setting should you wish.

■ Exposure

In photography 'exposure' is a measure of the total amount of light that is allowed to fall on a piece of film, or digital sensor, during the recording of a photograph. Regardless of the type of camera used, only two controls influence this amount of light: the exposure time is determined by the duration of the shutter opening (usually referred to as the shutter speed), and the level of illumination received is determined by the size of the opening in the lens iris (usually referred to as the aperture).

The exposure is also determined by the sensitivity of the recording medium. For photographic film this is usually referred to as the 'film speed', while the sensor of a digital camera emulates this by having a sensitivity that is equivalent to 'film speed'. This sensitivity is typically expressed as a value on a scale produced by the International Organisation for Standardisation (ISO). In the same level of light, the greater the sensitivity of the recording medium, the less exposure it requires to provide a correct exposure.

All digital cameras have auto-exposure as an in-camera system for setting the shutter speed and aperture automatically. There are several different types of auto-exposure systems, ranging from program exposure, where the camera sets both the shutter speed and the aperture automatically, through to aperture-priority and shutter-priority, where you choose the lens aperture or shutter speed respectively, while the camera automatically selects the other setting.

When taking photographs of moving vehicles it is important to select a shutter speed that is sufficiently fast to 'freeze' the action. If you find that you are taking photographs in which the background is sharp but the moving bus blurred, you need to use a faster shutter speed. Experience will help, but as a general rule a shutter speed of about 1/500th second is the minimum likely to give a sharp image. If the bus is slightly more head-on to the camera, a slower speed will suffice.

■ Program modes

Most cameras feature a Program mode of some sort, which will automatically take the camera's meter reading and set both your aperture and shutter speed in relation to the ISO, but still allow you to override many of the settings and use the exposure compensation function.

For a novice photographer, Program mode is a really good way to gain confidence in using the camera. Once you get used to Program mode, you should start progressing to aperture-priority and shutter-priority modes, or even to full manual mode for total control over your pictures. You can still use the Program mode as a fail-safe option.

■ Aperture-priority and shutter-priority

APERTURE-PRIORITY

This is an automatic exposure mode available on most digital cameras. In this mode the photographer specifies the desired lens aperture (f/number) and the camera automatically sets an appropriate shutter speed based on information from its internal light-metering system.

This mode is particularly useful in any shooting situation where it is important to control the depth of field, as the larger the aperture (the lower the 'f' number), the shallower the depth of field will be. This means that it is possible to have the subject in focus while the background is out of focus. Although this is not a technique that is likely to be deliberately used much by the transport photographer, it is worth being aware of the potential for a long subject, such as an articulated bus, to be partly out of focus.

It is also worth noting that most lenses offer the optimum image quality at an aperture setting about two stops below the

maximum aperture – that is, a lens with a maximum aperture of f2 will offer its best quality at f5.6.

SHUTTER-PRIORITY

A digital camera's shutter speed works in exactly the same way as with film cameras, so for the photographer already familiar with the application of shutter control, applying it to digital photography will be simple.

The shutter speed is a fraction, or multiple, of the number of whole seconds the shutter remains open to allow light to fall on the film or sensor. Used in conjunction with the lens aperture, it helps to control image exposure.

Shutter-priority is a semi-automatic exposure mode available on most modern film and digital cameras. In this mode the photographer specifies the desired shutter speed and the camera automatically sets an appropriate lens aperture based on information from its internal light-metering system.

This mode is particularly useful to the bus photographer seeking to freeze a moving subject. It is worth bearing in mind, however, that many modern buses have electronic destination displays that are often difficult to capture with a fast shutter speed as the display is constantly refreshing.

■ Using manual exposure

Although the automatic exposure functions on a digital camera give reasonable results most of the time, you will probably find, with experience, that you want to take control of the agenda yourself. Modern bus liveries often have contrasting areas of colour that can easily fool the camera's automatic functions. The camera will have a display in its viewfinder that will tell you when you have selected the correct exposure. With practice you will be able to assess this yourself and learn which subjects require a slight variation. White coaches in bright sunlight, for example, usually need a slightly shorter exposure time than the camera will indicate to avoid the white parts of the image being burnt out. The real advantage of digital photography is that you can practise exposures and see what gives the best results. The exposure information is stored in the resultant file, so it is easy to check back later.

■ Making sense of the camera histogram

Those who have used film cameras will be aware that different films have varying tolerances of under- or over-exposure, with

left A fast shutter speed was needed to freeze this moving bus, although as a result the electronic destination display has not been captured properly. Andybus N222 LFR is seen passing along Penzance Drive, Swindon, on 4 March 2008. The way in which such displays appear in photographs depends on their refresh rate – some will only display part of the image if a shutter speed faster than about 1/60th second is used, while others present no problem. Some, rather infuriatingly, come out some of the time!

right The histogram provides a useful means of assessing whether a photograph is properly exposed. This picture is under-exposed – all of the histogram peaks are grouped towards the left of the graph and fall off the scale at the end. This means that you will need to increase the exposure, using a longer shutter speed, a larger aperture (lower 'f' stop) or higher ISO setting.

right Perfectly exposed: all of the histogram peaks are grouped within the limits of the graph and tail off gently at each end.

right Over-exposed: here the histogram peaks are grouped to the right and fall off the scale at the end, showing that there are parts of the image that have been reproduced as pure white pixels. Again you'll need to change the exposure, but this time it will need to be *decreased*.

black and white negative film being the most tolerant and colour slide the least. This tolerance is referred to as 'exposure latitude'. Compared to film, digital sensors do not have a particularly wide exposure latitude and, in particular, over-exposure will result in areas of burnout within the brighter areas of the image.

The histogram is an invaluable tool to ascertain whether a photograph is properly exposed or not. In essence it is a bar chart that shows the brightness levels of a picture. It ranges from blacks or shadows on the left, through mid tones in the centre, to whites or highlights on the right. In more technical terms, the image is made up of pixels that all have a numerical value assigned to them – 0 equates to black while 255 is pure white.

Well-exposed images should have smooth peaks and troughs all the way across the chart. As we will see later, although it is possible to correct some images post-shooting it is always best to get a good exposure at the shooting stage

rather than at the editing stage. In digital photography, over-exposure is one of the greatest mistakes you can make, as vital highlight detail may be lost for ever. This happens because only a very precise range of tones can be recorded by the camera's sensor, and if parts of the scene are too bright, they'll appear as pure white. This is known as highlight clipping.

If you are not careful, large areas of the scene can fall outside your camera's exposure tolerances and block out in this way. This can look ugly and distracting, not to mention the fact that there is no visible detail in these white areas. For the bus and coach photographer this is a particular issue with white-based liveries, although white buildings and clouds present similar problems.

As far as highlights are concerned, concentrate on the right-hand side. If the histogram shows that there are lots of white-toned pixels in the image, touching the very edge of the histogram, this probably indicates that some tones in your scene have been over-exposed and detail has been lost.

above **When taking photographs of light liveries, especially white National Express coaches, it is easy to burn out detail in the vehicle. In this example a meter reading from the background indicated 1/640th second at f6.3. The photograph was taken at 1/800th second, which, although leaving the background marginally too dark, has ensured that detail is retained in the coach.**

Ideally what you want is a small gap at the right of the histogram: this indicates that no tones in your image are pure white, so you can guarantee that detail has not been lost. To avoid pure white tones, reduce the exposure by half a stop. It is often worth taking a test shot of the scene before the vehicle arrives and checking the histogram.

It is worth noting that there will almost always be some grouping of pixels towards the darker end of the display with any bus photograph, as the destination display is invariably black.

Another point to bear in mind when photographing vehicles with a predominantly white livery is that the bright areas can be easily burned out totally. The best approach is to take a meter reading of the background, then decrease the exposure slightly. Although this will result in a slight under-exposure of the background, this can be corrected later if necessary. The alternative is a loss of detail in the vehicle itself, which is more difficult to correct.

BRACKETING

Sometimes it is not immediately apparent what the correct exposure should be. In cases like this it is usual to take a photograph at the exposure setting indicated by the camera, then deliberately take one that is apparently over-exposed by one stop and follow this by another under-exposed by the same amount. It is then possible to select the best exposure afterwards. Clearly, however, this approach will not work with a moving subject!

Most digital SLRs offer an automatic exposure bracketing (AEB) option, whereby the camera will usually take three shots. One will be at the exposure suggested by the meter, while the other two will usually be over and under the suggested exposure by an amount selected by the photographer.

To take the three AEB shots, hold the shutter release down (in continuous shooting drive mode) or press the shutter three times (in single-shot drive mode).

It is possible to influence whether the camera changes the shutter speed or aperture during the bracketing by choosing the right exposure mode. In aperture-priority the camera will alter the shutter speed and keep the aperture constant, while in shutter-priority it will alter the aperture instead, keeping the shutter speed constant.

The AEB function is usually found on the camera settings menu. Consult the manual for how to do it on a particular model of camera.

HIGH DYNAMIC RANGE (HDR)

As noted above, the sensor in a digital camera has a limited ability to capture a full range of contrast, particularly in situations that have both bright sunlight and dark shadows. While this is likely to improve with time as image sensors evolve, the only options available at present are either a degree of compromise or the use of the newly developed HDR concept. This relies on taking a number of photographs at different exposure settings and combining elements of them afterwards using suitable software. Its reliance on taking a number of identical images (ideally using a tripod) means that it is of limited application in the field of bus and coach photography.

■ Drive modes

There are occasions when it is useful to be able to take a sequence of pictures, or more than one photo, to make sure that you have caught the subject properly. We have already touched upon the problems presented by certain electronic destination displays – while some only show part of the display, others, while visible to the eye, are in fact blank during their refresh phase. Sometimes by taking a series of shots it is possible to obtain at least one photograph with the display complete. Cameras offer a variety of different motor drive modes – here's how to choose between them.

In single-shot mode the camera will only take one image at a time. To take the next shot you need to lift your finger from the shutter release and press it again. This prevents you from accidentally taking more than one shot of the same subject. This is

left Exposure bracketing can be usefully employed when taking photographs of stationary buses. It entails taking one photograph at the indicated exposure setting, one slightly over-exposed and one slightly under-exposed. The range of the bracketing is set by the user. This image shows a 2/3 stop over-exposure. The lighter parts of the livery have been burned out and lack any detail.

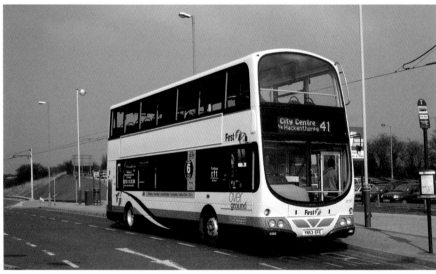

left This photograph was taken at the indicated setting ...

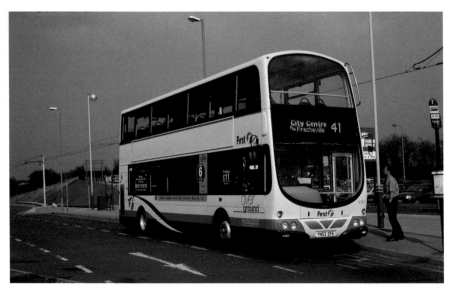

left ... and this shows an under-exposure, again of 2/3 stop resulting in an image that is too dark. While it is possible to recover this situation using image-processing software, there is a risk of introducing 'noise' into the final image. The vehicle is First South Yorkshire 31787 seen at Halfway in April 2004.

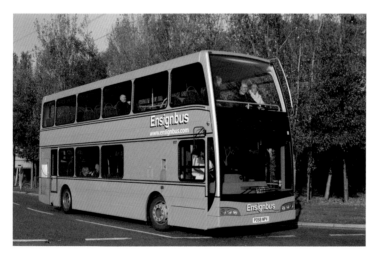

top, middle and above **The problems associated with capturing electronic destination displays have already been alluded to. This series of photographs was taken using the continuous-drive mode in the hope that at least one would include a clear display. Ensignbus 117 is seen at the Lakeside shopping centre in October 2008. A success rate of one in three is fairly typical for some types of display. At least with digital photography it is immediately clear which photographs have worked and which have not. When using film there was a wait until the film had been developed.**

perfect for shooting static subjects or where you have time to frame the shot beforehand.

In continuous mode the camera will fire a burst of shots when you press the shutter release. This is ideal for firing off a sequence of shots of, say, a moving bus in the hope that the destination display will be captured on at least one of them. As with all features the way in which this is accessed will vary between individual camera models, so it is best to read the instruction manual fully.

■ Focusing modes

Correct focus is critical for getting a good-quality photograph and something that cannot easily be rectified after the event. Almost all digital cameras have an autofocus mode and many have a manual override of the function. Depending on the model it may be possible to choose a number of options for the autofocus mode, including how many autofocus points are used. Although it is a matter of personal preference, I tend to opt for a single point as this gives far more control.

Most autofocus systems allow the user to lock the focus by prefocusing on a particular area then pressing the shutter release part way down while pointing the camera at the focus spot. Once the focus is locked the image is then composed in the viewfinder. When taking photographs of a stationary bus I tend to focus on a spot under the cab window (for an offside shot) or at a similar relative spot for nearside views (for example, the entrance door of a modern bus).

When taking a photograph of a moving vehicle the best approach is to prefocus on a spot on the kerb that marks the point at which it is intended to take the photograph. It is also worth remembering that many cameras will not actually allow the shutter to fire until the focusing system has locked onto something. If using a camera that suffers from shutter lag this can be reduced by prefocusing.

In addition to the single-shot mode,

Focus point

left The optimum focus point is just beneath the driver's window (or entrance door for nearside views). For stationary subjects it is a straightforward matter of focusing on this spot and taking the photograph.

Focus point

left When taking a photograph of a moving subject it is advisable to prefocus the camera, then frame the shot. The focus spot used in this view of Veolia Cymru 50202 passing along Carnglas Road in Swansea is a point on the kerbside near where it was anticipated the front wheel would be.

where the focus is locked only until the shutter is fired, some cameras have a continuous focusing mode where the camera will adjust the focus all the time the shutter release is pressed. This is often described as a 'sport' mode and is quite useful when photographing moving vehicles.

As with all automated processes there are times when autofocus does not work. You may experience a phenomenon known as 'hunting' when a camera cannot autofocus, and the lens 'hunts' back and forth for the focus. While hunting the camera will focus to infinity then at the closest focus, and will repeat this process usually about twice until the AF locks on. Autofocus usually struggles in cases where there is either not enough contrast in the subject matter or simply not enough light. This is particularly relevant when taking

photographs in fog or at night, when it is usually necessary to switch to manual focus.

■ Understand your viewfinder

One of the major advantages of an SLR over a compact camera is that the SLR viewfinder shows pretty much the same image as seen by the lens. The viewfinders of most DSLRs only show around 95% of the image that you're going to capture, as well as giving information on the exposure and the focus points being used.

With a DSLR you can always check the result by viewing it on the camera's LCD display. If the composition is critical, and you do not want to crop the image, check by eye what is just outside the viewfinder – just in case.

There are also certain adjustments you can make to your viewfinder:

- Some cameras allow you to display grid lines in the viewfinder to make it easier to get your horizon, or other straight lines, level or vertical.
- All DSLRs have multiple focus points, displayed in the viewfinder. The active point (or points) is usually indicated by a different colour or tone in the viewfinder.
- Most DSLRs feature a control to adjust the viewfinder for your eyesight. This is usually adjusted by means of a slider or wheel near the viewfinder eyepiece. You only need to touch this if you cannot see the viewfinder image clearly, so do not change it if you are happy with the sharpness. If you do need to adjust it, simply look through the eyepiece and slowly move the control until you can see the display and image clearly.

■ Understanding colour

The human eye is capable of detecting even the slightest variation in colour. Unfortunately for the photographer this is not the case with either film or digital media, which is why colours as reproduced in an image are often different from those

that the photographer remembers.

The amount of colour information available in a digital image is referred to as 'bit depth' (sometimes as 'colour depth' or 'pixel depth'). In simple terms, the greater the bit depth the more colours are available and the more accurate representation of colour it is possible to capture in a digital image. A pixel with a bit depth of 1 has only two possible values – black or white. An 8-bit pixel will produce 256 colours (2^8 = 256). Given that there are three colour channels (red, green and blue), this means that it is possible to represent 248 variations (8 bits in each of three channels) of colour, which is something over 16 million. Most digital imaging uses 8-bit channels, although 16- and 32-bit are beginning to find favour for some applications. These allow far greater control over colour, and even if images have to be converted to 8-bit depth for final printing it is worth editing them in the higher setting before converting them to 8-bit for saving.

Colour space defines the range of colours and tones available in an image. Some colour spaces offer a wide range of tones, giving more subtle images, while those with a more limited colour range give more punchy results. In some respects from one colour space to another is similar to changing films – from one that gives high contrast and punchy colours to a lower-contrast, more subtle film.

The most important reason for choosing the colour space that you will be using is consistency. If your software and printer use an sRGB colour space, make sure that your images are saved in this colour space as well.

There are two colour spaces commonly used in digital photography – sRGB and Adobe 1998. There are technical differences between the two, but the choice is mainly down to what you will be doing with your images.

- sRGB: if you are printing your pictures at home on an inkjet printer or using an online or high-street printer, use sRGB. This will give you the most

consistent and punchiest colours. It is also great for direct printing from your digital camera. It is used by most inkjet printers and high-street or online laboratories.

■ Adobe 1998: this offers a greater range of colours and tones but most of this will be lost if you print at home or at many normal commercial printers. Adobe 1998 has become the standard used by many professional and magazine applications, so if you're producing images for sale you may want to use it instead. It can produce weak colours when using inkjet, online or high-street printers.

In addition there is a difference between the 'RGB' colour space used in a camera sensor and computer monitors – which process colour using red, green and blue pixels that combine to form the full colour spectrum – and 'CMYK'. The latter is used in the print format and the three basic colours – cyan, magenta and yellow – are combined with black (K) to represent a full range of colours. If you are going to have photographs printed commercially they will have to be converted to the CMYK colour space. Many of the less expensive editing packages are unable to handle CMYK colour space – if you wish to process images in this way suitable software will be required.

HOT PIXELS

Hot pixels are bright pixels that can appear on your photos, usually during long exposures. They look like stars or coloured dots and can appear anywhere in your shots, but are more obvious on dark areas.

They occur because some pixel sites on the camera's image sensor can accumulate a charge without any light falling on them –

below **The bright green points caused by hot pixels in this shot of RML887 and RTW75 at Putney Heath are clearly visible. Although they can sometimes be addressed using image processing software, it is far simpler to take a series of photographs, using shorter shutter speeds, and hope that the problem will not manifest itself in some.**

exposure to light is normally how a charge is achieved. This charge is then falsely interpreted as light, giving a bright dot.

Most DSLRs produce very few hot pixels in a 30-second exposure, but longer exposures and warmer conditions will intensify the problem. For the transport photographer they usually become a problem when taking photographs at night with a long exposure time.

■ Metadata and EXIF info

As we have already noted, the cost of taking digital photographs is virtually zero and this should encourage you to go out and experiment with different settings. A great advantage of digital photography is that the shooting information is all stored in the image file. By right-clicking on the file name and selecting 'properties' it is possible to access a host of data for that picture.

This includes the shutter speed, aperture, ISO, focal length, date and time. While I started keeping notes of exposures, etc, when using film, it was something I quickly stopped doing! It is like having a personal secretary each time you go out.

■ Noise

'Noise' is apparent by the presence of colour speckles where there should be none. For example, in an otherwise blue sky you notice faint pink, purple and other colour speckles; in appearance it is not unlike the grain of a high-ISO film.

There are a number of causes of noise:

■ Heat generated might free electrons from the image sensor itself, thus contaminating the 'true' photoelectrons. These 'thermal electrons' give rise to a form of noise called thermal noise or dark current.

below and opposite
Noise manifests itself as coloured specks in an image and is most apparent in areas of dark plain colour. It is more likely to occur where a high ISO setting has been used. Arriva Guildford & West Surrey 3734 was caught in Parkway, Guildford, on a typically grey November day in 2004 using an ISO setting of 800. Speckles of noise are clearly visible in the dark areas of the bodywork, particularly when the image is enlarged.

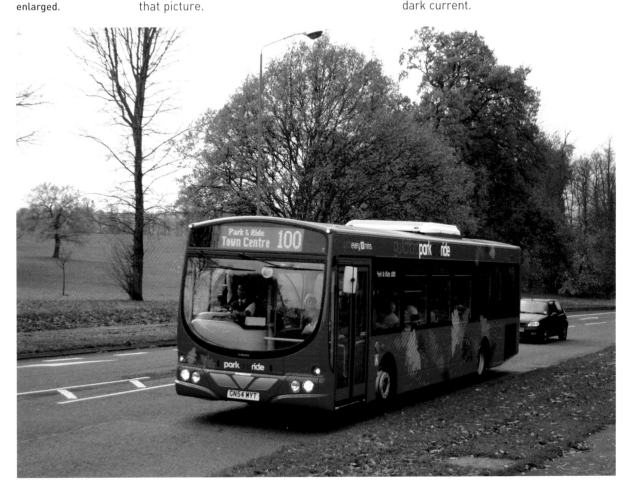

■ Using a high ISO setting amplifies the signal received from the sensor. This also amplifies the background electrical noise that is present in any electrical system.

■ In low light, longer exposure times cause a build-up of background signals.

Many cameras have a noise reduction capability, although this is often achieved at the expense of image quality. There are also a number of image-editing software products that can be used to reduce noise in a digital image after it has been taken.

A TRIP TO
THE COAST

We are an island nation and no part of the United Kingdom is more than 90 miles from the sea. The coastline is both attractive and at times dramatic, and there are a number of bus routes from which spectacular views of the scenery can be obtained. For the transport photographer these provide a change from the more mundane urban environment.

right First Hampshire & Dorset's Coastlinx service operates along the Jurassic Coast between Poole and Exeter. On 11 June 2004 Scania/East Lancs Omnidekka 36001 climbs from Abbotsbury with the last service of the day to Exeter affording passengers a splendid view of Chesil Beach from the top deck.

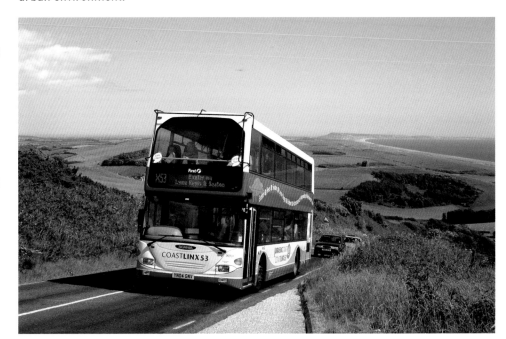

right Wilts & Dorset 3143 passes holidaymakers taking advantage of an unusually sunny Easter Sunday in 2007. Buses on this route, now renumbered 50, use the Sandbanks to Shell Bay ferry to cross the entrance to Poole Harbour.

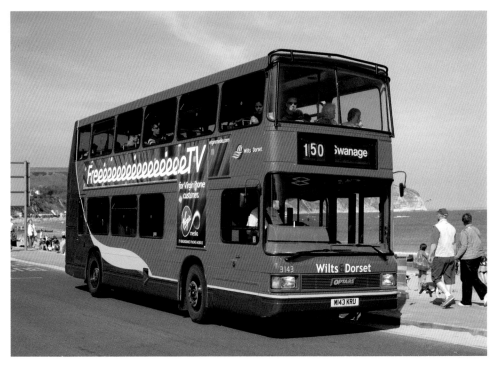

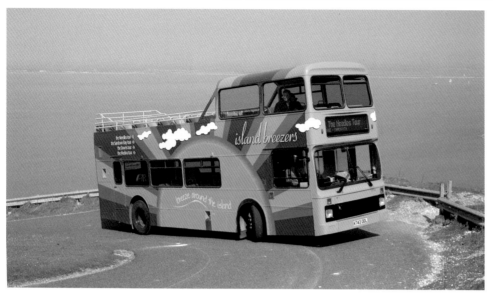

left Southern Vectis provides most bus services on the Isle of Wight, including a number of open-top services. On 2 April 2007 its 643, a Northern Counties-bodied Volvo Olympian tackles the final few metres of the climb to the Needles Battery at the western tip of the island. In slightly hazy conditions an exposure of 1/500th second at f6.3, using a polarising filter with an ISO setting of 400, has captured views of the Solent and mainland in the distance.

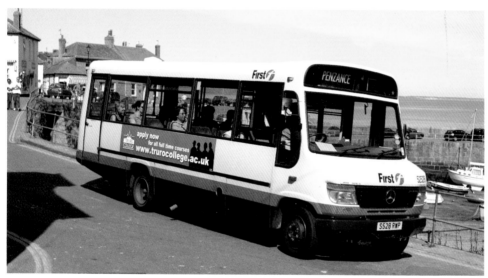

left The narrow lanes of the West Country have long been the preserve of small buses. Late afternoon on 4 June 2006 finds First Devon & Cornwall 52528 arriving in the picturesque fishing village of Mousehole. A polarising filter has been used to remove excess reflections and an exposure of 1/800th second at f6.3 has helped prevent burnout from the bright livery.

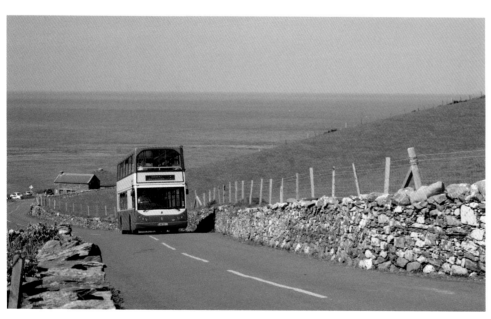

left The Isle of Man, a Crown dependency that is not part of the United Kingdom, has an extensive bus network provided by the state-owned Isle of Man Transport. Shortly after noon on 15 May 2008 fleet number 5, a 2003 DAF DB250LF/East Lancs Myllennium double-decker, climbs away from Calf of Man on the southern tip of the island. The photograph has been framed to ensure that the horizon and driver's cab are at the golden mean points.

TAKING
THE PICTURE

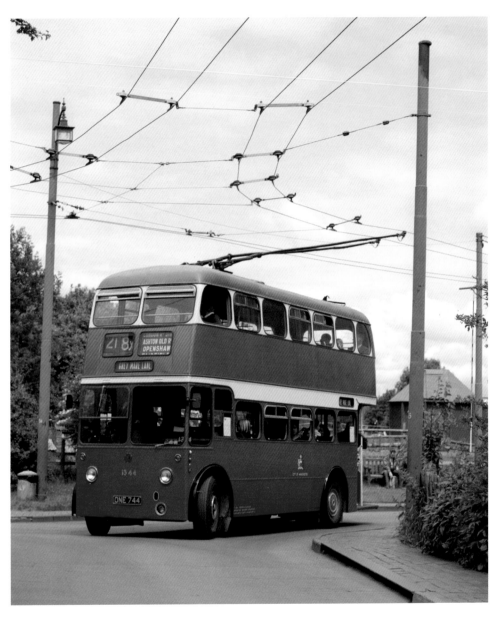

right **Most
photographs of buses
and coaches are taken
in landscape format.
The traction current
poles give this view
of Manchester
Corporation 1344, seen
at the Black Country
Museum, Dudley, a
distinctly vertical
aspect that lends itself
to a portrait format.**

Having looked at the equipment and cracked some of the terminology surrounding digital photography, it is now appropriate to look at actually taking photographs.

This section examines basic compositional techniques and how to ensure that the photograph is properly focused. We will then look at the challenges presented by different weather conditions before looking at finding a suitable location to take photographs.

If you are using a camera (or any accessory) for the first time, it makes sense to familiarise yourself with its

operation before leaving home. Also, before setting out on any photographic trip, although it sounds obvious, ensure that you have spare batteries and enough memory cards for the photographs that you are likely to take. Although it sounds obvious, it is also worth ensuring that you have your camera with you – believe me, people who have travelled some distance only to find that they are unable to take photographs feel more than a little foolish!

■ Metering

We have looked at exposure modes in the previous section. Suffice to say, before taking a photograph it is essential that the correct exposure is selected if you are not using one of the automatic modes.

■ Basic composition

The first fundamental of taking a good photograph is to ensure that you hold the camera correctly. Despite the advent of anti-shake and image stabilisation systems, this is still key to getting pin-sharp results.

The extent to which camera shake is likely to be a problem depends on a number of factors, including the shutter speed you use and the focal length of the lens. The slower the shutter speed, the steadier you will have to hold the camera, and the longer the lens, the more it will magnify any movement. Therefore not every hand-held shot will be sharp no matter how carefully you hold the camera, with or without any help from technology. But get it right and you will increase your chances of sharp images.

With the camera at eye level, first make sure that the forefinger of your right hand is free to both press the shutter button and operate the other controls. This is achieved by keeping your thumb on the back of the camera, and clasping the handgrip with all of your other fingers to support some of the weight of the camera. The majority of the weight should be taken by your left hand, which should be positioned underneath the camera, with the fingers free to operate the zoom control of the lens.

In most locations you will find all sorts of objects that you can use to help support your camera. It is especially useful if you are using a long, heavy lens, but it can also mean that you can use a much slower shutter speed than normal with any lens. Look out for fences, walls or rocks on which to rest the camera for a really stable platform, or simply brace yourself against a convenient bus shelter.

Finally, as we will see later, not every shot has to be taken at eye level, and by kneeling down with your right knee on the ground it is possible to rest your left elbow on your other knee for a more stable platform.

Before we look at location and composition in detail we will look at some basics. Although there will be some occasions when a side or front-on view of a bus is wanted, most photographs will be what is often referred to as a 'front three-quarter' view. This view provides a good view of the front and side of the vehicle, and is usually taken at an angle of about 45° to the subject to show the front and one of the sides. Although sometimes the angle may vary, the point is reached when the subject becomes too head-on or side-on for the photograph to provide a pleasing result. In general, a three-quarter view works best when taken with a 'standard' lens. This in turn dictates that you will need to be about 10 metres or so away from the bus in order to fit the subject into the frame. That said, there are occasions where even a full head-on or side-on view is sought.

It is also worth bearing in mind that people and traffic will be a constant issue in any busy town or city. There are three main ways of dealing with this: work with them as part of the composition, choose a time and place where there are fewer people, or simply be patient!

Early morning, especially on a Sunday before the shops open, is the best time to find the least traffic in most inner-city locations. This is the ideal time to shoot buses in major thoroughfares such as

above **Shortly after 10am on a July morning and Oxford Street is relatively quiet, allowing a clear view of Metroline SEL754 heading for Russell Square. Within an hour Sunday shoppers will start to gather and traffic will build, making views such as this difficult to obtain.**

Oxford Street in London or Princes Street in Edinburgh, with little other traffic in evidence. Major sporting events are also good at emptying the streets of crowds and traffic, particularly if all of the 'home' nations are playing!

In terms of keeping out of the way of people, apart from simply using common sense one of the best ways to avoid conflict is to find a viewpoint near street furniture, such as a bench, signpost and postbox, to shield you from the 'flow' of pedestrians.

Crowds, congestion and taking pictures don't always sit happily together. The sight of someone setting up a tripod on a busy city street can provoke adverse reactions from

pedestrians and authorities alike and is probably best avoided. It is possible that you will get angry glances or comments, while the over-zealous can start quoting all sorts of privacy laws to stop you taking pictures. In certain parts of the UK (especially central London) there is a chance that you will be approached by police exercising counter-terrorism powers. The best approach in such circumstances is to remain calm and polite, giving them the information they are asking for. After a few checks you will soon be free to continue your activities. Many shopping centres, and their bus stations, are private property, to which the public is only admitted under certain conditions – it is possible that taking photographs of buses is not one of them. While you may question the logic of preventing bus photography while allowing feral youth to run riot in the shopping centre, it is probably not worth getting into a debate with security staff. If you feel strongly about the matter, it is best taken up with the centre management.

Ultimately, good composition is about selecting the best part of a scene, then finding the right camera position and lens to make the most of it. The vast majority of bus photographs are likely to be taken in urban areas as, quite simply, this is where most buses run. This brings with it a host

right **Translink 2928 stands at a bus stop in Royal Avenue, Belfast. Unless the traffic is really heavy it is relatively easy to take a photograph of the bus without any other traffic getting in the way.**

of potential challenges that, while not insuperable, require some thought. Town centres are crowded places, and a combination of people, street furniture and other vehicles all need to be taken into consideration.

OFFSIDE VIEWS

By far the most straightforward photograph is a landscape-format front offside view while the bus is at a stop, taken from the opposite side of the road. This provides the opportunity to wait for a break in the traffic in order to take the photograph and allows time to ensure that the exposure is correct and the image properly focused. The image will invariably look more pleasing if there is sufficient background detail to place the shot in context. If things do not work out first time, it is possible to retake the photograph.

The main problem with photographs such as these is that they will, almost by definition, always be offside views, and the choice of location is dictated by the location of bus stops, which may not present the most attractive of backgrounds.

The biggest risk in taking a successful offside photograph of a moving bus is being 'bowled' when a car passes between you and the bus – frankly, there really is not much

that can be done to retrieve the situation. With the relentless growth in traffic, this is become an increasing problem. In an urban environment, where services are frequent, it is usually a case of waiting for a few minutes for the next bus and trying again. Unfortunately, in rural areas, or when photographing a special working, this is not possible. There are, however, a number of approaches that can minimise the risk:

- Exploit the road layout: the key to avoiding being 'bowled' is to find a spot where the chances of a vehicle obscuring your field of view are reduced.
- Roundabouts are a common feature of the British urban scene, and because joining traffic has to give way it is possible, by positioning yourself on the roundabout itself, to virtually guarantee a clear view of the bus that you wish to photograph.
- Traffic lights: although it sounds obvious, traffic lights stop the flow of traffic. Often by standing a short distance away from the lights it is possible to exploit the gaps in traffic that are created when they turn to red. This is particularly so with pedestrian crossing lights, as a red light in one

left **Solent Blue Line 526 waits for a break in traffic to join the roundabout at the end of Winchester's Broadway. Roundabouts offer a useful vantage point from which to take unobscured photographs.**

right **By standing on the central reservation the photographer has obtained a clear view of Travel West Midlands 4720 en route to Birmingham City Centre. Traffic at this point is reduced to a single lane by the road-markings, thus reducing the risk of another vehicle obscuring the shot.**

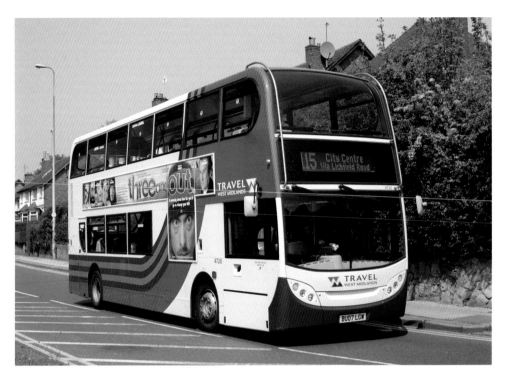

below **East Kent 19027 is caught in a queue of slow-moving traffic in Hythe. The bus was edging forward at a walking pace and it was possible to follow its progress, taking several shots. The driver rather obligingly did not close up the gap with the car in front.**

direction is not immediately followed by traffic joining from a side road. A few minutes' observation of the lights should give some idea of their phasing.

■ Central reservations: although most central reservations form part of a dual carriageway, and therefore introduce the risk of overtaking traffic obscuring the subject, there are a number of stretches of road where traffic is funnelled into a single lane despite the road itself being wide enough for two streams. This provides a clear field of view of any approaching buses. Some locations have a rarely used filter lane on the right-hand side of the road, which serves the same purpose.

■ Junctions: generally speaking, vehicles joining a main road wait until there is a safe gap before executing the manoeuvre. As long as the traffic is not too heavy, this provides the opportunity to capture the bus as it pulls out.

■ Slow-moving traffic: many British towns and cities are blighted by traffic congestion. While this is generally unwelcome, a queue of traffic edging forwards at walking pace does provide the opportunity for repeated attempts to get an unobscured view of a bus simply by preceding the vehicle along the road. The main risk is that there will not be sufficient gap between the bus and the vehicle in front – in such cases, one's chance of success is largely down to the attitude of the driver about having his bus photographed!

■ Single-track roads: one way to ensure that there is no chance of your view being obstructed by traffic is to find a location on a single-track road! However, the downsides are that the

service might not be that frequent and the view might be somewhat head-on.

NEARSIDE VIEWS

Thus far we have only considered offside views, and it is fair to say that the overwhelming majority of photographs taken of buses and coaches are from this angle. For obvious reasons very few nearside views are taken of buses at stops; in many cases narrow pavements tend to make it difficult to get sufficiently far back from the subject to get a decent angle of view. The relative lack of nearside views is unfortunate, as design features such as door layouts and the subtle livery variations on each side of a bus are under-represented. A particular challenge is the forest of railings and other street furniture that has sprung up in recent years!

As with offside views, it is possible to make use of the road layout to obtain photographs of the nearside of a bus:

- Grass verges: many roads, particularly on housing estates, have wide grass verges that allow you to get some distance back from the road. In more rural areas the village green serves a similar purpose. These are ideal vantage points to take nearside views of buses, the only real risk being the appearance of a pedestrian at the last

minute. Fortunately, they tend to move fairly slowly so there is time to move further along the road! In urban areas fire stations are often set back from the road with a clear forecourt on which, for obvious reasons, vehicles are not allowed to park. Shooting across the forecourt provides sufficient depth back from the roadside for a good nearside view.

- Junctions: as we have already noted, junctions with major roads provide a useful opportunity to capture buses joining the main road. In a similar vein, the fact that buses have to swing out slightly to execute a left turn means that it is often possible to get a reasonable shot during this type of manoeuvre.

above **The unique door arrangement on prototype Alexander Dennis Enviro 200 SN54 GRU is clearly shown in this nearside view taken during its period on loan to London United in February 2005.**

left **Stagecoach Midland Red 27504 offers a clear nearside view as it swings wide turning into the Parade, Royal Leamington Spa.**

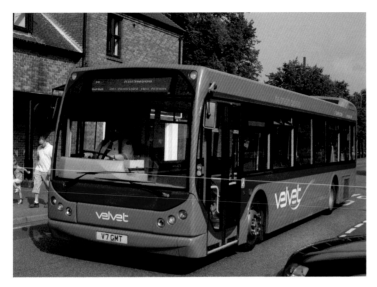

above Photographing buses on a main road across a joining side route offers a useful viewpoint. There is, however, always a risk that a vehicle may appear at the last moment, so it helps to choose a quiet road! Unless the joining vehicle obscures the side of the bus, it is often possible to remove it using image-processing software – this is examined in a later section.

■ Side roads: another vantage point for nearside views of buses is from the junction of a side road with a major thoroughfare, standing a few metres from the intersection and taking the photograph across the junction. There is a risk that the view will be obscured by cars joining the main route, so it is important to choose a road that is not too busy.

■ Service roads: many urban streets have a rarely-used service road running parallel to the main thoroughfare – these are often separated by little more than a narrow pavement, but they do allow the photographer to get sufficiently far back from the road for a decent angle of view.

■ Weather

As we have already noted, bus and coach photography is a largely outdoor pursuit. This means that we are subject to the vagaries of the British climate and all the challenges that this brings. In this section we will have a look at the issues raised by what the elements throw at us.

The constantly changing British weather brings with it different levels of light as well as the challenges faced by sun, rain, snow and variations in temperature. All experienced photographers will admit that there is an element of luck when it comes to the weather, but checking the forecast before setting out is a good starting point, if only to get some idea of the conditions you are likely to face, so you can dress comfortably. Unless the weather is a complete washout and not going to change it is often worth getting out there anyway, although I must admit to having questioned my sanity as I stood in pouring rain, camera at the ready, on more than one occasion. Who knows, it might brighten up unexpectedly!

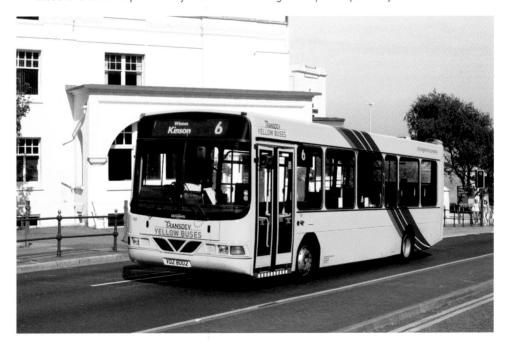

right A little-used service road running parallel to Bath Road in Bournemouth has allowed a clear view of Transdev Yellow Buses 151.

SUNSHINE

If asked, almost all of us will admit to preferring a sunny day, and most of the time sunlight improves the quality of a photograph significantly by bringing out the vibrancy of the colours. That said, there are some factors to take into consideration. The angle of the sun will have an impact on how your photographs turn out, and it is worth giving a little thought as to both where in the sky the sun will be at a given time of day and the effect this will have on shadows.

As a general rule you should aim to ensure that the sun is coming from behind you as you face your subject so that the bus you are photographing is evenly lit and not in shadow. By taking photographs into the sun you will have to contend with part or all of the subject being in shadow. While it is possible to address this using image-processing software, it is never going to create a truly acceptable photograph. The accompanying diagram (top right) shows the best position for the sun relative to the subject to avoid shadows on the subject for, in this case, an offside three-quarter view.

There are two key factors to take into account when considering the position of the sun; they may seem fairly obvious, but are in fact crucial to taking good sunlit photographs. First, the sun rises in the east and, in the northern hemisphere, arcs up and around to the south before setting towards the west. The exact point at which the sun rises and sets varies by season – the accompanying diagram shows the position and approximate time of sunrise and sunset for London (in degrees clockwise from north) on midsummer and midwinter days.

The second consideration is that the maximum height of the sun in the sky varies by season. We have all experienced long winter shadows but may not fully appreciate the impact on the bus photographer, in particular the extent to which buildings, posts and trees may cast shadows across roadways (and therefore buses running on them) in the winter months. The accompanying diagram (right) shows the

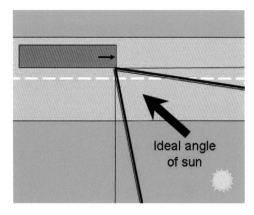

Ideal angle of sun

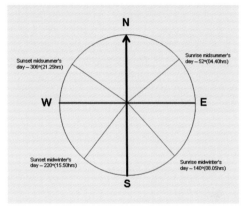

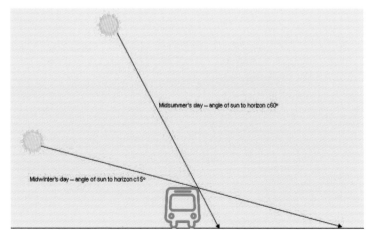

Midsummer's day – angle of sun to horizon c60°

Midwinter's day – angle of sun to horizon c15°

difference in the sun's angle between the summer and winter solstices in southern Britain. It shows that the shadow of a bus approximately 3 metres high is some 2 metres long in June, but a whopping 10 metres by Christmas.

It is also worth noting that the high noonday sun of midsummer can create its own problems, as the light quality is consequentially harsh. For this reason it is often best to avoid taking photographs when the sun is at its peak, which,

left In sunny conditions the optimum location is one that allows the photographer to have the sun falling from behind him so as to illuminate the elevations of the bus being photographed.

left Although the general view is that the sun rises in the east and sets in the west, the compass bearing of sunrise and sunset varies considerably during the year, as shown on this diagram. In practical terms this means, for example, that an offside view of a bus heading due west late in the evening during high summer will be properly illuminated by the sun.

below The height of the sun varies greatly during the year. Low winter light throws long shadows while the midday June sun casts short shadows, albeit at the cost of rather flat images.

right **Southern Vectis 735 heads away from Alum Bay on an overcast day. The top of the bus seems to merge into the murk. In conditions like this it is advisable to find a location with a solid background such as trees or a building.**

allowing for daylight saving time, is at 1pm in high summer.

Although it is possible to take photographs of the shadow side of a bus, these will invariably lack the impact of a photograph taken with the sun lighting the subject from behind you. In order to retain detail in the subject itself, it is necessary to take an exposure reading from the side of the vehicle that is in shadow – this will result in the sky areas being over-exposed and looking washed out.

We will return to the position of the sun later in this section when we look at choosing a location.

below **Sunray Travel GX56 AEB emerges from autumn mist near the summit of Box Hill shortly after delivery. In conditions like this it is easy to over-estimate the light level – a high ISO setting is often necessary to allow for a sufficiently fast shutter speed to freeze moving subjects.**

CLOUD

For much of the year in the UK the dominant weather pattern seems to involve a high-level blanket of cloud. From a photographic point of view this is actually quite easy to work with – the light levels are consistent and there are no dense shadows to make exposure difficult to calculate. The lack of direct sunlight means that it is possible to shoot in any direction and obtain an acceptable photograph. In some cases, for example when photographing a very dark image (such as a London Transport country area green bus), it might be necessary to open up the lens by half a stop to retain some detail in the vehicle itself. If the images look flat they can be tweaked somewhat on the computer – often increasing the colour saturation slightly helps to give them added punch. The main drawback of photographs taken in overcast conditions is the presence of a vast area of putty-coloured sky, which not only looks uninspiring but is sometimes of a similar colour to the roof of the vehicle. As a result the vehicle can appear to merge into the sky. In such circumstances it is preferable to ensure that there is a solid background to the photograph, such as trees or buildings.

FOG AND MIST

Fog and mist probably represent the greatest challenge – light levels tend to be low and it is therefore necessary to use a fairly high ISO setting and fast lens, particularly with a moving subject. As a general rule it is probably better to try and get as close as possible to the subject in order to avoid it vanishing into the mist. There are exceptions, and it is sometimes possible to get attractive shots of buses in the distance with a low-lying mist in the foreground. The lack of any background detail can make photographs look very flat, so it may help to have something of interest in front of the subject, even if it is only a grass verge. Getting the correct exposure can also be difficult – our eyes tend to be fooled into thinking that it is brighter than it really is, which tends to result in an under-exposed image. Autofocus systems can also be fooled due to the lack of anything to lock onto – it may be best to use manual focus.

Despite the obstacles noted above it is possible to obtain pleasing compositions in these circumstances and the ability to manipulate the resultant image can help address many of the shortcomings.

RAIN

Rain, too, represents a headache – not only are light levels low but the photographer and equipment get wet! Given that rain is a fact of life in these islands, the photographer who confines his activities to sunny days will be restricting his options. Although on the face of it a problem, rain can actually be a useful aid. On an otherwise drab day rain can add some sparkle to what is otherwise a rather flat scene. Wet roads glisten and, together with puddles, provide scope for reflections from headlights. It is essential to be fully prepared for the weather – take a good umbrella (and, ideally, someone to hold it for you!) and use a hood to keep raindrops off the lens. It may be possible to take shelter from the elements under overhanging buildings – market halls are particularly useful in this regard.

The generally low light levels call for a high ISO setting or a fast lens, particularly if you want to freeze a moving subject. As with fog there is a tendency to over-estimate light levels. Autofocus is also likely to be confused by heavy rain in particular.

Heavy showers are often followed by bright sunlight. The light quality can be brilliant in such cases, but reflections from road surfaces in particular can give the image too much contrast.

SNOW

Snow and sunshine invariably form the basis for a particularly attractive photograph. There are challenges, however, the greatest

Windsor's Market Hall provides a suitable shelter from torrential rain as RF600 passes by during the 2007 Slough running day. In conditions like this some form of shelter is essential in order to prevent photographer and equipment getting well and truly soaked.

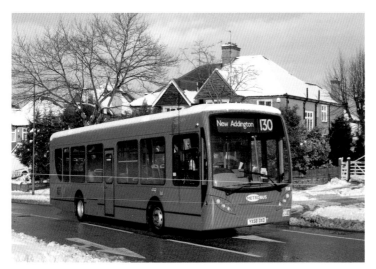

above **The beginning of February 2009 saw the heaviest snowfalls in southern England for many years, which were, unusually, followed by bright sunlight. On the morning of 3 February Metrobus 708 passes through, and still carries evidence of, the previous day's snowfall as it heads through the Shirley Hills. Although an exposure reading of 1/500th at f6.3 was indicated, the shutter speed was increased to 1/640th second to retain some detail in the snow. Reflections from the snow helped to illuminate the bus, preventing it from being under-exposed.**

right **The destination display on First Edinburgh 32669 adds a splash of colour to an otherwise truly bleak Musselburgh on 11 February 2009. A slow shutter speed of 1/50th second has been used to allow the falling snow to form streaks across the photograph. The somewhat front-on angle of view allows this while still freezing the movement of the bus.** RICHARD WALTER

of which is exposure. The bus itself will always be against a very bright background. Some form of compromise is necessary in order to avoid the snow being totally burned out. The best approach is to take the exposure reading for the main subject, then set the lens to one stop smaller. This may result in the subject being slightly too dark (although the reflections from the snow itself will help) but will ensure that the snowscape still has some detail in it. A few test shots will help give some idea of the best settings. If necessary it might be

necessary to brighten up parts of the bus itself using image-processing software on the computer. Unfortunately in the UK this combination rarely occurs, and snow is usually accompanied by leaden skies.

Falling snow presents similar challenges to fog, as everything defaults to shades of grey. In addition, snowflakes themselves form out-of-focus specks that cover the image and can become something of a distraction. The potential addition of copious amounts of road dirt adds to the generally bleak look, although electronic destination displays can add a splash of brightness to the scene.

An additional consideration in cold conditions is that battery life is reduced. It is therefore worth taking a fully charged spare and keeping it warm – a shirt pocket comes in handy for this!

WIND
The main challenge presented by a high wind is simply holding the camera steady, although windswept items such as leaves and general rubbish may interfere with composition. The effect of wind can be minimised by using a high shutter-speed and, where available, taking advantage of

left The vivid colours of autumn make for some attractive photographic opportunities. Here UNO 775, a 2001 DAL/Wrightbus Cadet, disturbs fallen leaves as it heads along College Lane, Hatfield.

buildings to provide shelter. Using street furniture such as lamp posts as a brace also helps.

CHANGING SEASONS

In addition to the length of shadows, the changing seasons bring other photographic opportunities, mainly associated with the changing colours of vegetation. The fresh green shoots and blossoms of springtime add a freshness to the scene, while the golden colours of autumn foliage make for particularly atmospheric shots. The bare branches of midwinter, particularly when set against a clear blue sky, help convey the bleakness of the season.

■ Darkness falls

For much of the year in the United Kingdom darkness falls quite early. Although many photographers take this as a hint to pack up for the day, twilight and night-time photography offers a range of creative opportunities, especially in urban centres. As the daylight begins to fade, buildings and vehicles become illuminated and twilight can produce some attractive scenes. Shooting in the first half-hour or

so after sunset will ensure that there is still some colour in the sky. This is especially good for shooting in built-up areas where the artificial lights make it impossible to record any detail in the sky once it has gone completely dark. Clearly lower levels of light will require either longer exposures or higher ISO settings (or a combination of both) to ensure that the subject is properly exposed.

As night falls getting the correct exposure becomes a greater challenge; unless you opt for a very high ISO setting (which brings with it the risk of 'noise'), long exposure times are essential. These may also necessitate the use of a tripod to hold the camera steady, although, as already observed, this is not a wise move in urban areas. Judging the correct exposure is more difficult than during daylight, and it is often best to bracket the suggested reading and review the images using the camera's LCD screen. Photography of moving subjects at night presents a particular challenge, and is unlikely to work other than in very brightly lit areas using a high ISO setting and a lens with a wide aperture. Finally, remember that autofocus may not work in low light conditions.

right The tungsten bulbs inside Ensignbus RT624 add a warm glow to the scene as the bus passes along Oxford Street as one of a number of special journeys run to mark the end of regular open-platform-bus operation in the capital on 8 December 2005. The following day saw route 159 converted to one-person operation. An exposure of 1/125th second at f2 with an ISO setting of 400 was used.

right Obtaining the correct exposure when taking nocturnal photographs is usually a matter of trial and error. This view of London General RML887 and Blue Triangle RTW75 about to set off from Putney Heath on the last crew-operated journey on route 14 was taken using a shutter speed of 1.2 second and an aperture of f2.
As with most of the photographs used in this book, an ISO setting of 400 was used – a higher value would almost certainly have led to significant amounts of noise.

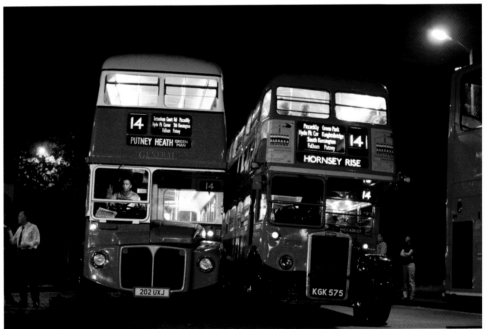

■ Protecting your camera from the elements

Your camera should never be exposed to excessively high temperatures. If at all possible, do not leave the camera in a car on a hot day, especially if the sun is shining on the car (or if it will later in the day). Indoors, avoid storage near radiators or in other places likely to get hot or humid.

Prevent condensation when taking the camera from a cold area to a warm one by wrapping the camera in a plastic bag or newspaper until its temperature climbs to match that of its environment. If some condensation does occur, do not use the camera or take it back out into the cold with condensation still on it or it may freeze the camera operation. Remove any batteries or memory cards and leave the

compartment covers open until everything dries out.

■ Choosing a location

A crucial element in taking a really good bus photograph is its location. The easiest approach is to seek inspiration from the work of other photographers in books, magazines and on the internet. Work out what it is about their work that you like so much and try to analyse what it is about the images that makes them successful. Do not try to slavishly copy the images you see, but try to understand why you like them and why they work. Is it the composition, the location, or the subject itself? There are a number of locations that have proved popular, either because they have a high number of buses passing through them or because they present an attractive backdrop, or a combination of both. They will have been featured extensively in books and magazines over the years and there is no harm in seeking to reproduce the works of others. Even if you are visiting a well-used location, it is worth trying to be a little creative and explore the area – you might find a new take on a familiar scene.

One of the most common mistakes is to try to include too much. This can result in a confused image that fails to draw the viewer into the scene. Even if you are using a well-known location, take time to analyse the view and decide which elements you want to include and which you do not. Change to a lens with a longer focal length if need be. It is important, however, not to overlook street furniture and the general scene – in its own way the photograph you take will become part of history, so things like fashions, shop fronts and even lamp post design are all important.

While there is nothing wrong with taking photographs at one of the popular locations, it is not difficult to strike out and find a new location. Many operators or local authorities produce bus maps (often available on the internet) and, within Greater London, Mike Harris's excellent

maps (see www.busmap.org) are invaluable tools in ascertaining what goes where. Having obtained an idea of where individual routes go, it is worth checking the relevant Ordnance Survey map or an internet resource such as Google Earth (www.google.co.uk) or MultiMap (www.multimap.com) to get a better idea of the lie of the land – the latter includes detailed aerial photographs with a street plan overlaid, while Google Earth even shows where bus stops are.

This was the approach I followed when seeking to take photographs of a batch of new Scania Omnicity double-deckers that had been delivered to East London and were being used on route 248. The route runs from Romford to Upminster, and although I was familiar with the area around Romford station my desire was to take photographs in a slightly different location. Reference to the Bus Map gave a clear indication of the route followed and I traced this on Google Earth. Given the time of year and day (mid morning in late November), I knew that the sun would be low in the southeast sky. From the satellite imagery it was clear that there was an open spot near the junction of Waycross Road and Brunswick Avenue, which would be free of shadows when taking a photograph of a southbound bus.

below **When researching locations a good bus map is essential. For routes within London, Mike Harris's Bus Map is recommended. Elsewhere many local authorities and operators publish maps that can either be obtained from travel shops or downloaded from the internet.**
IMAGE © MIKE HARRIS

right **The finished
result: brand-new
East London Scania
Omnicity 15007
executes the right turn
into Brunswick Avenue,
Upminster, at 11.35
on 19 November 2008.**

■ Trams and trolleybuses

Although this book is primarily aimed at the photographer of buses many enthusiasts will also be interested in capturing these forms of transport. Although not as common as in other developed countries, the UK does have a small number of tram systems. Trolleybuses are, sadly, currently confined to limited operations in working museums, although a new network is proposed for Leeds.

Photographing any form of electric street transport, or buses running along the same routes, brings the challenge of overhead wiring, in particular the shadows it casts. The wires are such as integral part of the photograph that as a general rule the support masts and their shadows are accepted from an aesthetic point of view. It is, however, important to ensure that shadows caused by span wires or supports do not fall across the front of the vehicle, as these will seriously detract from the

photograph. An initial assessment of the scene will quickly show where these are likely to be. Fortunately trams, unlike motor buses (and to a lesser extent trolleybuses), are forced to follow a very definite line, so will not swerve at the last minute!

■ Creative composition

Having picked your location, it is worth taking some time to think about the composition of your photograph.

DECIDE ON FORMAT
The very first decision you need to make is whether the shot is going to look best framed in a horizontal or upright format. Most buses present an aspect that lends itself to taking the photograph horizontally (landscape format). However, sometimes a vertical (portrait) format is more appropriate, particularly if the bus is being taken head-on or if there is a particularly impressive tall building in the background that you wish to include in full.

However, this does not mean that you have to use landscape format when shooting landscapes or portrait format for shooting portraits. In fact, including things such as foreground interest in your landscapes is often easier if you shoot in an upright format. The best advice is to choose whichever format suits the subject.

In almost all cases the bus will be the focal point of the picture and the viewer's eye should be drawn to it. If the vehicle is surrounded by heavy traffic, the resultant photograph is not likely to have impact.

Look carefully at the roofline of the bus – television aerials and cluttered rooflines can distract from the photograph, and can often be avoided by adopting a slightly lower angle of view. It is, however, important to include something of the background if only to prevent the photograph from appearing too sterile and contrived.

A particularly effective way of composing an image of a bus is to exploit the lines of buildings, road markings and the like in such as way that they follow the lines of the

left Croydon Tramlink is one of a small number of tramways operating in the UK, and on 8 April 2009 recently refurbished 2538 is seen heading along Addiscombe Road on one of the system's sections of street running. When photographing electric street transport some shadows from the overhead wiring are inevitable. This view has been composed to ensure that the shadow from the span section does not fall across the front of the vehicle, while at the same time including the support span for the overhead power supply.

top and middle **Often by changing your angle of view it is possible to obtain a more pleasing composition. These two shots of Brighton & Hove 703 taken in Mackie Avenue, Hove, show how, by shooting from a lower angle, it is possible to avoid the aerials and chimneys that appear to sprout from the roof of the bus when photographed from a standing position.**

right **The grid lines break this photograph into thirds. The driver's cab, which represents a focal point of interest, in placed at the intersection points of the lines. Similarly, the road heading off to the right behind the bus coincides with one of the thirds.**

bus and, if taken to their logical conclusion, to a common vanishing point outside the frame. These lead-in lines will draw the viewer's eye to the main part of the subject. When taking photographs in a rural environment the lead-in lines will be roads, hedges and walls.

Positioning the subject, or important elements of the image such as the horizon, in the middle of the frame can make the image look too static. The best way around this is to use the rule-of-thirds grid to position elements in a more pleasing way, arranging them off-centre. This entails mentally dividing the view into a grid consisting two equidistant horizontal and vertical lines. Any key linear elements (for example the horizon or a tree) are aligned

Modern buses with bonded glazing, curved windscreens and spray-painted bodywork produce reflections that are often a distraction in a photograph. These two photographs demonstrate the effect that is possible by using a polarising filter to remove these reflections. Most of the photographs used in this publication employ such a filter, the only exceptions being those taken in low light conditions where the added exposure time required to compensate for the filter would have proved problematic.

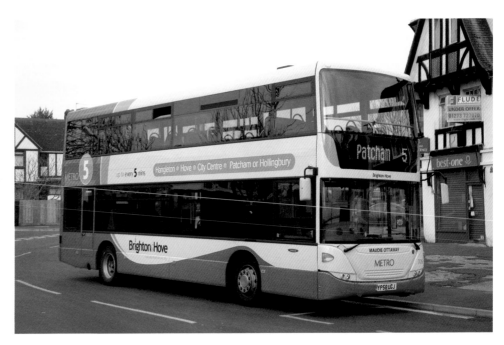

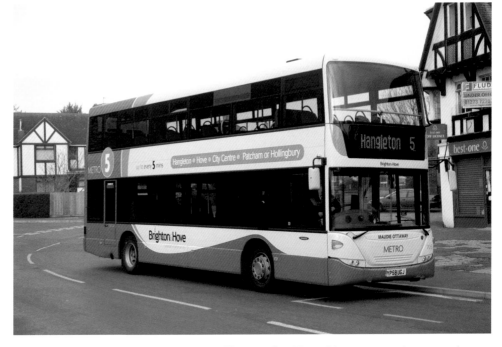

with the horizontal and vertical lines. The main focal point of the image, for example the cab of a bus, should be placed at one of the points where the lines intersect. This technique is sometimes referred to as the 'golden mean'.

Although some good photographs can be taken 'on the fly', it is worth taking the time to work out exactly what you want to include in your photograph. If you are unfamiliar with an area, take some time to assess the scene, looking at things such as traffic flows, pedestrian crossings and the like. It is also worth taking a couple of test shots to see what they will look like – after all, these can be deleted afterwards.

Try to resist the temptation to take dozens of photographs from exactly the same location. After all, you really can have too many photographs of similar buses

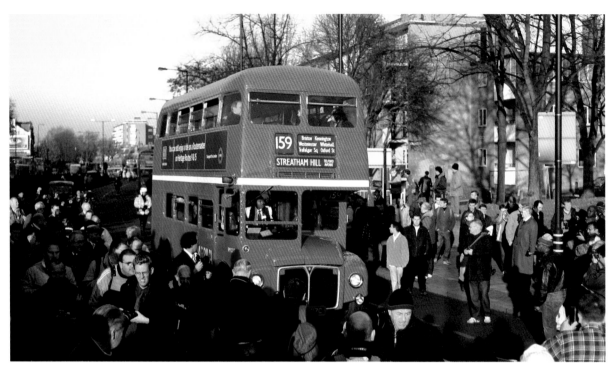

taken at Marble Arch! It is worth taking time to explore even familiar areas to see of you can get a new perspective on them.

BUSES IN THE LANDSCAPE

Although the vehicle is the focal point for most bus and coach photographs, there are plenty of locations where the landscape itself, whether urban or rural, can make for a more interesting composition. For photographs such as this to be truly effective it is worth looking for strong features such as lone trees, crumbling barns and the like, positioning them at the 'golden mean' intersections. The line of the road itself should lead the viewer's eye to the bus, which does not necessarily have to dominate the composition.

■ Polarising filter

One of the most useful accessories to help give real impact to a bus or coach photograph is a polarising filter. This is a screw-in filter that, on the face of it, looks like a lens from a pair of sunglasses.

Without going into the deeper mysteries of the science behind it, all light is transmitted in wave form. These waves travel in all directions at different rates and sizes, and polarising filters limit which waves enter the camera's lens at any one time. By rotating the filter, different ranges of waves are let through, so the effect of the filter is altered. The effect of this is to reduce reflections, particularly from the vehicle's windows but also from newly painted body panels. There are two types of filter available: liner and circular. An autofocus camera requires a circular filter. In addition to helping reduce reflections, this filter will also improve the colour saturation of your photographs and produce more vibrant skies. The only potential downside it that it reduces the amount of light entering the lens, so you will either have to increase the ISO setting of the camera or increase the exposure to compensate.

Finally, don't give up. We all have days when things do not work out – either the weather breaks down, an expected special working fails to materialise or someone steps into the frame at that crucial moment. Ultimately, it does not really matter and there will be another chance for most things. Hopefully, however, by planning ahead these occasions will be minimised.

above **There are few photographs that are genuinely unrepeatable and this is probably one of them. The final Routemaster in normal London service, Arriva London South RM2217, picks its way through the crowds outside Brixton bus garage on the afternoon of 9 December 2005. In circumstances such as this the crowds gathering around the bus are as much a part of the picture as the vehicle itself.**

A TRIP TO
CARDIFF

The Welsh capital has a colourful bus scene, and in addition to locally-based Cardiff Bus, it sees vehicles from the Principality's other local authority-owned operator, Newport Bus. The big groups are also represented, with FirstGroup, Stagecoach and Veolia adding further variety.

right Stagecoach in South Wales operates a number of longer-distance services mainly to the north of the city. Alexander-bodied Dennis Dart 33607 is seen heading out of the city along the Cowbridge Road, where it crosses the River Taff, at 3pm on 17 April 2008.

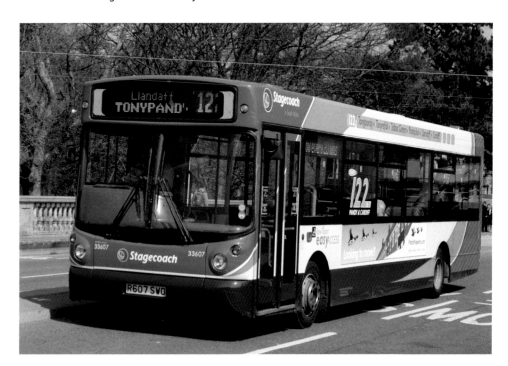

right The main operator of city services in Cardiff is local authority-owned Cardiff Bus. Like many former municipal fleets, double-decker buses now pay less of a role than hitherto, and a batch of 12 East Lancs Olympus-bodied Scanias are the only such vehicles in the fleet. 469 is seen on an evening peak working as it travels back into the city centre along Boulevard de Nantes.

left French-owned Veolia has a significant presence in South Wales, having acquired a number of operators including Bebb Travel, whose 50239 is seen passing City Hall on a spring afternoon in 2008.

left At the time of writing, service 30, linking the city with Newport, was the last remaining joint operation by local authority bus companies. In April 2008 Newport Bus's 1 leans into the turn from St Mary's Street as it nears journey's end. Both Cardiff and Newport have taken delivery of Scania's Omnicity single-decker in recent years.

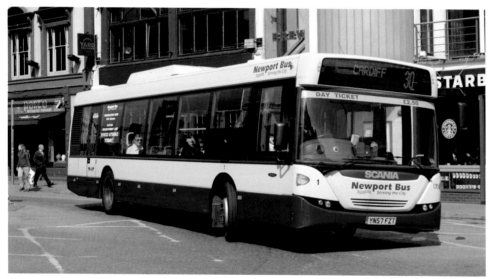

left Cardiff bus station, opposite the railway station, is the focal point for most bus services in the city. As with most bus stations the photographic opportunities are limited, but some good views can be achieved from the surrounding streets. Cardiff Bus 715 is seen turning from Westgate Street into Wood Street on the final approach to its destination on 24 September 2004. The photograph was taken from the exit road from the bus station, which is protected by traffic lights.

AN INTRODUCTION TO
SOFTWARE

SECTION 5

right When using a Windows operating system this window will usually open when the memory card is inserted into the reader.

■ Transferring files

After a day spent taking photographs you will want to transfer them from the camera to the PC in order to view them properly and probably make some minor improvements to them. It is worth bearing in mind that there is usually more than one way to execute a particular function with any piece of computer software. As a rule, this section will only describe one approach for each scenario. This does not mean that other methods of working are wrong, and if readers are already familiar with alternative approaches it is recommended that they carry on using them.

As already noted, it is possible either to connect your camera directly to the computer or to use a card reader; it was suggested that the latter is preferable.

below The user will be offered a number of choices for downloading photographs from a memory card.

The camera will have been supplied with a range of software that will have included a file transfer program. As mentioned in Section 3, however, all of the images used in this book have been processed using Adobe Photoshop Elements 6, and we will also use this to transfer files. This is a widely available package that serves to meet most editing requirements at a reasonable cost and is available for both Windows and Mac operating systems. It should be noted, however, that most editing packages offer similar functionality. It should also be noted that software is constantly being upgraded although developments are usually incremental. Whilst new packages will become available the general principles, and terminology used, will remain similar.

Transferring photographs is quick and easy. Although it is possible to connect a camera directly to the computer to perform this task, a memory card reader makes the job much quicker. Firstly plug the card reader into one of the USB

sockets on your computer and insert the memory card into the reader. At this stage a window will open up with various options including 'Organise and edit using Adobe Photoshop Elements 6.0'. (At this stage you may have other download options offered, depending on the software installed on your computer.) By selecting this option a photo downloader window will open. This is pictured below and will probably have automatically selected the card reader. If it does not, use the 'drop-down' arrow to select it.

By default the images will be saved to the 'Pictures' folder, although you can change this if you wish, using the 'browse' function to find an alternative. Again, by default, new sub-folders will be created to save your photographs according to the date on which they were taken. This can also be changed should you wish.

Files will be imported from the card with a file name assigned by your camera. The 'Re-name Files' drop-down gives you the option of renaming them with a slightly more descriptive title, should you wish, although this is not a facility that I tend to use. The 'Delete Options' function gives you the option of deleting files from the memory card once they are downloaded. I tend not to use this function as an insurance against the download process not working correctly.

When you click the 'Get Photos' button, the images will be transferred to the computer. The photographs will appear in an organiser window similar to that shown below. By moving the thumbnail adjustment slider it is possible to change the size of the images on display.

Having transferred your photographs to the computer they will be saved with the rather meaningless names that the camera has given them, in a series of sub-folders within the 'Pictures' folder.

Anyone who has sat surrounded by slides and prints, trying to fathom what, where and when, will know that it is important to establish a system for storing and organising your digital photographs. There is no right or wrong answer, and if

you have a system in place already there is no reason why it cannot be adapted for digital imagery.

The first essential is to rename the files to give some idea of subject matter. The easiest way to do this is by using Windows Explorer. The images will have been stored, by date order, in sub-folders within the 'Pictures' folder. This can be reached by clicking 'Start', 'My Computer', your name, then 'Pictures'.

Clicking on the first image will open 'Photo Gallery'. By right-clicking the mouse within the image area, a window is opened that has as an option 'Rename'. By clicking this, the file name becomes visible on the right-hand side of the image. If you click within the file name (currently IMG_7764) it will gain a blue background and it is then possible to add a file name of your choice. In common with the practice adopted with my slide collection, I use a unique number (in this case the file number) followed by a brief description of the subject and location. Therefore, my renamed file in this case is:

above **Once images have been downloaded to the computer an organiser window will open – the photographs are clearly visible.**

below **A screenshot showing how to access the folder in which photographs have been saved from Windows Explorer.**

right A screenshot showing how to rename files using 'Photo Gallery'. By clicking on the 'next' command it is possible to move between files.

IMG_7764_Stagecoach East Sussex 27577 Milfoil Drive Langney

By pressing the 'next' button you will be taken to the following image, and the process can be repeated. If you have a number of photographs of the same vehicle, or ones that will have a similar name (the same operator or location, for example), it is possible to save time by copying the file name (apart from the file number) and pasting it into following images. This saves too much repetitive typing! It is also worth using the time spent naming files to critically assess each photograph and, if any are of poor quality, delete them.

right By default, photographs will be stored in a folder structure similar to this.

The view below gives some idea of the hierarchy of these folders, accessed by going to 'Start', then 'My Computer'. The size of the images on show can be changed by clicking the arrow to the right of the 'views' tab and choosing one of the options. The display in this shot is of 'large icons'. Note also that by allowing the cursor to 'hover' over an image, various other pieces of information, including the time at which the photograph was taken and its size, are shown. This (and more data) is referred to as 'metadata', quite literally information about information. It is attached to files on the computer and contains a wealth of information about the subject. To see all of it, right-click on the file and select 'Properties'.

Another way in which files can be indexed is to use tags (sometimes described as keywords). These are general categories into which photographs can be placed – the example above could be given the tags 'Stagecoach', 'Eastbourne' and 'Enviro300'. Having given tags to photographs, it is possible to search for images by specifying tags. For example, a search for 'Enviro300' will yield all similarly tagged photographs in the collection. Although I can see some advantages, I have yet to be persuaded that it offers any real advantages over using the

'search' facility within Microsoft Windows to look for all files containing a specified word in their names.

In order to understand how to catalogue photographs it helps to have a basic knowledge of how your computer's file storage works. We have already seen that photographs, by default, are saved into a sub-folder called 'Pictures' with a further sub-division by date. This will sometimes be expressed in the following terms:

C:\Users\[your name]\Pictures\2009 01 31\Filename.jpg

Although it is quite possible to leave photographs in these folders, it is clear that very shortly you will end up with potentially dozens of folders that will make finding photographs very difficult. My approach, therefore, is first to identify those photographs that I am likely to have an immediate use for and copy them to a folder specially created for this purpose. The folder structure that I use is shown below. In addition to having a 'to sort' folder (which is called 'Aa to sort', as folders are stored in numerical and alphabetical order), I also have one for each year, rather imaginatively named 'Buses 2004', 'Buses 2005' and so on,

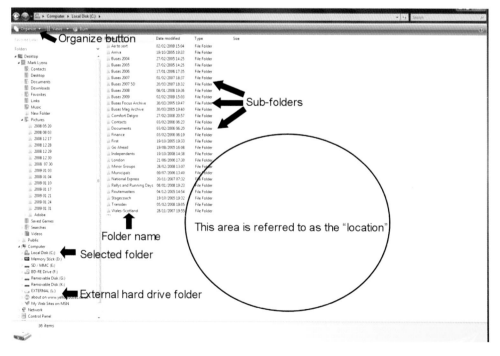

left To ensure that images are properly filed it makes sense to develop a logical folder system, much as would have been the case with slides or negatives.

as well as a series of folders for photographs that I have worked on. These are broken down by major subject headings, which generally follow the names of the big groups, further divided into London and provincial.

Before copying any files it is necessary to create the folders to put them in! To do this select the location where you want to create the new folder, in this case the local disk (C). Then right-click within the blank area of the folder window, which will open a dialogue box that contains the option of 'New'. By clicking on this a further set of options, including 'Folder' is offered. The new folder will be highlighted and can be renamed to fit with your filing system. It is possible to create folders within folders by using the same process – this is how, for example, the Arriva folder can be sub-divided into London and provincial.

To copy images they must first be selected from their current location. This is done by clicking on the image using the mouse. If you want to select more than one image, simply hold down the 'Ctrl' key while clicking. The selected files are highlighted. Using the right-click button on the mouse will open a dialogue box with the option of 'Copy' – left-clicking on this will copy the file(s) that have been selected. Open the location where you want to store the copy, in this case the 'Aa to sort' folder within the C drive. Right-click within the location, then click 'Paste'. The files selected will now have been copied into the new folder, although the originals will still

be in the source folder. If folders or files are named by date, it is important to bear in mind that, because of the way in which the computer's operating system will sort them, it is preferable to use the format YYYYMMDD (so for example 21 January 2010 is shown as 20100121).

Before we go on to look at moving images to the appropriate 'Buses' folder, it is appropriate to look at backing up files. Unfortunately, computer hard drives are known to fail and if this happens to you there is a real risk that you will lose your photographic collection. Backing up is no more than making copies of your files and storing them somewhere other than on the computer's hard drive. In Section 3, I suggested that an external hard drive would be a wise investment. This is a mains-powered device that is connected, via a USB socket, to the computer – in the screenshots shown above it appears as 'EXTERNAL L' in the folder hierarchy, and sub-folders can be created in the same way as on the computer's disk. To copy files from the 'Pictures' folder into the 'Buses' folder on the external drive, click on the 'Organise' button, then 'Select all'. Follow the instructions for pasting, but instead of opening the 'Aa to sort' folder, open the appropriate 'Buses' one within the 'EXTERNAL L' drive. Right-click and select 'Paste' as before. If you open the relevant folder you will see all of the images stored there. It is also prudent to create a second back-up on a CD or DVD – we will return to this in Section 10 when sharing images is explained.

Before we go on to look at editing images we will move the files from the 'Pictures' folder to the appropriate 'Buses' folder on the computer's hard drive. The easiest way to do this is by 'dragging and dropping'. First select all of the files in the 'Pictures' folder as above. Click the left mouse button and, holding the button down, drag the mouse over to the folder to which you wish to move the files.

above A screenshot showing how images appear as they are 'dragged and dropped' between folders.

right Finding the image you are after is made easier by the 'search' facility – simply type details of the subject matter and the computer will do the rest.

As you do this the folder will expand and all its sub-folders will be visible. Move the mouse until the cursor is over the sub-folder into which you wish to move the files – the message '+ Copy to [folder name]' will appear, and when you release the mouse button the files will be copied to the destination folder. Once this process has been completed the sub-folder in 'Pictures' is empty and can be deleted (although it's worth checking first that it is empty!).

▪ Finding files

The ease of taking digital photographs means that you will quickly amass a large number of photographs and it may be difficult to find the one that you want quickly. The ability to find images can be improved by astute use of file names and arranging folders in a logical fashion, although even then locating a particular shot from many is potentially time-consuming. A quick and easy tool is the 'search' facility within

left **When Adobe Photoshop Elements 6 is opened the user will be presented with a screen like this.**

Microsoft Windows. Simply open the folder in which images are stored and enter some text that describes what you are looking for. Any files in the folder meeting the search parameter will be displayed.

▪ Editing software

Having successfully transferred images to the computer, we will now look at some of the main features and terminology likely to be encountered with editing software. As with cameras and computers, software manufacturers are continually developing their products. The passage of time means

below **The Editor function opens with a screen like this. All the key functions are grouped together for ease of use.**

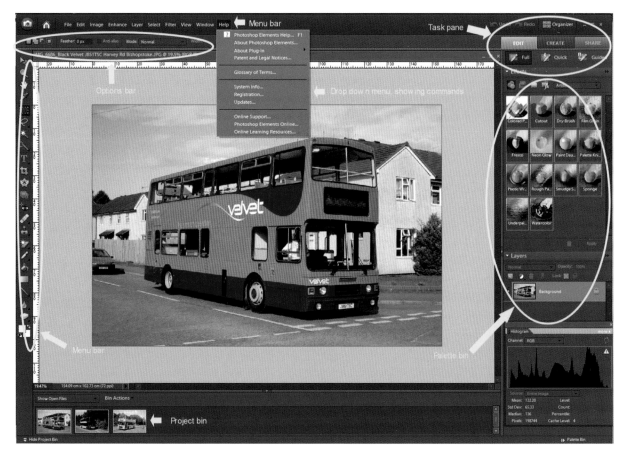

above **The 'tools' are all grouped together.**

that newer versions of the software described in this book will almost certainly be available by the time you are reading this. Although some of the detail may have changed, the basic functionality and terminology will not have altered to any significant extent. If anything, new releases are likely to continue the trend of recent years in becoming more intuitive for the inexperienced user.

When you start Photoshop Elements a 'Welcome' screen appears on the desktop. This features a pop-up menu in the left-hand corner offering the choice of start-up with the 'Welcome' (the default setting), 'Organiser' or 'Editor' screens. We have already looked at how the Organiser function can be used to import images into the computer, so will now look at the Editor.

When the Editor is opened you will be presented with a screen similar to the one on the previous page, although until you open individual files you will not have any images on display. Although the exact view will depend on the image-editing software you are using, they all have a similar basic layout.

At the top of the screen is a 'Menu bar',

which offers drop-down menus for performing common tasks, image-editing and organising your work. It also contains a 'Help' menu, which you can use to obtain answerers to any problems or questions that you may have in a relatively easy-to-use manner.

Running down the left-hand side of the window is the 'Toolbox'. This is probably the single most important component of the work area and contains all the tools that you will need for selecting, cropping, retouching and improving your photographs. The tools are, generally, arranged in order of usage with the most commonly applied ones at the top. Some tools hide additional tools beneath them – these are indicated by a small triangle on the lower right of the tool icon. By left-clicking on the icon the tool is selected. Clicking and holding the left mouse button or right-clicking will reveal the other tools available with that setting.

Immediately below the Menu bar is the 'Options bar', which provides bespoke settings for each tool in the Toolbox. For example, when you are using the clone stamp tool it gives you a number of choices of brush size and texture.

right **Most image-processing software has a similar look to it. This is Corel Paint Shop Pro.**

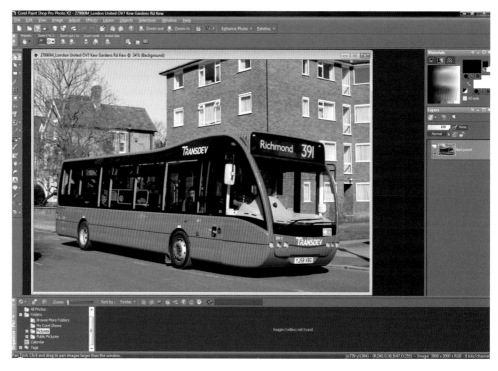

left Files are opened by double-clicking on the image. The view can also be changed.

The 'Task pane' and 'Palette bin' are on the right-hand edge of the window and group together common tasks and controls. The 'Project bin' at the bottom of the window contains all of the images currently open. By clicking on a particular image it is possible to select it for editing.

KEYBOARD SHORTCUTS

Many of the commands that are accessed from the Menu bar of the image-processing software have a keyboard equivalent (shortcut) that appears beside each command name in the menu; for example, the 'Open file' command is displayed as 'Ctrl' and 'O' (ie, hold the 'Ctrl' key and simultaneously press the 'O' key). Some users find these a far easier way of working – as with many choices, the decision is subjective and there is no right or wrong answer. A full list of these commands can be found in the 'Help' section of your software program.

You may also have noticed that when you select many of the commands within an editing package there is a letter after the name of the command. This is a menu shortcut command and by using the 'Ctrl' key in addition to the shortcut you will be able to access the feature directly. For example, the 'Move' tool can be accessed by using 'Ctrl' and 'V'.

OTHER SOFTWARE

As already noted, there are a number of image-processing programs available on the market and your computer may well have been supplied with one pre-installed. Alternatively, camera manufacturers supply a disc containing software with their product. Windows Vista users have the option of using the Photo Gallery, which forms an integral part of the operating system – although it is pretty basic, it will give some rudimentary functions. Fortunately, the functionality and language applied does not vary too much between different programs.

■ Opening and closing files

To start work on an image it is necessary to open the file that contains it. The simplest way to do this is to choose 'File' and 'Open' from the Menu bar. You may need to navigate to the drive and folder in which the image you want to open has been saved – simply double-click on the appropriate folder to select it. Once you have reached the correct folder you can open the image by double-clicking on the appropriate file.

There are a number of viewing options for files, ranging from simply showing the filename itself through to large thumbnail images of the photograph. The format can be changed by clicking on the 'View' menu.

To close a file simply select 'File' and 'Close' on the Menu bar. If you have made any changes to the image you will be offered the option of saving them. By selecting 'No'

any alterations will be discarded.

■ Saving files

After you have carried out any changes to a file you will need to save those changes. As ever, there are a number of options available.

The first choice to make is between using the 'Save' command or 'Save as'. The former will overwrite the existing file with any changes that have been made. Once you have done this you can never revert to the original file (unless you have archived it elsewhere). The 'Save as' function will let you save the image with a new name of your choice. This gives the option of reverting to the original file at some point in the future should you wish. For this reason alone I strongly recommend always using this function to save an image.

The 'File' 'Save as' option will open a dialogue box. Navigate to the folder in which you wish to save the image – if appropriate you can create a new folder by clicking on the appropriate button – and enter the new file name in the relevant box. I tend to give files new names as I save them in order both to make it clear which files have been edited and also to provide a quick guide to the properties of the file. The system is a simple one – I delete the IMG prefix afforded to files created by my Canon SLR (different makes will use different prefixes – Nikon, for example, use DSC by default) and add a suffix to indicate the size of the file. Finally, as I have long since taken more than the 9,999 photographs that the file counter allows, I add an extra 10,000, 20,000 or whatever to the file number. If this sounds convoluted, the following example may help.

Original file name:

IMG_7764_Stagecoach East Sussex 27577 Milfoil Drive Langney

New file name, to reflect that fact that the camera's image counter is now on its third 'circuit' and the file is medium-sized:

27764M_Stagecoach East Sussex 27577 Milfoil Drive Langney

I always save edited files into folders that reflect their contents. Although not prescriptive, I have adopted folder names that reflect operator details.

Once you have changed the file name, choose the file format that you wish to use. If you are saving as a JPEG file, a window will open prompting you to choose a file quality, in this case on a scale of 1 (low) to

right, below and below middle Once a file has been edited it should be saved with a new file name. Depending on the file format chosen, the user will be presented with various options for file compression.

below right It is possible to personalise the 'Save' settings within some programs.

12 (high), which determines how much compression will be applied to the image. Your choice will depend on what the image is to be used for – if it is to be printed I would always opt for the maximum quality. Images that are intended to be emailed or posted on web pages can be of lower quality without adversely affecting their viewing properties. If saving the file as a TIFF, the most common compression options are LZW (after Lempel-Ziv-Welch, the Israeli authors of early papers on compression of files) and ZIP. LZW compression tends not to work particularly well with photographic images, while ZIP files cannot always be read by all computers. For this reason I tend to apply no compression to the image, even though it means that files can be very large. The size of a TIFF file can, however, be reduced by flattening it (ie, removing 'layers'). This is achieved by using the 'Layer' and 'Flatten image' commands from the Menu bar. The use of layers is examined in more detail in Section 8.

If you are concerned about accidentally overwriting a file, it is possible to use the 'Saving files' section of the 'Preferences' dialogue, which is accessed from the 'Edit' menu to ensure that you are always prompted with the 'Save as' option by selecting the 'Ask if original' option.

There are a number of other preferences that can be selected from this dialogue that dictate how images will be displayed and so on.

■ Resizing files

As already noted, it is strongly recommended that photographs are taken using the highest resolution that the camera can deliver. There are occasions when it is desirable to reduce the size of an image, usually in connection with sending it as an email message or uploading it to a web page. This resizing is necessary to ensure that email messages do not clog up the recipient's mailbox or, in the case of a web page, that it does not take too long to download. Although there is an inevitable loss of image quality, this will not be noticeable in an image being viewed on a monitor. It should be noted, however, that many programs have the necessary functionality to undertake this resizing automatically. That said, by undertaking the

above The 'Image size' dialogue box allows for the size of the file to be changed. If the 'Resample image' box is not ticked only the resolution or dimensions may be changed; the overall size of the image remains constant.

resizing operation yourself you retain more control over how the final image will look.

Having opened the image to be resized, select 'Image', 'Resize image' and 'Image size' from the Menu bar. This will open up a window that displays the current size of the image, specifically its pixel dimensions, the document size in centimetres and the resolution (pixels per inch).

As noted earlier, these three items are all interrelated and, if you double the resolution, the document size will be halved. Making changes such as this will have no impact on the overall size of the file.

To change the document's size it is necessary to check the 'Resample image' box. The 'Constrain proportions' box should also be checked, as this will ensure that the original height-to-width ratio of the photograph is maintained. When this is done the pixel dimensions box will also become editable.

Of the three variables (pixel dimensions, document size and resolution), it is possible to change two. Changes to the third will be determined by how you have altered the other two. In the example below the resolution has been altered to 72ppi and the pixel dimensions to 960 x 640 (in practice it is only necessary to change either the height or width, as the ratio of these has been locked). The resultant image will have dimensions of about 33cm x 22cm when these settings are applied. The overall pixel count has now been reduced from its original 18 million to about 1.7 million.

The 'Resize image' dialogue also contains a drop-down menu providing a number of options for resampling the image. Depending on the software, there will be a number of options provided here that determine how the process will take place. Whenever an image is resampled its pixels are transformed by a process known as interpolation. The end result will depend to a large extent on how resampling is applied. There are three options:

- 'Bicubic' is the default setting and produces a good-quality image with smooth graduations. It has spawned two offshoots, 'bicubic smoother', which can be used when increasing the size of an image, and 'bicubic sharper', which is designed to retain sharpness and detail within the image.
- 'Bilinear' produces an acceptable overall result.
- 'Nearest neighbor', although a fast process, may produce jagged edges to the final image.

It is also possible to resize an image to something larger, a process known as 'upsampling'. As already noted, it is not possible to add detail that was not included in the original image, so when upsampling a photograph the computer program will use interpolation to add pixels based upon what is already present. As a rule images treated in this way tend to lack definition, particularly in areas of great detail. The most appropriate resampling option to use when increasing the size of a file is bicubic smoother.

If you increase the resolution of a file and allow resampling to take place without reducing the size of the image, the resampling process will create a

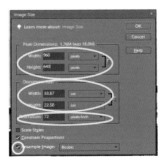

right By allowing resampling to take place, any of the size variables may be changed. If the overall image size in increased the software will add pixel information based upon interpolation. This can result in both a loss of image quality and potentially massive files.

SIMPLE
IMPROVEMENTS

For many people, digital photography is treated very much like its analogue predecessor. Instead of taking a film to the local shop to have it developed and processed, they take their memory card to the same shop and have prints made from it. Maybe they will have a CD burned at the same time, but that's it.

One of the real strengths of digital imaging is the ability to make simple improvements to a photograph that significantly enhance the end product. We have already looked at compositional techniques, but it is not always possible to frame the ideal shot. Similarly, we have considered exposure settings to ensure that the photograph is neither to light nor too dark. Again, there are occasions when, for whatever reason, it was not possible to use the correct exposure. The changes to images that used to require hours of patient darkroom work can now be achieved easily and quickly in full daylight. All that is required is a PC with suitable software. Many PCs and almost all cameras come with some form of imaging software that will be more than adequate for simple enhancements. For more complicated jobs there is a wide choice available capable of almost every conceivable task.

There is a lot of debate as to whether one should alter a photograph in any way, and it would certainly be wrong to manipulate a photograph to show something that was not there, for example by superimposing the blinds from another bus to make it look like an unusual working has taken place.

Having said that, some changes are more likely to be acceptable, particularly if you did not notice them when you took the picture. The key question has to be, did the object distract you when you looked at the photograph for the first time? If there is no alternative – like taking the picture again from a slightly different angle or going somewhere else – try and crop the photograph to remove the offending item (for example, a car parked up the road). The unexpected, such as a bird flying up, an elbow suddenly appearing at your right shoulder or a newspaper blowing across in front, can probably be removed from the image with a clear conscience as they are not material to the scene.

A single curved top of a lamp post projecting above the roof of a double-decker bus in a clear sky is very intrusive and the eye immediately focuses on it. If you did not spot it or could have just ducked down to eliminate it, then it too can be erased.

By contrast, the bus, and the scene in which it is set, is something that is being recorded for posterity and should not be fundamentally altered. In years to come it will serve as an historical record of life at the time it was taken. At a more mundane level, others may be disappointed if they try to recreate your photograph and find that it is not possible.

■ Quick fixes

Many digital camera users have little patience for extensive editing of photographs yet recognise that their images need a little tweaking. Many editing packages offer just such a facility to adjust common problems such as low contrast, over-exposure or under-exposure in a photograph with just a couple of quick actions. They work by analysing the image and adjusting the settings accordingly. To access the quick-fix menu within Photoshop Elements simply open the Editor and click

on the 'Quick' tab in the Palette bin. Use the 'File' and 'Open' commands to select the image that you wish to work on. By clicking on the 'View' command above the Project bin, you can select an option to view the image before and after any changes have taken place. The Palette bin itself contains a number of functions – by clicking the 'Auto' command a number of improvements will be carried out to the shadows, highlights and colour balance of the image. The extent of these can be controlled using the slider bar under this command. There are also more specific quick-fix options for lighting, colour and sharpness. By having both the original and tweaked image on display it is possible to ascertain the impact of the changes that you are making.

right The quick-fix function is an easy way to make simple improvements to a photograph. The sky areas in particular have benefited from this tool.

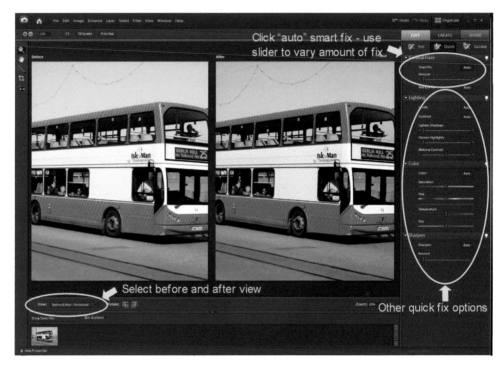

right Isle of Man Transport 14 is seen passing along Douglas Promenade in April 2008.

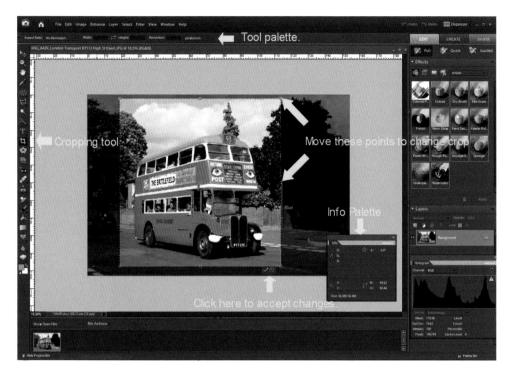

left and below
Careful cropping of a photograph will not only remove distractions but improve its overall impact. In this example, showing pre-war RT113 passing through Ewell village, a nearly square crop has added impact to the image while retaining something of interest in the background.

Once you are happy with the overall effect, save the file with a new name, as described above.

■ Cropping

This is probably the simplest improvement that can be made to a photograph and one that you are almost certain to want to apply even if you do nothing else to the picture.

Cropping is quite simply the process of removing those elements around the edge of a photograph that you do not want in the image. There are a number of reasons why you might want to do this: to remove distracting detail at the edge of the frame, to improve the balance of the photograph, or to change its aspect.

To crop an image click on the 'Crop' icon in your image software. There are then two possibilities – use either a standard print ratio, a custom ratio that you can select by entering the desired dimensions (either in terms of pixels or units of length), or the free-form option, allowed by choosing 'no restriction'. If you intend printing the image it is probably best to go for one of the standard sizes.

Once you have chosen the 'Crop' tool it is

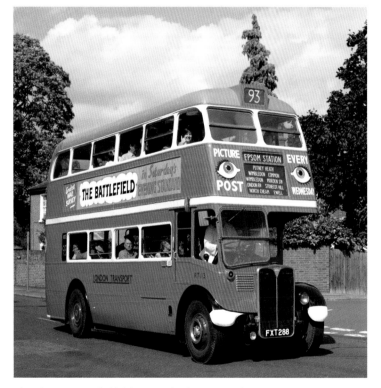

simply a case of clicking on the image and, holding the mouse button, dragging the cropping tool until you have drawn a rectangular box around the part of the image that you want to keep. If you are using a free-form option there will be no

restriction to the height or width of the crop. If you are using a specific print proportion (either a standard print size or a custom ratio), the proportions of the crop box will be constrained by these ratios. To move the crop box around within the image, simply place the mouse in the image area, click and drag. To change the size of the image, hold the mouse pointer over the edge of the box, click and drag to change its height or width. Those areas of the original image that have been cropped out are still visible on screen but are darkened.

If you have the 'Info palette' open you will be able to see the cropped size of the image as you work.

When you are happy with the look of the photograph, click the green 'tick' symbol in the bottom right-hand corner of the crop box. The image will be cropped down to the new ratio. Save the file with a new name and close it.

In the example shown here the original photograph is somewhat spoiled by the car to the left of the bus. In addition, the vehicle itself is rather too 'head-on' to look right in a landscape-format photograph.

It is important to remember, however, that cropping not only removes unwanted parts of the image but, as it is permanently deleting some of the original shot, some of the pixels. This may have implications if you decide that you want to print the image later on.

■ Straightening

We have all taken photographs that, despite our best endeavours, are slightly wonky. This happens when the camera is not quite held level and rather detracts from the final photograph. Most software editing packages have the function to rectify this problem. Some of the tools simply allow you to create a straight horizontal line, which is fine for a view of sunset over the sea where the horizon is quite clear, but of limited use for photographs of buses and coaches. Fortunately, there are other options.

Almost all software will have a rotate function of some sort and we will now look at how to use this to straighten a sloping photograph. The accompanying photograph of DM1052 shows a distinct lean, as evidenced by the way in which the window frames of the house on the left-hand edge are clearly not vertical.

The first stage is to ensure that you have a clear reference point against which to judge whether the image is straight or not. This can be achieved by using the grid

right and opposite top
A photograph's appearance is improved greatly if it is actually straight! This is simply achieved using any editing program. DM1052 is seen passing along Stanley Park Wallington during a running day held on 15 April 2007.

overlay common to most software packages. Open the image to be straightened and activate the grid overlay by using the 'View' and 'Grid' commands.

Use the 'Image', 'Rotate' and 'Free rotate layer' commands. This may prompt a dialogue box warning that transformations should be applied to layers. If this happens, just click 'OK'. Similarly confirm any further layer prompts that follow.

The image should now have positioning 'handles' similar to those that we saw when cropping. If you allow the mouse cursor to hover over the corner of the image, arrows will appear indicating that you can now rotate the image in either direction.

Using the grid as a template, click on one of the corners and rotate the image until its vertical and horizontal elements are aligned with the grid. In this example the vertical lines on the house in the background are ideal reference points. Once you are happy with the result, click on the 'tick' symbol and the transformation will be applied.

You will notice that there will be some areas around the image that will need trimming to tidy up the edges. This can be achieved by using the crop function. The final image is now properly square and looks all the better for it!

■ Removing unwanted objects

As we have already noted in Section 4, it is far better to spend a little time and care choosing a location and composing the photograph than to have to spend ages editing images afterwards. We have, however, all found ourselves in the situation of having a photograph containing an object that spoils the overall composition or distracts the eye.

In the example shown here the bus is in an attractive location on Putney Heath. Unfortunately, however, the viewer's eye is

below **The lamp post protruding from the roof of this bus detracts from the overall scene.**

drawn straight to the lamp post emerging from the roof of the bus.

We are going to remove the lamp post by using the 'Clone stamp' tool. This tool does exactly what its name implies, and using it you can copy a portion of an image and reapply it repeatedly to cover an unwanted portion of the photograph. In this case we are going to clone parts of the sky and reapply them to cover the lamp post. Here is how it works in practice:

- Open the image in your editing software and use the 'Magnify' tool to zoom into the area to be worked on.
- Click on the 'Clone' tool – the cursor will change to a small circle, which is the 'brush'.

right and below
By using the clone tool it is possible to copy pixels from the sky and paste them over the offending post.

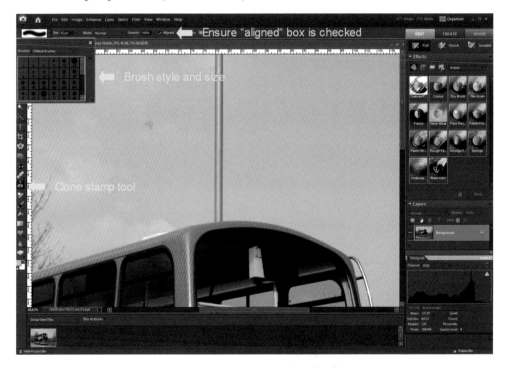

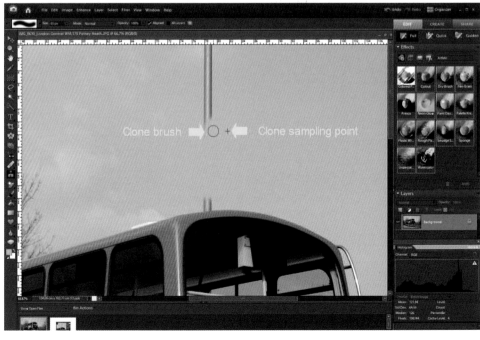

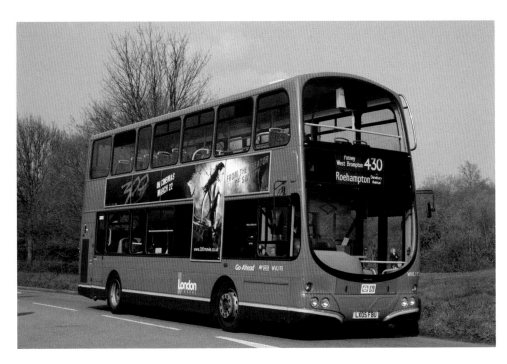

- Select a brush size and style – in this case we will use a soft round brush, about the width of the lamp post. Ensure that the 'Aligned' box is checked – this will ensure that the cloning point moves with the brush.
- Move the 'brush' to the area from which you want to clone pixels, press the 'Alt' key (the brush becomes a 'target'), then click the mouse. It is best to choose an area as close as possible to the object that you wish to remove in order to ensure that the pixels are the same colour.
- Click and drag the clone brush over the area that you wish to remove. You will notice a small cross showing the point from which pixels are being sourced.
- Carry on until the lamp post has been covered. You may need to reselect the clone point and zoom in closer, particularly when working near to the roof of the bus, and use a smaller brush.
- Once the offending post has been removed, carry out any other changes (in this case cropping the image slightly to give it better balance) before saving it with a new file name.

Some software packages also have a 'Healing brush tool', which is particularly useful for cleaning up an image to remove areas of imperfection such as dust specks on the image sensor, an errant bird or, in the example shown here, an empty bottle lying on the grass verge.

The healing brush tool works in the same way as the clone stamp tool by sampling a clean area of the image used to paint over the area of imperfection. However, this tool differs from the clone stamp tool because, instead of simply copying pixels from the sampled area, it transfers the texture and blends it in with the colour and luminosity surrounding the area being painted over. This more advanced method of cloning makes for a smoother blend and less noticeable retouching of images.

In this example the area to be sampled has been taken from the verge immediately adjacent to the offending bottle and painted over it. Close examination of the photograph also shows a bright red piece of litter on the path in front of the bus, which has been similarly 'healed'. This process is repeated until the 'repair' is completed, after which any other changes can be made before the image in saved. Had I wanted to I could also

have removed the lamp post in a similar way, but in this case have chosen not to. The original photograph was slightly angled and the car behind the bus was something of a distraction. Both aspects have been addressed by straightening and cropping the image using the approach outlined above. This represents the adoption of a workflow method in which each improvement to an image is carried out in a logical sequence before finally saving the photograph after all the changes have been made. This concept is similar to the darkroom workflow adopted when processing film, and ensures that each change to an image is undertaken in a way that ensures the final photograph is what is sought.

■ Correcting the exposure

All photographers have taken pictures that are too light or too dark, and although it is clearly preferable to get it right at the time of taking the photograph, this is not always possible. Although nothing can ever recover an image that is very badly exposed, it is possible to retrieve many photographs using your image-processing software. We have already touched on developing a digital workflow to ensure that changes to a

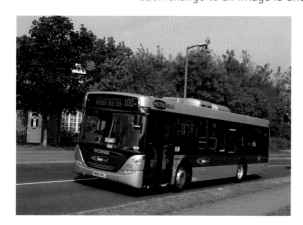

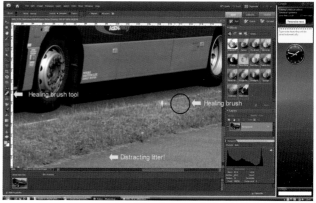

above, above right and right **A sad feature of modern life is the plethora of litter on our streets. The healing brush can be used to remove such distractions from a photograph.**

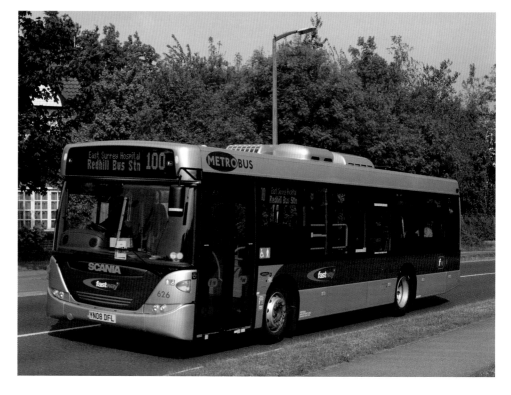

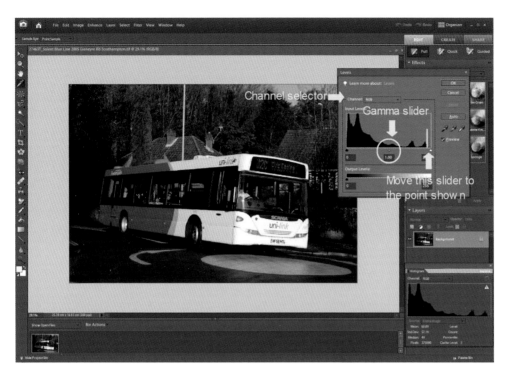

left **By adjusting the levels using the histogram it is possible to improve the exposure of an image that was over- or under-exposed when taken. As with all adjustments it is possible to see the effect of any changes immediately.**

photograph are made in a logical manner – it make sense to hold off adjusting exposure levels until you have made any other changes, which may include removing some parts of the image using the crop tool.

We have already looked at the role of the histogram in ascertaining whether an image is correctly exposed or not. To recap, the histogram displays, in a graphical format, the distribution of light and dark pixels throughout the image, with dark ones on the left and light ones to the right. As a general rule you want the distribution of pixels to be fairly even across the image.

Most software packages have an option to adjust the levels within an image using the histogram and a slider. To use the tool it is simply a matter of moving the sliders under the histogram to set the black and white points – this then spreads the distribution of dark and light information across the photograph.

To correct the levels in Photoshop Elements first open the image that you wish to correct. Select 'Enhance', 'Adjust lighting' and 'Levels' to open the Levels dialogue box.

In the example shown here it is immediately clear that there is a bunching of pixels towards the left-hand side of the

graph, which tells us that there are very few pixels with bright colours.

Drag the white point slider to the left until it is at the point where the graph ends. If you have the 'Preview' box checked you will be able to see the effect of this change as you make it. If necessary (although not in this case), do the same for the slider on the left-hand side of the scale. Also if necessary, use the 'gamma' slider to adjust the overall brightness level in the mid tones of the image.

The default setting for the levels adjustment is 'RGB', which means that red, green and blue colour channels will be adjusted together. By selecting each one individually it is possible to fine-tune the adjustment.

You will also note an 'Auto' button – by clicking this the software will automatically calculate the extent of any levels of adjustment needed. Underneath the 'Auto' button there are three pipettes – these can be used to select, from left to right, the black, grey (ie, mid tone) and white points within the image. This will also allow the software to calculate the levels adjustment for the whole image as it will, in effect, fill in the gaps.

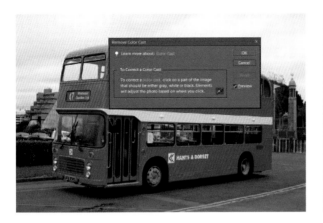

above and above right
The colour balance of an image can be altered easily – by setting the white or black points all other colours are set relative to that reference. This is particularly useful when an incorrect white balance was set originally.

Once you are happy with the overall effect, click 'OK' to accept the changes and save the image.

■ Adjusting colours

Although we have already looked at white balance settings, there are occasions, usually because the wrong white balance settings were applied or the camera's automatic white balance has made the wrong choice, when a photograph has a colour cast that needs to be corrected. Most software programs have a function that removes colour cast. With Photoshop Elements this is accessed by following 'Enhance', 'Adjust color' and 'Remove color cast' from the Menu bar. This will open a dialogue box. By clicking with the pipette icon on an area that is either completely white, completely black or grey, the program will ascertain the correct shades for the whole image relative to this point. The best results are usually obtained by selecting a white or black point, as these are more easily defined than shades of grey.

Further enhancement of colour can be achieved using the 'Adjust hue/saturation' dialogue, which is also accessed through the 'Adjust color' menu. This gives the option of adjusting the hue (colour), saturation (purity), and lightness of the entire image or of individual colour components within the image. Those who have used slide film will be familiar with the concept of saturation – Fujichrome Provia, for example, was noted for giving colour reproduction with a great deal of punch.

Use the 'Hue' slider to add special effects, to colour a black and white image (giving a 'sepia' effect), or to change the range of colours in a portion of an image.

Use the 'Saturation' slider to make colours more vivid or more muted. A good use of this adjustment would be to add a colour punch to a bus by adding saturation to all the colours, or to tone down a distracting colour, such as someone wearing a fluorescent jacket.

The 'Lightness' slider used in conjunction with the other adjustments will lighten or darken a portion of the image. It should not be used on the whole image as this will reduce the overall tonal range of the photograph. We will look at how to select part of an image for editing in the next section.

As with other alterations, it is possible to see the effect that you are creating by ensuring that the 'Preview' box is checked. Make changes gradually and, when you are happy with the overall result, click 'OK' to confirm the change and, if you are not planning to make any further changes, save the image with a new file name.

■ Colour curves

We have already looked at how to adjust the brightness of an image using the options of adjusting the histogram and setting the black and white points within the Levels menu. Another way of making fine changes to an image is to make adjustments using the 'Adjust color curves' function, which is accessed using the 'Enhance' and 'Adjust color' menu.

Although Photoshop Elements does not have a full curve function, the 'Adjust color curves' dialogue offers both a number of pre-set options and the ability to make changes to the highlights, mid-tone brightness, mid-tone contrast and shadows within an image. If one of the pre-set options is selected it is still possible to make further adjustments to the image using the sliders. As you make changes you will see the straight line representation of tone becoming an 'S' curve. Rather helpfully, the dialogue box shows a before and after image so it is possible to see the impact of your changes. Once you are happy with the effect, click 'OK'.

◼ Sharpness

Although there are limits to what can be done to rescue a badly out-of-focus or blurred photograph, there are some improvements that can be made using image-processing software. In addition to the 'Sharpen' function available in the 'quick-fix' option there is also a 'Sharpen' tool available from the Tool bar. This tool works by increasing the contrast between soft edges in a photograph to increase clarity or focus. You can avoid over-sharpening by setting a lower-strength value in the Options bar. As with all enhancements it is best to make the sharpening subtle and increase it as necessary by dragging over the area several times, building up the sharpness each time.

The 'Adjust sharpness' dialogue box, accessed through the 'Enhance' menu, allows a greater degree of control over the sharpening process than is available with other tools. It also has a Preview option and allows you to zoom into a particular part of the image. Registration plates and fleet-numbers are ideal choices to enlarge as it is readily apparent when they appear sharp.

The following options are available:

- ◼ 'Amount': this sets the amount of sharpening. Choose a value or drag the slider to increase or decrease the contrast between edge pixels, giving the appearance of greater sharpness.
- ◼ 'Radius': this determines the number of pixels surrounding the edge pixels affected by the sharpening. Type a number in the box or drag the slider to change the radius value. As you increase the radius, sharpening becomes more obvious.

left Using the 'Adjust color curve' function helps to make changes to the colour, contrast and mid tones in an image.

■ 'Remove': this determines the sharpening algorithm (an algorithm is simply a set of instructions) used to sharpen the image and is accessed from the drop-down menu.

'Gaussian blur': this is the method used by the 'unsharp mask' filter (see below for more on this filter). 'Lens blur' detects the edges and detail in an image, and provides finer sharpening of detail and reduced sharpening halos. 'Motion blur' attempts to reduce the effects of blur due to camera or subject movement.

The 'Motion blur' works by compacting the image in the plane specified and can be effective at minimising the effect of blurring caused by a moving bus being photographed with too slow a shutter speed. When it is applied, the 'angle' setting is used according to the direction in which the vehicle was moving across the field of view. Either enter a value or drag the angle dial to change the angle percentage to the left (counter-clockwise) or right (clockwise).

■ 'More refined': this option processes the file more slowly for a more accurate removal of blurring. It does, however, result in increased levels of noise within the image.

■ Unsharp mask

All digital images have a very slight softness to them as a result of the filter covering (and protecting) the camera's image sensor. This effect can be rectified by using the paradoxically named 'unsharp mask'.

Unlike other sharpening tools, which increase the contrast across the whole image, this one tool works by adjusting the contrast of pixels at the edges, and in the

above and right
The 'Adjust sharpness' function will help rescue a slightly out-of-focus image. Classic Southdown Omnibuses 901 is seen heading along East Overcliff Drive, Bournemouth, on 29 June 2008.

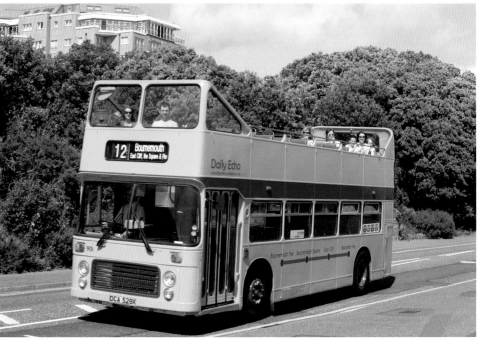

areas around the edges, of a photograph. This greater contrast leads the eye to conclude that the whole image is sharper.

To apply the unsharp mask select 'Enhance' and 'Unsharp mask' from the Menu bar. This will open a window that gives you the following choices:

- **'Amount'**: this is the intensity of the sharpening effect. As a rule you should get good results with about 75%.
- **'Radius'**: this determines how many pixels around the edges are affected by the filter – the higher the number, the greater the number of pixels that get sharpened. It is best to use a value of 1 or 2.
- **'Threshold'**: this dictates how far different pixels need to be from their neighbours to be considered an edge. A value of 0 will treat every pixel as an edge and over-sharpen the image. A value of about 5 is a good starting point.

It is possible to select a part of the image and, by checking the Preview box, see the effect of differing amounts of sharpening. It is important not to apply too much unsharp mask as this can result in halos appearing around the edge of the image. Once you have an acceptable result, click 'OK'.

The unsharp mask is a common tool and most digital photographers will apply it to any image that they plan to print. It is usually best to leave applying this effect until you have made all the other adjustments to an image.

■ Correcting lens distortion

Some lenses, especially budget models, can produce distorted images. 'Barrel' and 'pin-cushion' distortion are effects caused by certain wide-angle and telephoto lenses respectively. Barrel distortion is a lens effect that causes images to be 'inflated', while the pin-cushion effect causes it to appear pinched. It is most visible in images with perfectly straight lines, especially when they are close to the edge of the image frame.

Perspective distortion is usually apparent when a photograph is taken of a tall building from a low angle, causing the vertical lines of the building to converge. Both of these affects can be corrected by selecting the 'Filter' and 'Correct camera distortion' menus, which will open a window offering a series of options to make corrections using sliders. The image is overlaid with a grid, which makes it easy to see when the desired effect has been achieved. When applying these corrections it is important to ensure that the perspective of the bus itself remains true.

■ Correcting a mistake

If you want to correct a mistake that you have made while editing a photograph, it is a straightforward matter of using the 'Edit' and 'Undo' commands from the Menu bar. It may be, however, that you need to correct several changes, in which case rather than using the 'Undo' command several times it is possible to use the 'Undo history' command, accessed by selecting 'Window' and 'Undo history' on the Menu bar. This will open a dialogue box listing all of the changes made to the image from the very first to the latest. Scroll through the list until you find the first unwanted edit and click on it. All changes subsequent to that one will be deleted. To confirm the change, right-click and choose 'Delete'.

below **The 'unsharp mask' works by increasing the contrast between pixels at the edges of areas of an image. It is common practice to apply a slight 'unsharp mask' to any photograph that is to be printed.**

A TRIP TO
BIRMINGHAM

England's second city and historical home of the UK motor industry, Birmingham is crossed by urban motorways. This notwithstanding, it has much of interest to the bus photographer, although shadows thrown by the high buildings of the city centre make finding a suitable location for photography something of a challenge other than in high summer.

right The dominant operator in Birmingham is Travel West Midlands, owned by National Express. Locally built MCW Metrobuses played a key role in the fleet for more than three decades. In the city centre, late-model 2909 is seen heading along Priory Queensway in May 2008.

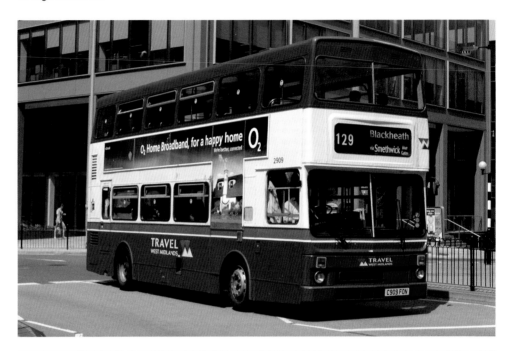

right Sutton Coldfield sits on the north-eastern edge of Birmingham. Arriva Midlands is one of the heirs to the vast Midland Red empire and its 4204, a Wright Eclipse Gemini-bodied Volvo B9TL, is seen heading into the town centre en route to Birmingham at 11am on 7 May 2008. An ISO setting of 400 and a polarising filter to reduce reflections, together with an exposure of 1/640th second at f5.6, have been used.

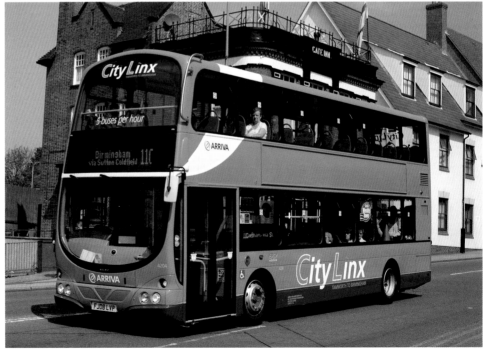

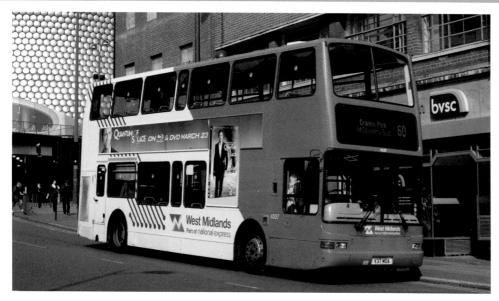

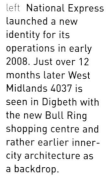

left National Express launched a new identity for its operations in early 2008. Just over 12 months later West Midlands 4037 is seen in Digbeth with the new Bull Ring shopping centre and rather earlier inner-city architecture as a backdrop.

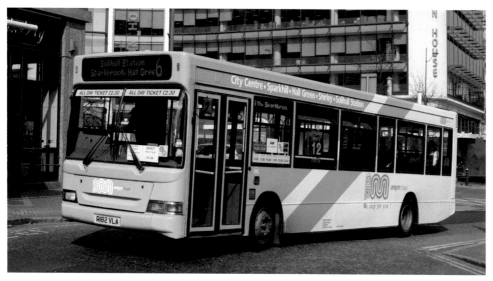

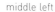

middle left
In common with many conurbations outside London, Birmingham has seen competitive services launched against the dominant ex-PTE operator. The vehicles used have often been well past the first flush of youth, although Acocks Green-based AmPm Travel, which launched a Birmingham to Solihull service in early 2009, does not fall into this category. Seen on 21 March 2009 in Corporation Street, along which many services pass, is a Plaxton Pointer-bodied Dennis Dart SLF new to Metroline.

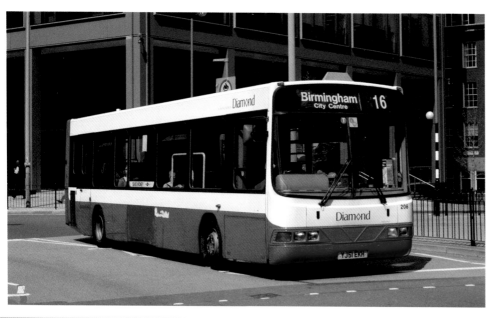

left Diamond Bus is a well-established operator in the West Midlands, having been established after deregulation in 1986 to operate route 16 in competition with West Midlands Travel as 'The Birmingham Coach Company'. It was acquired by Go-Ahead in 2005, then by Rotala three years later. On 7 May 2008, 208 passes through Priory Queensway in central Birmingham on the original route.

SECTION 7

ADVANCED
EDITING

right Selection tools allow the isolation of one part of an image for further manipulation. The edge of the selected area is delineated by a dotted line.

All but the most basic editing software will allow users to make a wide range of changes to enhance the quality of their images. This section looks at some of the tools of most use to the photographer of road transport subjects.

■ Making selections

Digital imaging software offers a range of options for enhancing and retouching a photograph. As you will often only want to make changes to one part of the image, it is necessary to select a specific area of the photograph on which to work. Once a selection has been made, it is possible to change its colour, remove something distracting or copy it into another image.

There are a number of selection tools available that can either be used individually or in conjunction with others.

Over the next few pages we will have a look at how these can be used.

Most software packages use similar descriptions for selection tools, and mastering them is key to being able to make more advanced alterations to digital images.

■ Marquee tools

The marquee tools are the easiest to use and allow you to select either a rectangular or elliptical area. Having selected the required tool, it is simply a matter of clicking and dragging to choose the desired area (which will be marked by a dotted line, sometimes described as 'marching ants'). When you release the mouse button the selection is made. If you want to reposition it, simply click anywhere in the selected area (a small arrow will appear) and drag the selection to the desired area.

■ Lasso tools

The lasso tools are used for irregularly shaped objects. The 'pure' lasso tool allows a free-form selection to be made, while the polygonal lasso is most useful when selecting an image consisting of a number of straight edges. Finally, the magnetic lasso automatically seeks the edges of an object based upon differences in pixel colour. If you are trying to select a bus, it will ensure that the selection clings to the edge of the vehicle. The last two tools are the most useful and we now look at their use in more detail.

The 'pure' lasso tool is the most straightforward to use, although it takes some practice and requires a good mouse (or graphics tablet) and a steady hand to get really good results. The most important thing to remember is to zoom in close to the image to ensure that you have greatest control. To use the tool, all you need to do is click on a part of the photograph that you want to select and 'draw' the area that you want to select. When you lift your finger off the mouse the selection is 'closed'.

As noted above, the polygonal lasso tool is used to make a selection based upon a number of straight lines. To use it, simply click at points around the object you wish to select in order to create straight-line segments. Double-click back at your original starting point to 'close' the selection. In the previous section the use of the clone stamp tool to remove unwanted objects was described. By making a selection around the object to be cloned from the image, it is possible to achieve a cleaner edge to the cloned section.

To select using the magnetic lasso tool, click on or very near to the edge of the area you want to select in order to establish the first anchor point. Move the cursor along the edge of the selection area, and as you do so the tool will trace along the edge of the object and place additional fastening points along the way. If the selection jumps to the wrong object, place the cursor over the correct edge and click the mouse to establish a fastening point. To close the selection double-click the mouse.

The magnetic lasso tool has a number of variable options that determine how it will make a selection:

- ■ 'Width': this sets out the size of the area scanned by the tool as it makes the selection, and can be set at anything from 1 to 40 pixels. A wide width setting is best for areas with high contrast while a lower value is more suited to low-contrast images. From personal experience I have found that a setting of about 5 works best for most applications.
- ■ 'Edge contrast': this establishes the amount of contrast for an edge to be recognised as such and traced. Edge contrast is determined by the percentage contrast; lower settings work best with low-contrast images and higher values for higher-contrast selections.
- ■ 'Frequency': this determines how close to each other the fastening points are and is expressed on a scale of 1 to 100. As a rule, the more irregular the shape the higher the value should be.

■ Using colour to make selections

The 'magic wand' and 'quick selection' tools allow the selection of areas having the same colour. Again, it is sometimes difficult to get used to, but can be useful in selecting parts of the photograph that have similar colours such as a single block of livery colour within a bus, or the sky. When you first select an area within an image the tool will select all of the pixels within a colour or tonal range close to the pixel that you have already selected.

The magic wand allows for setting tolerances, which determine the range of colour or tonal values around the pixel that you have selected to be included in the selection, anti-aliasing (which is covered in more detail below), and contiguousness, or whether pixels need to be connected to those selected to be included in the selection.

Having opened an image and selected the 'magic wand' tool, choose whether you wish to create a new selection, add to or subtract from an existing one, or intersect with a selection that you have already made.

In the example used here we will see how to select the orange sections of the bus. Selecting parts of a vehicle in this way is useful when a vehicle has a livery made up of both light- and dark-painted areas, which make getting a correct exposure for the whole bus difficult. If, for example, the dark part of the vehicle is under-exposed, it is possible to select it and lighten that part without affecting the rest of the photograph.

■ Select the tolerance range to establish how wide a tonal range you want to include in the image – to pick colours very close to the originally selected pixel, choose a low setting, to select a wider range opt for a higher setting. We are going to want to select not only the bright orange pixels but also those that have been affected by shadows, so in this case a higher setting is more appropriate.

■ Check the 'Anti-alias' box (see below for more on anti-aliasing).

■ If you only want the pixels that are conjoined to the originally selected one to be selected, check the 'Contiguous' box. In this example we want to select all of the orange parts of the bus, some of which – for example, the route numbers – are not physically connected to orange pixels, so this box should be unchecked.

■ If you want to select pixels in all of the layers, click the 'All layers' box. We will return to layers later in this section.

■ Click a colour or tone within the image – based on your settings a range of pixels will be selected. The selection area can be expanded by using the 'Grow' command, which is accessed from the 'Select' menu. This will allow you to change the tolerance setting. By clicking back in the selection area the revised setting will be applied.

The selected area will be marked by dotted lines. It can be added to, or reduced, using the 'Add to selection' or 'Subtract from selection' commands (see below).

The 'quick selection' tool is similar in many respects to the 'magic wand' in that it

right **The 'magic wand' tool allows the user to select areas of similar colour, in this case orange.**

makes a selection based upon colour similarity. As its name suggests, it is a quick and easy way of selecting areas of an image that have a similar tonal range. Simply click within the area that you want to select and drag the tool. As you do so you will see the selection grow. The selection can be refined as described below. This stool is best used to select large areas of similar-coloured pixels that do not have too much fine detail, such as sky or road surfaces.

The final selection tool that you may encounter is the selection brush. This works by allowing you to make a selection by painting over a part of an image using a brush. Only the parts actually painted over will be affected. The tool offers differing choices of brush size and texture.

◼ Selection brush – mask

The selection brush tool also offers a 'mask' mode that allows the creation of a protected, unselected area. The opacity and colour of the mask can be altered to make it easier to work with – its default setting is red, which is rather difficult to see on a photograph of a London bus!

To make a mask with the selection brush, first choose the selection brush tool and select 'Mask' from the Options bar.

- Choose a brush style and, if desired, select values for brush size and hardness.
- Select a colour and level of opacity for the mask.
- Drag the brush over the image to create the mask. As soon as another tool is selected the mask overlay will change to a selection border and the area is protected from any changes applied to the rest of the image. If you want to modify the mask select the bush tool again – the mask will automatically appear over the image and additional areas can be painted in.

The mask overlay is particularly useful for confirming the area of a selection, and can be used in conjunction with any of the selection tools. It is simply a matter of clicking the selection brush tool and choosing the mask to see the masked area. Click 'Selection' from the drop-down menu when you have finished viewing the mask.

Using selections can be frustrating but it is possible to build them up gradually using the 'Add to selection' function. This is particularly useful when trying to select an irregularly shaped object such as a person, or a bus with prominent rear-view mirrors that extend some distance from its bodyside. It is possible to obtain greater control by slowing the mouse down. This can be achieved by adjusting the speed of the mouse reaction time in the computer's Control Panel. Start by setting the slider just above the slowest setting and gradually increase the speed until a satisfactory result is obtained.

There are four modes that can be used with the selection tools that are located within the 'Options' palette. These are indicated in the accompanying screenshot. From left to right they are:

- 'New selection': this is the default setting to create a selection. If you start a new selection it will cancel any others within the photograph.
- 'Add to selection': this is useful if you are selecting a complex area in an image, such as a bus with protruding mirrors. Any selections made get added to those already made, which allows you to build up the selection gradually. It is also possible to combine selection tools so that, for example, part of the selection can be made using the polygonal marquee tool and other sections using the magnetic lasso.
- 'Subtract from selection': as the name suggests this allows you to subtract areas from the selection that you have made. It is useful of you are using the lasso, for example, and realise that you have selected an extraneous part of the image.
- 'Intersect with selection': this tool allows you to select only those parts of a multiple selection that overlap. To be honest, it is of limited use!

Selections work best when the edges are smooth. All of the selection tools offer the option of an 'anti-alias' feature, which adds blended pixels to the image to create a smooth edge. This is usually checked by default and it is suggested that all selections are made with this feature enabled.

Selections can sometimes have harsh edges, and by using the 'Feathering' command it is possible to soften the outline of a selection. This feature is particularly useful when part of one image is copied and pasted into another.

Once part of an image has been

right and opposite **The mask mode makes it easy to see which parts of an image have been selected – it is then an easy matter to adjust the selection to the desired area using a combination of tools.**

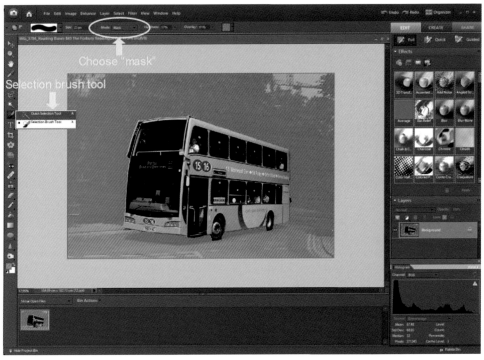

Select opacity
and colour

Selection area
clearly visible

selected, it is possible to make alterations purely to the part of the image within the selection or, by inverting the selection, to make changes only to those parts of the image not covered by the original selection. To invert the selection, go to 'Select' and 'Inverse' on the Menu bar.

■ Shaded front ends

As noted in Section 5, the optimum position for the sun is behind the photographer in order that the elevations of the bus being photographed are fully illuminated and any shadows are on the 'far side'. There are occasions when, despite careful planning, it is not possible to find a location where the sun is ideally placed – this is usually the case when waiting for a special working that is running late. In seeking out a new position there is a real risk of missing the bus altogether. Usually in such cases the sun will only be a little too far round, which results in the front of the bus being in shadow.

Earlier sections have looked at how to lighten an image that is too dark using the levels adjustment. By selecting only a part of the image it is possible to apply the adjustment to that part alone in order to lighten it.

The example shown here is a brace of Bristol VRs entering the Wiltshire village of Netheravon on a special run to mark the passing of the type from service. The photograph is, therefore, not one that can be repeated, although by the time the buses arrived the sun had moved slightly too far round.

In this instance the black and white sections of the livery have not been affected by being in shadow, but the red front panels are noticeably darker than the side of the bus. These are therefore selected using a suitable selection tool (the polygonal or magnetic lasso tools are probably best). This requires two selections to be made: after completing the first selection, use the 'Add to selection' command and make the second. Both selections will be clearly visible on the screen.

Open the levels adjustment (using the 'Enhance', 'Adjust lighting' and 'Levels' commands from the Menu bar). The histogram will show bunching of pixels towards the left (ie, dark) side of the mage. By moving the input levels slider to the left

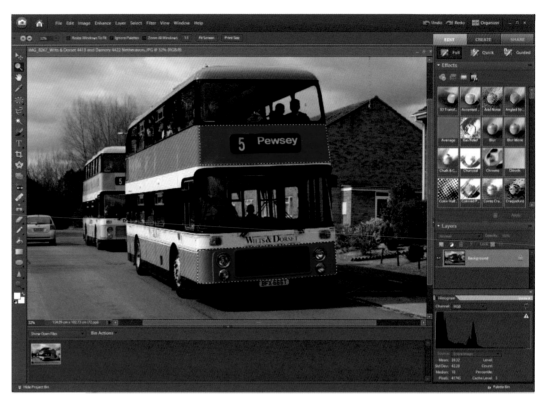

top, above and opposite When the front of a bus is in shadow this can usually be corrected by selecting the affected area and using the levels adjustment to lighten that part of the image that has been selected. Wilts & Dorset 4413 leads Damory Coaches 4422 into the Wiltshire village of Netheravon on 28 March 2009. The buses were performing a number of special duties to mark the end of service by Bristol VRs within the Go South Coast group.

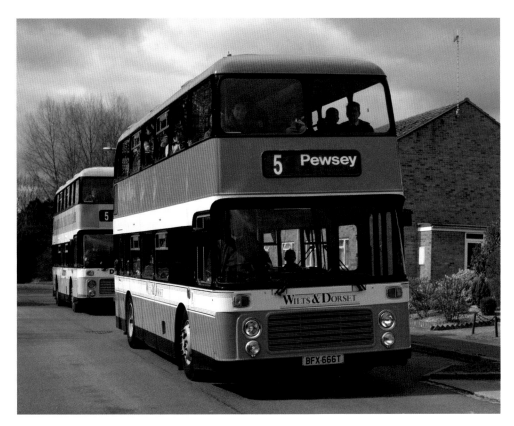

it is possible to lighten the image. Note how the change only takes effect within the selected area of the image. Once a satisfactory result has been obtained the alteration should be accepted by clicking 'OK'. The selections can be removed by double-clicking anywhere within the image, after which any further changes to the image (for example, a levels adjustment to the whole photograph, cropping, etc) can be made. Finally, save the image with a new file name.

■ Layers

The image captured by your camera, and transferred onto the computer, consists of one layer, just like a colour slide. The simple changes that were made to images in the previous section have been applied directly to that simple image, in much the same way as you might write directly onto a photograph.

Most image-editing programs have a feature referred to as 'layers', which allows you to make a composite image where each element is on a separate layer or level. In its most simple form, a layer can be thought of as a sheet of transparent acetate laid over a white background. You can create as many layers as you want and edit each one individually. This allows us to cut sections selected from one image and paste them into another, where they can be moved around, and aspects such as brightness, size, etc, changed to allow them to blend in smoothly. Once you have finished editing a photograph containing layers it can be 'flattened', ie the different layers are located together as one image and cannot be moved or edited again. Alternatively, if the file is being saved in TIFF or PSD format it is possible to preserve the layers so that they can be separately edited at some point in the future.

■ Adjustment layers

Adjustment layers allow you to make changes to the colour and tonal range of an image without changing the underlying image. They work by creating a new layer within the image on which the changes are carried out.

top and below **Layers are an important image-editing tool** – in this example a new layer has been created and adjustments to brightness and contrast applied to it. The opacity of this layer is then altered, allowing some of the original to show through. Solent Blue Line 1301, carrying Uni-Link livery, is seen passing Southampton Civic Centre in December 2008.

Adjustment layers are created by following the 'Layers', 'New adjustment layer' prompt and selecting the adjustment layers that you wish to add to the image. These will then appear in the Layers palette and, by clicking on the layer thumbnail, it is possible to open a dialogue that will let you make changes. Once you are happy with the overall effect, the opacity of the adjustment layers can be altered gradually, allowing some of the original image to show through. This provides far greater control over the adjustment process than working on a single layer.

It is also possible to create a duplicate layer, which is useful if, for example, you

only want to make changes to part of the image. For example, if editing a photograph of a bus that has light and dark components to its livery, it is possible to edit the darker parts on a duplicated layer, then erase the lighter sections from that layer, allowing the original photograph to show through.

■ Restoring what the eye saw

As we have already noted, there is a degree of debate about what can and cannot be changed on a photograph. An aspect of modern bus photography that causes great frustration is that of LED destination displays, which, with few exceptions, are now the norm for most operators. All electronic destination displays refresh themselves at a rate that cannot be detected by the human eye. Unfortunately for the photographer, this often results in either a totally blank display or a row of meaningless dots, depending upon the speed with which the display refreshes.

Clearly if the bus is stationary it is possible to retake the photograph – for some displays it is necessary to use a shutter speed slower than 1/60th second, whereas for others it is something of a gamble whether the display will come out or not, although the shutter speed has no bearing on matters. If the bus is moving, however, these options are not available, although unlike film it is possible to see which shots are affected straight away and plan how to correct it.

All that is needed to correct this problem is a suitable correct display to superimpose on the chosen picture. From a moral point of view we are simply recreating what the eye actually saw, which, for technical reasons, could not be captured by the camera.

In the example here the photograph of a moving bus has been taken with a shutter speed of 1/800th second to freeze the subject. Unfortunately the destination has come out as a line of dots in the centre of the display. In this case another

below and overleaf
The problems caused by electronic blinds failing to reproduce photographically have already been mentioned. Using digital editing tools, it is a relatively straightforward matter to 'cut' the display from one photograph and 'paste' it into another. Shamrock Buses 249 is seen in Sea Road, Boscombe, on 29 June 2008.

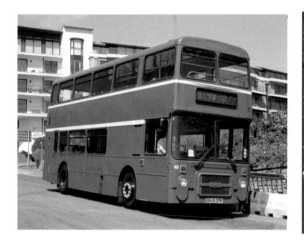

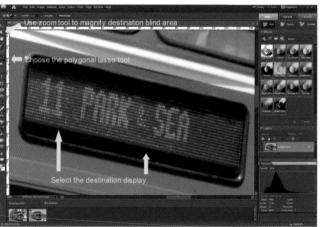

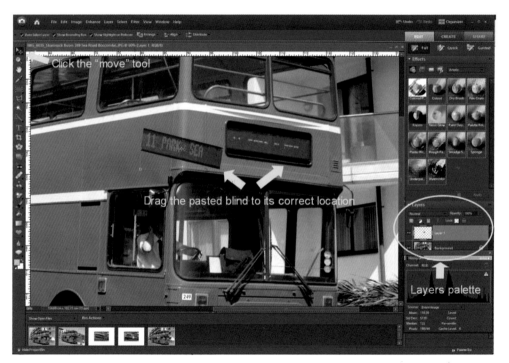

photograph of the bus, at a shutter speed of 1/40th second, was taken when it was stationary, in which the display has come out clearly. The image itself, however, is inferior, as the background in particular is rather cluttered. We are going to use 'Select', 'Copy' and 'Paste' functions to take the display from the second photograph and insert it in the first.

- Open both images.
- Zoom into the area of the display on the image from which it is to be copied.

- Use the polygonal lasso tool to select an area around the destination display.
- Copy the selection.
- Paste the selection into the other image. Notice how the pasted image of the display now appears in the Layers palette as a new layer.
- Use the 'Move' tool to move the pasted display to the correct part of the photograph, then zoom into that area – at this stage it is likely that the display will not be properly aligned.
- It is very unlikely that a selection pasted from another image will be exactly the

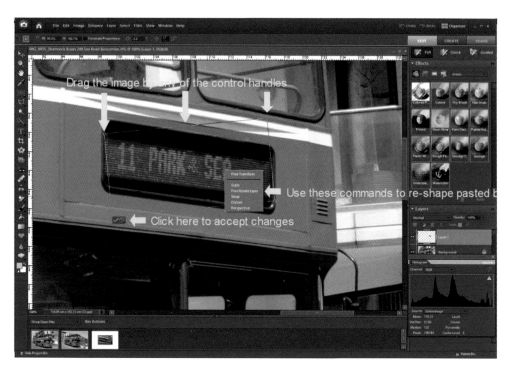

same proportions as the photograph into which it has been placed, either because the vehicles are in a slightly different position or because the photographer has moved slightly. These differences can be compensated for by using the transform tools, accessed by selecting 'Image' and 'Transform' from the Menu bar. The 'Perspective' command is the most useful function to alter the vanishing point of a selection, for example if the destination blind has been copied from an offside view but pasted into a nearside one or vice versa. Its application is fairly intuitive – when a corner handle is dragged, the opposite corner moves as a mirror image. Once the desired result has been achieved, a double-click of the mouse inside the pasted area will apply the changes.

right, above and
opposite **An ever-present risk when
taking photographs
of moving buses is the
last-minute appearance
of another vehicle or
pedestrian. By taking
another photograph
from the same
viewpoint immediately
afterwards it is possible
to create a patch to
cover the offending
object. Kent Top Link
PO58 KPX is seen in
Upper Bridge Street,
Canterbury, on
12 November 2009.
The photograph was
taken from across the
forecourt of the city's
fire station, which
allowed a suitable angle
of view to be obtained.**

other improvements (such as cropping). If you are unlikely to want to edit individual layers again, the image can be 'flattened' by using the 'Layer' and 'Flatten image' commands from the menu. Finally, save the file.

This problem caused by LED displays is such that many bus and coach photographers have started to build up a library of destination displays to draw on as required!

■ Removing unwanted distractions

One of the frustrations of bus and coach photography is the last-minute distraction, usually a vehicle or errant pedestrian, that appears as you take the photograph. We will look at two methods of addressing this, both of which involve building up an image using layers.

In the previous section we looked at using the clone stamp to remove small distractions such as lamp posts from a photograph. To remove something larger, a slightly different approach is required. To begin with it is necessary to have a second photograph of the scene that is, as far as

Greater control can be achieved by using the 'Skew' command, which allows the selection to be twisted in all directions by clicking the handles and dragging the selection. The 'Free transform' command allows total freedom, although the results can be unpredictable!

■ Once the pasted display looks right, accept the changes, and make any

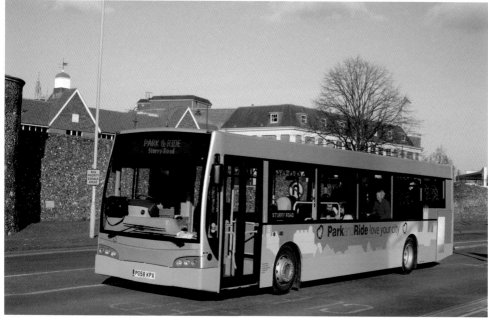

possible, taken at the same angle and with the same exposure as the one from which the errant object is to be removed. If you realised the problem as soon as you took the original photograph it is best to take another immediately afterwards. If this is not possible for any reason, you will need to find another image that is as close as possible to the original. In essence, the

procedure that we will now look at entails merging two images together to make one good one.

APPLYING A PATCH

As we are going to be working on two images, it helps if they are both visible. With Photoshop Elements it is possible to do this by using the 'Window', 'Images', 'Cascade'

menu. By clicking on the borders of the images themselves they can be moved around the screen and selected for editing.

In the example shown here the photograph, taken in Canterbury, suffers from the last-second appearance of a white van. I noticed this immediately and took a second photograph that included an unobscured section of the city walls.

■ Having opened both images, the first stage is to apply a grid to both in order that an appropriate selection can be made. This is done by selecting 'View' and 'Grid' from the Menu bar for each image in turn.

■ Choose a selection tool (in this case the polygonal lasso, with a 5-pixel feather) and, using the grid as a guide, select a part of the second image that is large enough to cover the offending van.

■ Copy the selection and paste it into the original image.

■ Select the 'Move' tool and transfer the pasted patch to the correct location. At this stage it helps to remove the grid lines (in the same way that they were applied).

■ Zoom into the appropriate part of the image and use the 'Image' and 'Transform' menus to select an

appropriate option to alter the size of the patch to fit. If the second image was taken from a slightly different perspective, it may be necessary to use the 'Skew' or 'Distort' commands to ensure a clean fit.

■ Any minor imperfection in the join can be cleaned up using the clone stamp tool.

Once you are satisfied, and if you do not think that you will want to edit the image layers again, the image can be flatted. Any additional changes, such as altering levels or cropping, can then be carried out and the image saved.

Although it would be possible to apply the same approach to the lamp post bearing the warning of 'Bus Priority Signals Ahead', since this was quite clearly there when the photograph was initially composed its removal would be a step too far!

MERGING IMAGES

Sometimes there are occasions when the application of a patch to remove a distraction from a photograph is not possible, particularly when the object is actually touching (or very close to) the bus, as it is very difficult to create a patch that will not cover parts of the bus.

right When the object to be removed from a photograph is close to, or actually touching, the bus, it is not always possible to apply a patch...

In the example I will show how to remove the pedestrian who, while clearly very interested in examining RTW75 is not really dressed in a fashion that fits the rest of the scene. I did not take a second shot at the time so have had to look for another take at around the same time where the part of the frame occupied by the pedestrian is free. The view of a London General EVL fits this bill; it will form the background layer and the image of the RTW will be laid over it. Once this is done the pixels containing the image of the pedestrian will be removed.

Here is how to do it:

■ Open the image from which the distraction is to be removed and select all of it using 'Select' and 'All' from the Menu bar.

■ Copy the selected image using the 'Edit' and 'Copy' commands from the Menu bar.

■ Open the image that is to form the background layer and paste the other image into it. You will now see both in the Layers palette with one named 'Background' and the other 'Layer 1'. It is possible to switch between layers by clicking on the one you wish to work on.

■ It is now necessary to remove the pedestrian from the layer. This can be done either by using one of the selection tools or the eraser tool, which does just what its name suggests. The tool has a number of settings that can be accessed from a drop-down menu.

■ Zoom into the appropriate part of the photograph and gradually erase the offending part of the image. As you do so you will see the pixels below show through. Carry on until all of the

above and left
...In such an instance another photograph, without the distraction, is used as the base layer and the original photograph is laid over it...

top, below and opposite
The offending item is then removed, using the eraser tool, allowing the layer below to show though. London Bus Company RTW75 heads into Worcester Park on 10 August 2008.

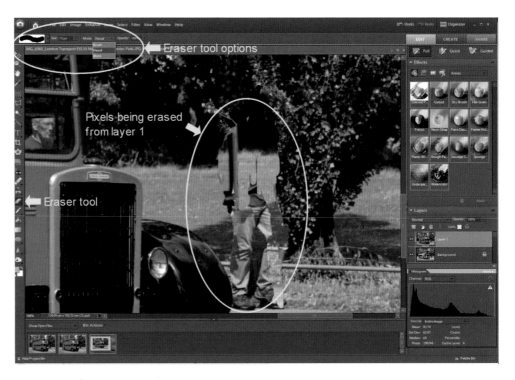

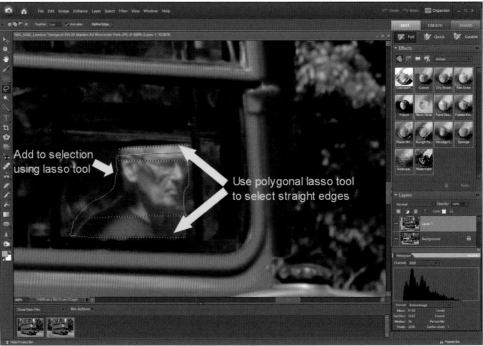

offending item has been removed. In this example it is clear that the images do not exactly match, and part of the bus in the background image is showing though.

■ The layered image will need to be moved and, if necessary, resized slightly to ensure a neat fit with the background layer. Select the 'Move' tool and adjust the layers until they coincide – in this example, the tree and railing present useful reference points.

■ There may be a harsh edge where the pixels have been removed – this can be

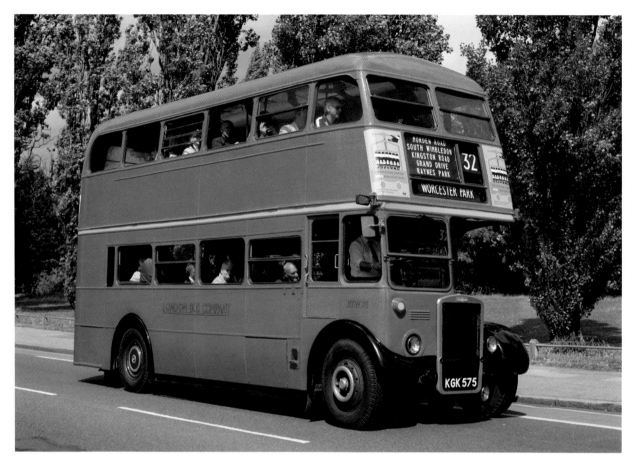

softened by making small selections using a lasso tool, with a feathered edge, and removing them from the image using the 'Edit' and 'Cut' commands from the Menu bar.
Any other small imperfections can be covered using the clone stamp tool.

There is also a further pedestrian visible through the cab window. If desired, he too can be removed from the image. The clone stamp tool is probably best for this, sampling from the piece of vegetation behind the bus as seen though the cab window. To ensure a clean edge to the cloning, it helps to make a selection, using the polygonal lasso tool, to identify straight edges at the top and bottom of the cab and adding to it with the lasso for the outline of the man's body. This approach will ensure that the cloned pixels are only added to the selected area.

■ Once you are satisfied with the image it can be cropped, flattened and saved.

■ Low winter light

We have already looked at the way in which low winter sun affects the choice of location for bus photography, particularly in bright sunlight, causing long shadows. Another issue is that of excessive glare from the reflective registration plates fitted to most British buses and coaches. In essence, the angle of the sun is such that it creates a high level of contrast between the white plate itself and the black characters. This makes the registration appear indistinct, and can be dealt with in the following way:

■ Zoom into and select the area of the registration plate. In this example the magnetic lasso tool has been chosen.
■ Select the 'Brightness/Contrast' adjustment dialogue, which is accessible though the 'Enhance' and 'Adjust lighting' menu.
■ The brightness of the white number plate needs to be reduced – this is

this page Low winter sun has been reflected off the registration plate of Arriva Kent Thameside 3755 as it heads west on the afternoon of 6 December 2008. By selecting and reducing the brightness of the plate the effect of this is minimised. Further edits are carried out to remove the photographer's shadow from the image.

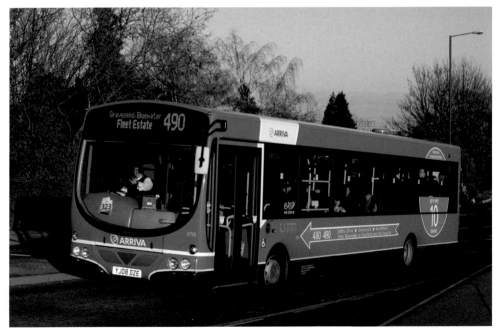

done by moving the 'Brightness' selector until a more satisfactory result is obtained, in this case to about 20%. Similarly, the contrast between the white plate and black characters needs to be reduced – again, 20% has been selected, although some experimentation is a good idea. Click on 'OK' to confirm the change.
■ The very bright reflection has caused a loss of sharpness in the black text of the plate. This can be corrected by applying a little sharpening to the selection.

This photograph also exhibits another of the challenges of winter photography – that of the photographer's shadow falling across the image. The risk of this can be mitigated at the time of taking the photograph by crouching down, thus reducing the length of the shadow. In this case, however, a selection has been made from the road surface in front of the bus (using the lasso with a feather of 15 pixels), which has then been pasted and moved to cover up most of the shadow. The image has then been cropped, which has removed the remaining shadows. A levels adjustment has been applied and the colour cast corrected, using the white band under the fleetname as a reference point.

■ Removing halos

Often when you create a new image layer from a selection you will find that you have selected a few pixels around the image that you did not wish to include. This is particularly so when the selection was made using the 'magic wand' or 'quick selection' tools. When examined closely, what appears to be a clean selection does, in fact, contain a halo of pixels from the original background. This can be removed by selecting 'Enhance', 'Adjust colour' and 'Defringe layer'. This will open up a dialogue box that invites you to enter a value for the number of pixels that you wish to remove from the edge of the selection. Choose a low value, certainly no higher than 5, and click 'OK' to see the results. Increase the value if necessary.

■ Shadows

Despite our best efforts there are occasions where a photograph has shadows cast across the vehicle, usually from a lamp posts or trees. Where the shadows are

left and overleaf
Many urban areas are veritable forests of lamp posts and other signs, all of which can case annoying shadows on the sides of buses. By using a combination of patching and the clone stamp tool it is a simple task to remove them. Hatton Cross station is particularly noted for its lamp posts; shortly after Metrobus assumed the route in April 2005, a Scania Omnicity single-decker is seen leaving for Croydon.

limited they can be removed using the clone tool or by selecting a patch from another part of the vehicle and pasting it over the offending shadow. This process only works, however, where the shadow falls on a part of the bodyside with relatively little detail.

In the example dealt with here a patch has been selected, using the rectangular marquee tool, from the bodyside of the bus immediately to the front of the shadow under the windows. To ensure that it blends in softly with the rest of the vehicle, a feather of 5 pixels has been selected.

The patch has been pasted and moved into position before being resized to ensure that it fits neatly into place. This process

has been repeated for the part of the shadow above the window. If the edges of the patch are too apparent they can be touched up using the clone stamp tool. The offending lamp post has also cast a shadow on the ground leading up to the bus, which now simply disappears, giving a rather odd appearance. Part of it has therefore been removed using the clone stamp tool.

The lamp post emerging from the roof is also rather obtrusive, so has been cloned out before cropping the image and saving it.

DODGING

Dodging is a technique used in a traditional darkroom when producing photographic prints using photographic paper and wet

left and overleaf
Trees have cast shadows across the rear of Damory Coaches 5401 seen in Manor Road, Bournemouth. The presence of cooling grilles and a complex livery mean that the patch or clone stamp method of removing shadows is not possible. In this case, therefore, the 'dodge' tool was used to lighten the shadow areas of the image.

chemistry; it allows for one or more selected area of the paper to receive less illumination during the printing exposure than the rest.

Typically, a piece of card or other opaque material is held between the lens of the enlarger and the photographic paper in such a way as to block the light, and since the technique is generally used with a negative-to-positive process, reducing the amount of light results in that part of the image having a lighter tone.

The method of shadow removal described above is easy to apply to less detailed areas of an image where the shadow itself is a relatively simple shape. For larger shadows on more detailed parts

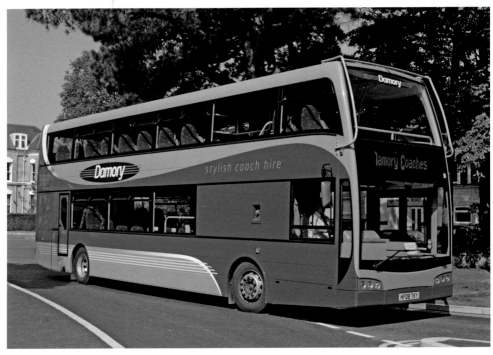

of a bus the 'dodge' tool can be used to lighten the darker areas of the shadow. The accompanying view of the Damory Coaches bus is spoiled by heavy shadows from trees falling across its rear section, but there is too much detail in that part of the bus to cut and paste patches into it.

To lighten parts of an image using the dodge tool, first zoom into the part of the image containing the shadows that you wish to lighten.

- Select the dodge tool from the tool box.
- On the Options bar select a brush size using the slider – something around 40 pixels is a good choice.
- Use the 'Range' and 'Exposure' settings to select a specific tonal range to lighten (the choice is shadows, mid tones and highlights) and control the amount of lightness applied.
- Move the brush to the area you want to lighten, hold down the mouse button and drag through the area.

It is easy to overdo the dodge tool, which can result in a 'noisy' image in the lightened area. Once you have achieved an acceptable result it is possible to adjust the overall image by using the 'Shadows/ Highlights' adjustment, which can be found by following the 'Enhance' and 'Adjust lighting' commands on the Menu bar. By dragging the 'Adjust shadows' bar to the right you will reduce the intensity of the shadows – as you do so you will see the effect of the changes both in the image and in the histogram.

Once you are happy with the result save the file.

■ Burnout

Occasionally part of an image is burned out, losing detail in the bright parts of the photograph. This can be corrected by using the 'burn' tool to give added exposure to and thus darken the affected area.

Having opened the image it usually helps to select the parts of the image to which you wish to apply the burn tool. In the example used here both the white front of the bus and the concrete surface of the busway are very bright. Both areas are selected using the 'quick selection' tool, which readily identifies the bright pixels.

A suitably sized brush is selected as well as the tonal range that it is intended to burn – in this case highlights. Finally, the

left and overleaf
The 'burn' tool takes its name from an old photographic printing technique and is a useful way of darkening parts of an image that are too bright, such as the newly laid concrete of the Edinburgh guided busway and the white parts of the livery on Lothian Buses 110.

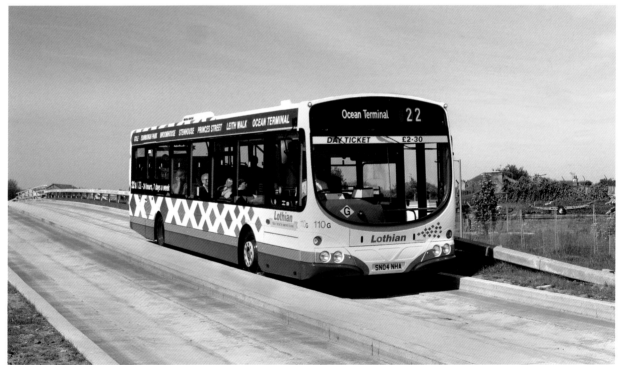

'Exposure' setting is chosen to control the amount of darkening to be applied – it is generally best to try a relatively low value and see what the overall effect is.

As with the dodge tool, the brush pointer is moved over the area to be altered while holding down the mouse button. Because a selection has been made, only those pixels selected will be altered, so it does not matter too much if the brush 'spills over'.

■ Putty skies

The rather bland putty-coloured skies that are a feature of the British climate do not make for particularly interesting photographs. An effective way to brighten up an image is to use a sky scene taken from another image (or one from a library kept for this purpose) and apply it to the photograph with the offending sky. To achieve this I will introduce the concept of using masks to protect part of an image.

A masks is a useful tool that allows for portions of two images to be covered over and revealed in such a way that elements of both are merged.

this page and overleaf
Large expanses of grey cloud do little to enhance a photograph. It is possible to take a more interesting sky from another image to create a more pleasing effect. Thames Travel 508 stands in Wallingford Market Place on one of the overcast days so typical of the summer of 2008.

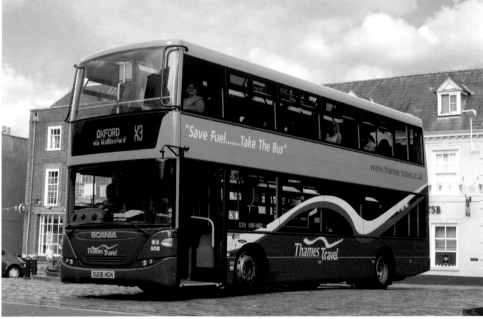

- The first stage is to open both images (I will refer to one as the 'sky' image and the other as the 'bus').
- Select the image of the bus and create a copy of it using the 'Layer' and 'New layer via copy' commands from the Menu bar – it will appear in the Layers palette as 'Layer 1'.

- Click on Layer 1 to select it and use the selection tool(s) of your choice to select the sky area in that layer, then delete the selected area using the 'Edit' and 'Delete' commands.
- Select the paintbrush tool and 'Mask' mode. The non-sky area of the image will turn red, showing that it is now protected by a mask.

- Use the 'Select' and 'Feather' commands to open the 'Feather' dialogue box. Apply a feather of about 3 pixels to the edge of the selection to smooth its edges.
- Select the 'sky' image and use the 'Select' and 'All' commands from the Menu bar to select all pixels. Use the 'Edit' and 'Copy' commands to copy the entire image.
- Click on the bus image and select the 'Background' layer. Use the 'Edit' and 'Paste' commands to apply the 'sky' image to the 'bus' image. This will create a new 'Layer 2' containing the pixels copied from the 'sky' image overlaying the 'bus' image.
- The image will now consist of three layers – 'Background' (which is untouched), 'Layer 2' (which contains the sky) and, on top, the masked 'Layer 1'. Any fine-tuning can be done by selecting the relevant layer and selecting parts of it for editing – it may help to defringe the layers to remove any halo that is

present. Each layer can be edited separately to ensure that the levels are correct. In this case I have also removed the legs and feet appearing from behind the rear wheels of the bus using a combination of the polygonal lasso tool to select the boundary of the changes and the clone stamp.

When making changes like this, care is required to ensure that the result does not look unnatural – given that the bus is clearly not in full sunshine, it is unlikely that the sky was totally clear.

■ Shooting into the sun

As already noted, there is an optimum angle for the sun to produce a pleasing final result, and we have already seen in this section that minor improvements can be made to an image where the sun is only slightly too far round. By contrast, a photograph taken looking into the sun is rarely going to be satisfactory as it is virtually impossible to

below **Shooting into the sun is generally accepted as being fundamentally incompatible with obtaining a decent photograph. By using a combination of techniques it is possible to create a result that, although far from perfect, is at least acceptable. On 20 July 2006 Blackburn Transport 5, carrying a locally built East Lancs body, pauses to pick up passengers in the town's Railway Terrace. The sky is washed out and there is little detail in the roadway.**

ensure a correct exposure for both the subject itself and the background – sky areas in particular are almost certain to be washed out with little detail. One possible approach is to take several photographs of the same subject with different exposure settings and merge them afterwards, but this is not practicable with a moving subject, and even something of

a challenge with a stationary vehicle – success depends on each image being taken from exactly the same angle, so a tripod is almost essential. In the time it takes it is likely that the bus will have moved off or the photographer will have been moved on!

On the basis that you may only have one attempt at taking the photograph, the best

right **The sky area has been selected using the method described in the previous example.**

right **A properly exposed sky scene has been added to the image, where it forms a new layer. The 'burn' tool has then been used to adjust the over-exposed areas in both the roadway and the light-coloured building behind the bus.**

approach is therefore to ensure that the vehicle itself is properly exposed and accept that other parts of the image will almost certainly require a degree of remedial work.

This example shown here is typical of the sort of photograph that results from shooting into the sun. There is no detail in the sky, the road surface is too bright and,

in selecting an exposure setting that captures detail in the bus, the buildings behind have become burned out. Ordinarily this is the sort of image that will either be deleted immediately or languish somewhere in the hard drive, never to be viewed again. The passage of time, however, has given it an interest

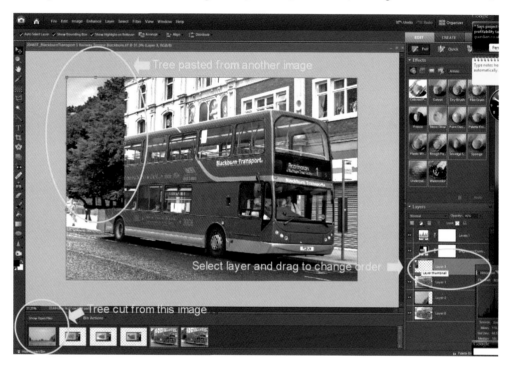

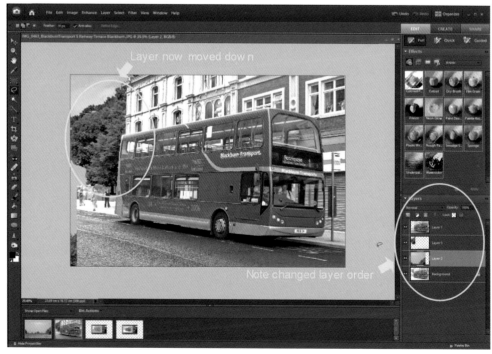

left and below
A suitable tree to replace that lost when the original sky was removed has been copied and pasted from another photograph into this image.
This has created a new layer which has to be dragged into the right place in the layers palette.

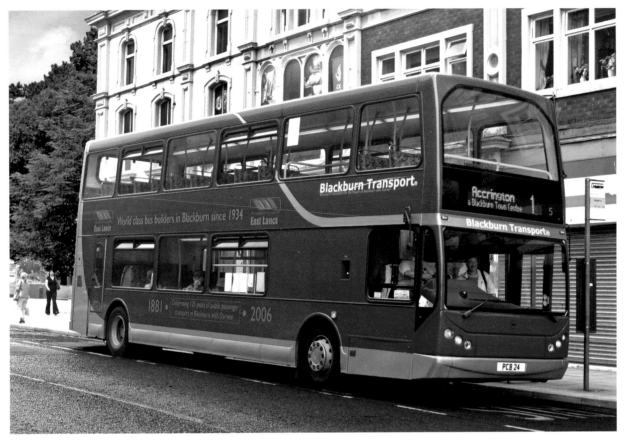

above **Once all of the edits are complete the image can be flattened, cropped and saved.**

value that compensates for its technical shortcomings.

The first stage is to do something about the burnt-out sky, for which the approach detailed above is adopted. The heavily over-exposed tree is also included in the selection that will be cut from the image. The initial selection is best made with the 'quick selection' tool, but some fine-tuning will be needed, zooming in on the image if necessary, to select the fine detail of the edge of the building.

Once a suitable sky image has been added, it is time to look at the roadway, which is far too light. Using a combination of the polygonal and magnetic lasso tools the roadway is selected and an initial alteration is undertaken using the 'Enhance', 'Adjust lighting' and 'Brightness/Contrast' commands. Further darkening of the roadway is then carried out using the 'burn' tool, which is also used to darken the pale stone buildings behind the bus.

A suitable image of a tree is found to replace that cut out with the original sky. In this example the image from which the sky has been taken contains just such a tree, which is selected, copied from its original location and pasted in as a new layer. This is now the top layer in the image and is obscuring parts of the photograph below. To change the order of the layers simply select the layer to be moved (the one with the tree in it) and drag it up or down in the Layers palette. When the layer is in the desired position, release the mouse. Finally, the image can cropped and saved.

Many photographers keep a library of suitable sky and background images to use in cases such as this. Clearly it is important to ensure that the resultant photograph is still generally true to the original.

■ Noise

The concept of digital 'noise' was mentioned in Section 4, where it was noted that high ISO settings are likely to give rise

to this problem. Noise can also be caused during the editing process, when attempts are made to lighten an under-exposed image or by over-use of the 'dodge' tool to lighten shadows. Although it appears to be a random pattern of specks in an image, there is actually a mathematical pattern to most noise. This means that it is possible to use the 'noise reduction' filters to seek out and reduce the amount of noise.

Having opened an image with a high level of digital noise, the noise reduction filter should be selected. This is reached by selecting 'Filter', 'Noise' and 'Reduce noise' from the Menu bar.

Click and drag the image in the Preview window until the part of the image showing most noise (usually a dark section) is shown. By default the filter will apply moderate noise reduction – moving the noise reduction slider to the left or right will respectively reduce or increase the effect. If there are still colour blotches visible after the initial adjustment, drag the 'Reduce color noise' slider up to around the 65% level. If the overall image looks grainy, moving the 'Strength' slider further to the right will improve matters, although at the expense of a softened image. This can be corrected by moving the 'Preserve

details' slider to the right until an acceptable image is achieved. As with all alterations to an image, some trial and error is required.

Unless the image shows 'artefacts' (blocks of colour), the 'Remove JPEG artifact' box can be left unchecked. Care should also be taken not to overdo any changes. Once you are happy with the overall result, click 'OK' to implement the changes.

There are also a number of dedicated noise-reduction programs available – the best known of these is probably 'Noise Ninja', which can be purchased over the internet.

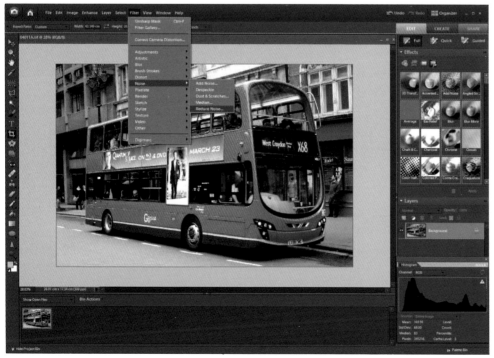

left, above and overleaf
Most software programs have the capability to reduce 'noise' in an image. This view of London Central WHD1 was taken using an ISO setting of 800 and noise is clearly visible as a pattern of coloured specks in the black area of the staircase panel.

127

■ Using RAW images

We have already noted that many cameras are able to produce RAW files and that these are not processed by the camera's software in any way, unlike JPEG files. This means that they retain all of the information captured at the time the photograph was taken and, although the file itself is considerably larger than a JPEG, this gives you the chance to process the image in the way that you want rather than how the camera's systems think it should be handled. This is particularly useful when processing images that contain very dark or very bright detail, which tends to be lost in the process of conversion to a JPEG file. From the transport photographer's point of view this includes white (or near white) liveries and shadow areas. When taking photographs against a background of trees, a RAW image is less likely to lose the detail in the shadow areas.

RAW images also have a considerable advantage in terms of the amount of colour information they store. Unlike JPEG or TIFF images, which contain 8 bits of colour information in each of the three colour channels, a RAW file holds 16. Although none of this information can be seen on the computer monitor, it is there and can be used when editing images.

A further difference is that RAW files do not have any sharpening or saturation applied as part of the image processing undertaken by the camera. Many users unfamiliar with the processing of RAW images approach the subject with a degree of trepidation, despite the clear advantages of 'shooting RAW'. Fortunately, most digital SLR cameras allow the user to record both a RAW and a JPEG image simultaneously. Apart from the extra memory taken up, there is really no reason not to shoot RAW images all the time.

Unlike a JPEG file, a RAW file needs to be processed before it can be printed, emailed or posted to an internet site. Furthermore, most camera manufacturers have their own proprietary RAW file format; this will require suitable software to open it, which will have

been supplied with the camera. The file extension for RAW files therefore differs according to manufacturer (for example, Canon uses CR2 and Nikon NEF). In addition, most major image-processing programs include what is often referred to as RAW conversion software within their offerings.

A RAW image is opened in the same way as any other file; however, when you open the file it will launch the RAW converter within the software.

In addition to a preview of the image, the window contains a number of familiar commands and some new ones. Those that are used in Adobe Camera RAW are summarised below from the top left working clockwise.

■ The tool bar contains a number of tools that will be familiar. The extreme left-hand one is a zoom button; right-clicking brings up a menu with various options. The hand control allows you to move the zoomed image around in the preview area. The 'eyedropper' tool allows you to select the white balance; by clicking on an area of the photograph that should be white, it will adjust all other colours accordingly. Other tools are for cropping, straightening, fixing red-eye (of limited use to the bus photographer!), preferences (for the camera RAW dialogue), and finally rotate counter-clockwise or clockwise.
■ The 'Preview' box should be checked in order that you can see the effect of any changes on the image;
■ The 'camera RAW dialogue' contains a number of adjustment tools for correcting an image before it is opened in the editing software:

☐ the 'White Balance' drop-down menu can be used to select a number of pre-set white balance settings corresponding to differed types of light. Alternatively a custom setting can be selected by clicking on a white part of the image using the eyedropper tool. The colour balance of the image

can also be adjusted using the temperature and tint settings.
☐ by selecting the 'Auto' setting the software will attempt to improve the image.
☐ the 'Exposure' slider brightens or darkens the image.
☐ the 'Recovery' slider will pull detail out of very bright or very dark parts of the image.
☐ 'Fill Light' will brighten the mid tones without causing over-exposure.
☐ 'Blacks' will make darker areas tend to black.
☐ 'Brightness' and 'Contrast' speak for themselves.
☐ the 'Clarity' control applies sharpening to the edges on the image, in very much the same way as the 'unsharp mask'.
☐ 'Vibrance' is used to increase colour saturation without causing colours to become clipped, whilst the 'Saturation' tool increases or decreases saturation to the whole image.
■ By clicking on the 'Detail' tab two more controls are available:

☐ a 'Sharpening' tool, which applies sharpening to the entire image in the same way as that described in Section 7.
☐ 'Noise Reduction', which removes the digital noise produced when shooting in low light conditions or at high ISO settings (or both). The 'Luminescence' slider applies to greyscale noise while the 'Color' slider controls chromatic noise (ie, that made up of multiple colours).

■ The colour depth can be altered by using the drop-down menu. 16-bit provides a larger file but contains more information. Not all software packages support 16-bit colour depth.

The histogram in the top right-hand corner of the screen contains two small triangles. That on the left is a 'shadow

above Light-coloured buses taken against a background with dark areas, especially trees, lend themselves to RAW processing as none of the detail is lost by the in-camera processing. Alexander D19, a 1948 Burlingham-bodied Daimler CVD6, is seen near Cuckfield while taking part in the 2009 HCVS London to Brighton run.

clipping warning' while on the right-hand side is a 'highlight clipping warning'. Clicking these buttons will show all areas where there is a risk that the shadows or highlights will have been clipped and thus lost any detail. Shadow clipping is shown in blue and highlight clipping in red.

The 'Exposure' and 'Recovery' sliders are used to correct highlight clipping. The 'Exposure' slider should be moved slightly to the left and the 'Recovery' slider to the right until most, if not all, of the red clipping warning has been removed. Shadow clipping is removed by using the 'Black' and 'Fill Light' sliders, moving the former to the left and the latter to the right in a similar way to remove the blue shadow clipping warning. This capability is one of the real advantages of shooting is RAW, particularly given the large number of bus liveries that contain large amounts of white.

Once you have made any changes within the RAW converter, clicking the 'Open Image'

button will open the image in the main editing program. Any further alterations can then be made. If the software that you are using does not support 16-bit colour management you will be asked to confirm that you wish to convert to 8-bit mode.

Remember that, unlike a JPEG image, a RAW file will have had no sharpening or colour saturation applied – if required these can be added as part of the image manipulation process.

Once you are happy with the image, flatten it, if the individual layers are not going to be separately edited again, and save with a new file name as either a JPEG or a TIFF file.

In addition to modern light liveries, night photography lends itself to being pursued in RAW format. The ability to recover areas of excessive brightness and shadow, correct noise and set the white balance to correct the colour cast caused by artificial light are all powerful arguments to shoot RAW.

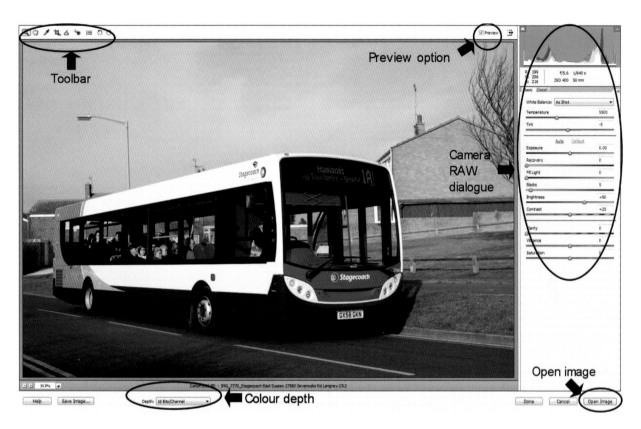

Toolbar

Preview option

Camera RAW dialogue

Open image

Colour depth

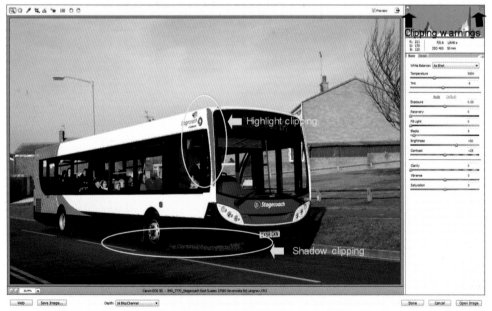

Clipping warnings

Highlight clipping

Shadow clipping

The final example in this section shows how the extremes of contrast have caused significant areas of shadow and highlight clipping. Zooming in shows that there is also some noise visible in the darker areas of the bus – this has been corrected by clicking on the 'Detail' tab and altering both the

'Luminescence' and 'Color' sliders. Finally, the white balance has been set, using the background of the front registration plate as a reference point, before opening the image for further editing. The colour saturation has been increased slightly, the image cropped and an unsharp mask applied.

above, left and overleaf
Most mid- to high-end digital cameras are able to create RAW images. These contain all the information captured by the camera without any alterations or deletion. Unlike JPEG or TIFF files, however, they require software dedicated to the camera on which they were taken for processing. A particular strength of RAW files is the ability to recover areas of an image that would otherwise be burned out. The bright white livery of newly delivered Stagecoach East Sussex 27580 contrasts with the dark window surrounds. The RAW conversion software ensures a perfectly exposed final image.

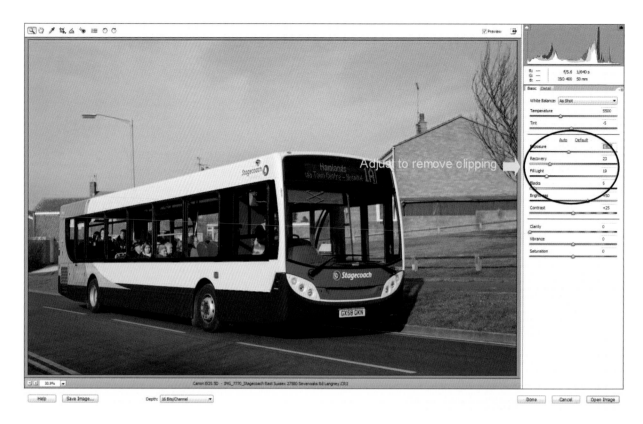

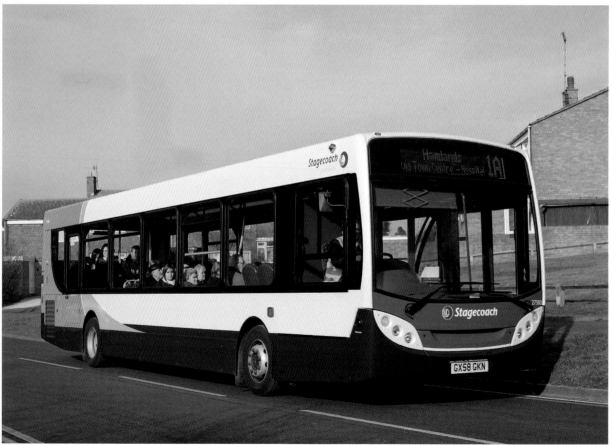

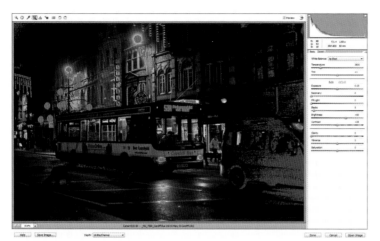

left RAW files really come into their own for night photography – Cardiff Bus 240 is in St Mary Street, Cardiff, shortly before Christmas 2008. An exposure of 1/50th second at f1.4 using an ISO setting of 800 was used. A polariser filter helped minimise the reflections of lights from the bus's windows.

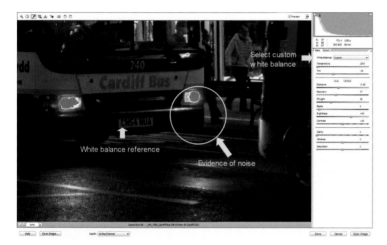

left and below **By processing the image in Adobe Camera Raw it has been possible to recover detail in both the shadow and highlight areas as well as removing the noise caused by the high ISO setting.**

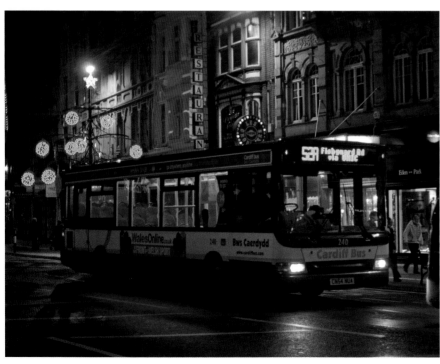

A TRIP TO
EDINBURGH

Scotland's capital, with its elegant Georgian buildings and imposing castle, also has a lot to offer the bus enthusiast.

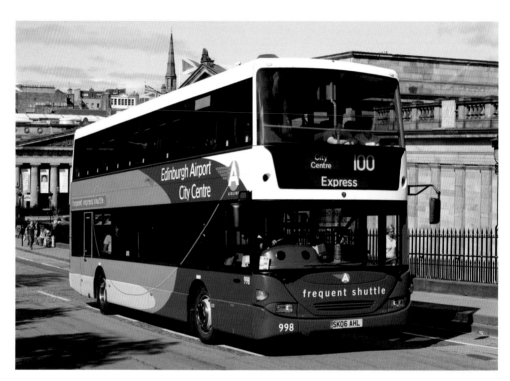

right Lothian Buses operates a regular service to the city's airport. On 24 August 2007 suitably branded Scania Omnicity double-decker 998 is seen climbing The Mound, passing the elegant architecture so typical of the city.

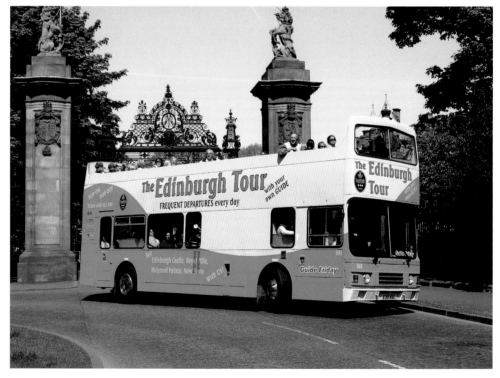

right Edinburgh is a major tourist destination and Lothian Buses runs a number of open-top tours, each with a distinct brand identity. Guide Friday livery is carried on 301, seen passing Holyrood on 14 May 2005.

left A number of long-distance services from Edinburgh lay over in Waterloo Place, to the east of Princes Street. MacEwan's Coach Services YP02 AAY, a Wright Solar-bodied Scania L94UB, has just arrived from Dumfries and was captured for posterity with a shutter speed of 1/640th second at f6.3.

left The main operator in the Scottish capital is Lothian Buses, the largest local authority-owned bus operator in the UK. Although the elegant madder- and white livery has now disappeared, its buses still eschew such passing fashions as electronic destination displays and retain white-on-black blinds. At 11.55 on 22 May 2004 President-bodied Transbus Trident 680 is seen turning into Hanover Street. The Kingdom of Fife is clearly visible across the Firth of Forth.

left First Edinburgh is the successor to Eastern Scottish and operates many services linking the city with its hinterland. Alexander Royal-bodied Volvo Olympian 31732 heads west along Princes Street on 14 May 2005. This scene has now changed considerably as a result of works connected with the New Edinburgh Tramway.

GETTING
CREATIVE

In the previous two sections the focus has been on the use of editing software to manipulate a photograph in order that it more closely resembles what the photographer saw (or thought he was seeing). In this section we will look at how images can be edited in a way that is largely creative. Whether such results are sought, the techniques described are useful exercises in developing control of selections and learning what the software is capable of doing.

■ Creating a panorama

A panorama is an image that is wider than those produced by your camera, which ordinarily have an aspect ratio (the relative length and height of the image) of about 3:2. There are occasions when a wide angle of view is sought without the potential image-distorting effects of a wide-angle lens. An example is when photographing a line-up of vehicles in a garage or at a rally.

Most image software has the ability to make a panorama by stitching a number of photographs together and, providing you take a few simple precautions when shooting the images in the first place, they are fairly effective. All the photographs must be taken from the same position with some overlap between them, ideally using a tripod, using the same focal length of lens and at the same exposure setting to ensure a consistent set of images. It is probably best not to use automatic exposure although the software will usually remove any slight variations in brightness and contrast. In this example we are going to merge two photographs to make one.

■ Open all of the images you want to merge.
■ From the 'File' menu select 'New' and 'Photomerge panorama'. This will open the 'Photomerge' dialogue box.
■ Click the 'Add open files' box.

right and opposite
The ability to stitch a number of photographs together to create a panoramic view is a useful tool in most editing programs. Although it would have been possible to take a wide-angle view of RMs 2217, 6 and 5 posing in Brixton tram depot after their historical final journey on TfL route 159, the resulting photograph would have almost certainly shown some barrel distortion.

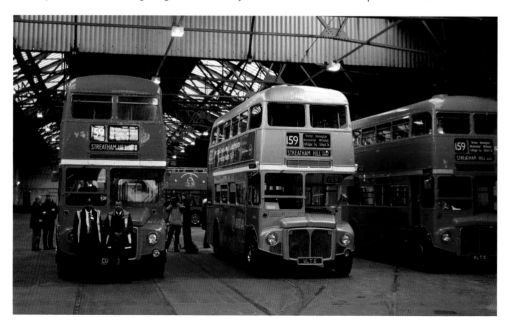

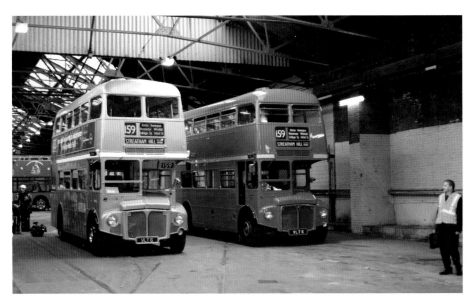

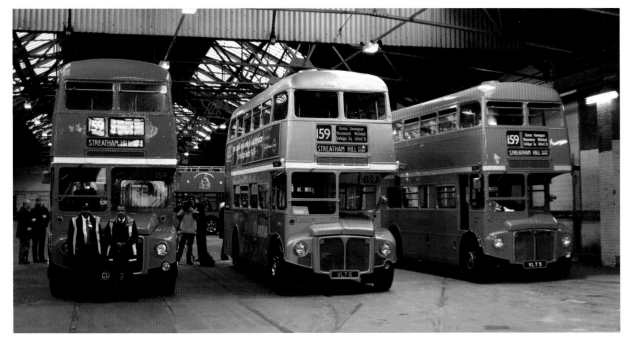

■ Choose a panorama style from the layout column – in this example we will go for 'Reposition only' – and click 'OK'.

The software will work its magic and usually ensures that the colours and contrast are well matched. If there are any minor imperfections it is possible to clean these up using the clone tool. Once you are happy with the overall look, use the cropping tool to trim the rough edges and give the panorama a nice crisp edge. Any adjustments to brightness and contrast can then be made before saving the file.

■ Converting an image to black and white

There are certain scenes, especially those involving preserved vehicles, which can benefit from being captured in black and white. Many cameras have a 'mono' mode that allows you to capture images in black and white rather than colour. While this is a good way of learning to 'see' in black and white, it has limitations for the transport photographer, especially if the subject is moving, as it will not be possible to capture the scene in colour as well. Many software

right, below and opposite **Photographs of vintage vehicles, especially when taken against a background that lacks modern paraphernalia, can benefit from the 'retro' look of black and white conversion. London Bus Preservation Trust STL2377 passes through Islington on a special working to mark the end of Routemaster operation of TfL route 19 on 1 April 2005.**

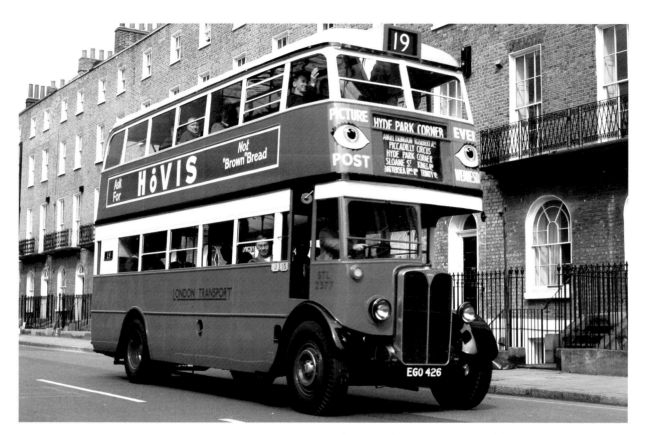

programs allow you to shoot in colour and convert the image to black and white, which potentially gives the best of both worlds.

Having chosen a suitable picture to convert, there are a number of possibilities to achieve the desired outcome.

It is possible to create a black and white image by using the 'Image', 'Adjustment' and 'Desaturate' commands, although this approach can result in fairly flat images that lack contrast and brightness. Recent versions of Photoshop Elements have a 'Wizard' to convert an image to black and white, which gives quite pleasing results with good tonal range and contrast. First open the photograph you wish to work on.

- From the 'Enhance' menu choose 'Adjust color' and 'Adjust Hue/Saturation'.
- This will open up a window headed 'Hue/Saturation'. By moving the 'Saturation' slider to the left the colour will be removed from the image – you will see the value on the saturation scale change from 0 (normal

saturation) to -100 (totally desaturated).
- The image is now in black and white and probably lacks impact. Using the 'Enhance', 'Adjust lighting' and 'Brightness/Contrast' commands opens up a dialogue box. Most images will benefit from increasing the contrast slightly and reducing the brightness – this is achieved by moving the sliders.
- Once the desired appearance is achieved, the file can be saved with a new name.

Recent versions of Photoshop Elements have a 'Convert to black and white' option that we will look at in the example below.

■ Pop outs

This is a simple and effective way of creating a slightly different image that is popular in the advertising industry. Basically, it entails having everything in black and white except one item, probably the bus itself, which is in full colour. The technique works because the viewer's eye is drawn to the coloured object. The approach works best with a photograph

in which the bus is fairly central and with plenty of detail in the background.

■ Having identified a suitable photograph, the first stage is to make a selection around the bus itself.

■ The selection should then be inverted using the 'Select' and 'Inverse' commands.

■ Convert the background to black and white by using the 'Enhance' command followed by 'Convert to black and white'. This will open up a window with various styles from which to choose. In this example I have selected 'Urban/Snapshots', but it is best to try a variety of options (and adjust the contrast) to get the desired effect. This

right, below and opposite **Pop outs, where part of the image is converted to black and white to emphasise another section, are commonly used in advertising. In this example, by removing the colour from Piccadilly Circus, the viewer's attention is drawn to RML2621.**

command can also be used to convert all of an image to black and white.

Once you are happy with the image save it with a new file name.

■ Motion blur

One of the most difficult techniques to master is that of panning where a moving subject is tracked by the camera with the intention of capturing it sharply against a blurred background to create the impression of motion. Fortunately this technique is quite easy to reproduce digitally using image-processing software. Most programs include 'blur' filters that can be applied to selected areas of your photograph to create an impression of movement. If seeking to produce an illusion of a moving subject

left By applying the 'Motion Blur' filter to parts of a photograph it is possible to create an impression of movement similar to that made by 'panning' an image. The first stage is to select to those parts of the photograph to which the blur is to be applied. This is achieved by using the magnetic lasso to select the bus and then inverting the selection so that it applies to the background.

frozen against a blurred background, the following process should be followed:

■ Identify a suitable picture – ideally the vehicle should be as near to side-on as possible and have a background with sufficient detail to allow the blurring to be apparent.

■ Select the bus using one of the selection tools, including a feather around the selection.
■ Invert the selection so that the background is now selected.
■ From the 'Filter' menu select 'Blur' and 'Motion Blur'.

right and below **The amount and angle of the blur applied can be varied depending upon the result being sought.**

This will open the 'Motion Blur' dialogue box, which contains choices for the motion angle and distance.

■ Select the 'Angle' and 'Distance' options. For most bus and coach images the 'Angle' is going to be 0° as the vehicle will be travelling from left to right or right to left across the image. The 'Distance' setting determines the number of pixels included in the linear blur – the higher the number, the greater the sense of movement. The default setting in Photoshop Elements is 10, which gives a moderate amount of blur. As with any image manipulation, it is best to establish the best setting by trial and error.

Once you are happy with the image, click 'OK' to apply it to the image and save with a new file name.

left and below
To complete the impression of a panned photograph of a moving bus the wheels are selected and a 'Radial Blur' applied to them. The image is then cropped and saved.

143

A TRIP TO
LONDON

Samuel Johnson famously said that when a man is tired of London he is tired of life. Uniquely in Great Britain the capital was spared (or denied, depending on your viewpoint) deregulation of bus services. Local bus services are run by private companies, contracted by Transport for London (TfL). Although TfL exercises strict control over most aspects of the operation, most obviously the livery, there is still considerable variety on offer. Furthermore, the sheer density of services means that there is always something to see. Although the volume of traffic means that some potential shots are spoiled by other vehicles, there will always be another bus along shortly, so all is not lost.

right Marble Arch is a key node in the London bus network with a number of routes converging. The wide roadway on the south side of the eponymous arch allows for photographs to be taken, free of shadows, all year. Short-term loans between London bus operators have become commonplace in recent years, usually to cover late delivery of new vehicles when a contract is taken on. However, when First London TN32959 was seen heading west shortly before 4pm on 10 October 2007 it was on loan to London United to allow for LU's own fleet to be fitted with the iBUS passenger information system.

right Waterloo Bridge is a busy river crossing that runs roughly north-west/south-east. This, combined with its wide open roadway, means that it is possible to take photographs in bright sun during the middle part of the day all year round. On 3 April 2009 London Central PVL176 heads south. Somerset House forms an attractive backdrop.

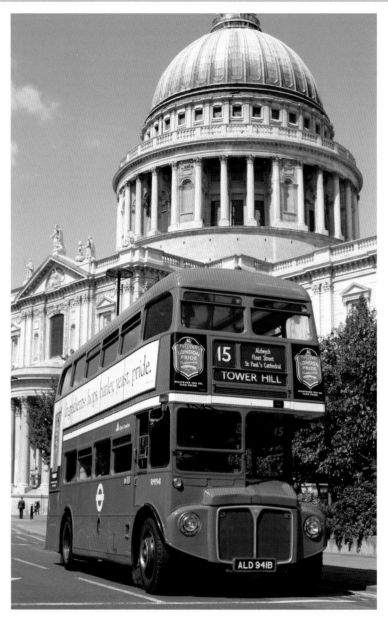

left The AEC Routemaster is still viewed by many as the archetypal London bus and, although normal service ceased in 2005, examples can still be found at work on two 'Heritage' routes in central London. East London RM1941 is seen here passing St Paul's at around noon on 15 August 2008. The temptation to use a wide-angle lens to capture all of Wren's magnificent dome has been resisted as this would have caused distortion to other parts of the image.

below Another busy location where it is possible to get shadow-free views of buses year round is the Elephant & Castle, although a redevelopment scheme for the area is under consideration. Recent years have seen articulated buses introduced onto some of the busiest routes in London, although a change of administration in 2008 may lead to some of them being converted to 'conventional' buses as contracts are renewed. Unless there is a change of policy, route 453, on which brand-new Mercedes-Benz Citaro MAL112 was seen on 17 February 2008, will be the last to feature this type of operation.

SECTION

9

SHARING
IMAGES

We have now taken a look at all of the activities that will allow you to take a good-quality photograph and, if you wish, edit it to improve it still further. It is one thing to take pictures of buses for one's own enjoyment, but most of us will want to share them with others. This is one area where digital photography has a clear advantage over film – as we saw at the beginning of this book. In this section we will look at a number of ways in which your photographs can be shared with others – ultimately the most appropriate method will depend to a large extent on the intended audience.

■ Printing photographs

While many photographers will take their memory card to a local photographic dealer to get prints made of their images, it is likely that, sooner or later, you will want to print your own. Reasonable-quality printers, especially inkjet models, are relatively inexpensive, and by printing images at home you can ensure that they are cropped according to your wishes and to a size of your choosing. We have already

looked at different types of printer in Section 3 – as most users are likely to be using inkjet printers, we will concentrate on these in this section.

To print a photograph you will first of all need to ensure that your printer is connected to your computer and switched on. Open your image-processing software – in this example I am using Adobe Photoshop Elements 6, although, as with editing tools, other packages offer similar functionality.

■ Having opened the file that you wish to print, select 'File' and 'Print' from the Menu bar. This will open the 'Print' dialogue box.

■ The 'Print' dialogue box contains a preview of the image as it will look when printed – you can change the orientation of the paper by clicking the icon to the bottom left of the preview. If the image is too big for the paper size selected, you will only see a part of it in the preview window – by checking the 'Scale to Fit Media' box it will be resized accordingly.

■ If you have more than one printer installed on your computer you will need to select the correct one using the 'Printer' drop-down menu and select the print size that you wish to make. The print size relates to the size that the image will print, not the paper size – to change this, select the 'Print Size' drop-down and choose the appropriate size.

■ The 'Print' dialogue box offers a number of options such as whether you want to print the picture centred on the page, add a coloured border or have the file name printed on it. Also, by clicking on the 'Printer Preferences' button you

below **Most editing software provides the user with an intuitive means of printing images that provides a preview and allows for simple changes to be made.**

will open a window that gives a number of options including that of setting the type of paper being used.

■ It is possible to resize the image by using the 'resize' handles at each corner in the preview screen. As you change the size of the image notice how the print resolution will change – the larger you make the photograph, the lower the resolution. For optimum print quality the resolution should not be lower than 300ppi, and certainly no lower than 150. When you are happy with the look of the image, click the 'Print' button. Depending on your computer's settings you may then open another 'Print' dialogue – if this is the case, simply click 'Print'.

You may have a number of photographs that you wish to print at the same time. Open all of the files that you wish to print – to select multiple files hold down the 'Ctrl' key as you click on file names and click 'Open' when you have selected them all. You will see thumbnails of these images in the Project bin.

Select 'File' and 'Print Multiple Photos'. This will open a dialogue box that will offer a number of options, in addition to a single

photograph per sheet, for laying out your prints, each of which will appear within the preview window. Among the choices available are:

■ A contact sheet, which shows a number of thumbnail images on a single sheet of paper together with file names. This will be a familiar concept to those who used to develop and print their own films. The function also gives a choice of how many images appear on each sheet and whether to include file names. Contact sheets are

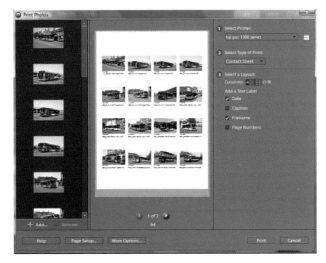

above and left
Contact sheets are useful, particularly when sending a disc containing a large number of images, as they allow the recipient to view the contents quickly and easily.

particularly useful if you are sending images on a CD or DVD to someone, as it allows them to quickly see what is on the disc.

■ A picture package that prints a number of images on each sheet to varying layouts that can be viewed by choosing one of the options in the 'Select a layout' drop-down menu. It is also possible to choose to print images onto labels.

It is possible to scroll through the images by using the page arrows under the preview screen. As before, once you are content with the view offered on the preview screen, click 'Print'.

If you are using a computer that has a Windows operating system, it is also worth noting that it is possible to print files directly from the folder in which they are saved.

Select 'Start' and 'Computer' to allow you to access the drive and folder in which the photographs are saved. Click on the 'View' button to change the way in which the files are displayed – the image shows 'Large icons'. Select the file(s) that you wish to print and click the 'Print' icon. This will open a window that will give you a number of options, including individual prints and contact sheets. Simply follow the step-by-step instructions to print your photographs.

As we have seen, one of the options available when printing images is that of choosing the paper type being used. When printing using an inkjet printer the quality of the paper is almost as important as the printer itself.

There are four main types of paper on the market, although several sub-types have been introduced over the years:

■ Plain paper: this is just what it claims to be – straightforward and relatively cheap, it is fine for printing text. However, it tends to absorb ink, so photographs tend to look blurred and the paper itself will curl.

■ Inkjet paper: this is still relatively inexpensive and has been coated with an ink fixture to prevent inks from spreading.

■ Photopaper: this has a special coating that makes it specially suitable for printing photographs.

■ Premium photopaper: not only is this significantly heavier than the other types described, but it also has either a glossy or lustre surface on one side. It is quite expensive by comparison with other types of paper. Printer manufacturers often market their own paper and claim that it will provide the best results when used in their products. Whether this is the case or not is a matter of personal judgement.

The quality of the inks used in a printer will also have a significant influence on both the quality of your prints and their longevity. Manufacturers have developed inks that not only give photo-quality colours but are more resistant to fading than earlier generations of ink, although the permanence of any inkjet print can be improved by displaying it out of direct sunlight and under glass.

Although inkjet prints are of generally good quality, they consist of a relatively small number of colours printed in a halftone format. For really high-quality prints it is worth using a professional service, which will employ continuous-tone printing techniques.

Another option for obtaining prints is to use an online service that can be accessed directly though a number of editing programs. These require an internet connection to upload the prints and in practice there is even less control over the quality of the prints than with a high-street printer, where at least you have the option of refusing to pay for the service when you collect the photographs!

Finally, some providers offer the chance to have photographs printed onto media other than paper, for example mugs, T-shirts and mouse mats, as well as providing bound books containing your photographs, with or without descriptive captions.

■ Email

Sending images by email is probably the most common way to share digital photographs. The process is quick and easy, and photographs are attached as to the email message.

The most important thing to remember when emailing images is not to send large files (or large numbers of files, unless specifically asked to do so). Not everyone has broadband, and large files can block the recipient's email server and, in some cases, become garbled in transmission. In addition, some systems have a limit to the size of messages that will be accepted. As a general rule do not send messages larger than 1MB in the first instance. If the

Left and below Email is a quick and easy way of sending photographs to others. It is, however, important to ensure that the images are resized to avoid overloading the recipient's in-box.

recipient wants higher-resolution files, wait for them to be requested.

Fortunately, most image software programs have the capability to resize images and attach them to a message. The Microsoft Windows operating system also provides an intuitive way of sending files, accessing them by selecting the folder in which they are located from the 'Start' and 'Computer' commands.

Select the folder containing the photographs, then choose the image(s) that you wish to send – multiple images can be selected by holding down the 'Ctrl' key as you select.

Once you have selected all the images you want to send, right-click on one of them. This will open a menu with a number of options including 'Send to'. Select this, then 'Mail recipient'.

A window will open that provides a drop-down menu with a number of options for resizing the images and, rather helpfully, an indication of the final size of the email message. Once you have chosen a suitable

resize option, click the 'Attach' button. This will open your email program with a draft message to which the image files have already been added. It is a simple matter of adding the recipient's email address, compiling the supporting message and pressing the 'Send' button. The program may add some covering text of its own, but this can be deleted should you wish.

If you have already resized the images it is possible to compose a message then attach the relevant files using the 'Insert' and 'File' options from the Menu bar of your email program.

If you use a web mail service, such as Yahoo Mail or Gmail, you will need to resize your images using the procedure described in Section 6. Once you have composed your message, files can be attached using the 'Attach files' commands.

■ Burning files to disc

If you wish to share a large number of files with the same person it is probably easiest to burn them to a disc. A CD will hold about 700MB of data while a DVD can store 4.7GB (which is about 1,000 high-resolution JPEG images).

■ To burn files to a disc, first insert a recordable disc into the CD/DVD drive of

above and right
As well as allowing large numbers of images to be sent relatively easily, CDs and DVDs provide a useful medium for backing up files. It is good practice to back-up files regularly to guard against the risk of loss if something happens to the computer in which they are stored. It also allows for files to be deleted from the computer, thus freeing up memory space.

the computer, which will open a box. Click 'Burn files to disc – using Windows'.

■ In the 'Burn to disc' dialogue box click on the 'Show formatting options' drop-down menu. In order to ensure that the disc plays on all computers it is recommended that 'Mastered' is selected. At this stage it is also possible to attribute a name to the disc (the default setting is the date). Click 'Next' and 'Wait while the disc is formatted'.

■ Open the folder that contains the images you wish to burn to the disc, select the images and drag them into the empty disc folder. Repeat as necessary with other folders until all of the files you want to burn are in the disc folder.

■ Click the 'Burn to disc' button – a series of instructions will then guide you through the remaining steps of the process. When the burn is complete the disc will be ejected from the computer. It is worth reinserting it and opening the files to ensure that they have been correctly copied.

If you are sending a disc containing images to someone, it is usually worth printing a contact sheet of the images included for the recipient's ease of reference.

Burning files to disc also represents an effective way to store back-up copies of your images. This helps ensure that if, for example, something happened to your computer (or external hard drive, if used) the photographs are not lost. As a matter of practice I tend to save a back-up disc every time I have enough images to fill a disc. Although the long-term storage properties of CDs and DVDs are not known, there is nothing to suggest that, kept under proper conditions, they should not last for at least a century. This can be ensured by using quality discs and employing 'write once' media rather than rewritable discs.

■ The internet

Many photographers choose to share their photographs on the internet. Although there are a number of web design programs available, they are beyond the scope of this publication. A far simpler method of web publication is to use one of a number of photo-sharing websites, such as Flickr and Fotopic, that have sprung up in recent years, which save having to become too bogged down in the drudgery of web design. These sites all have a simple interface that allows you to upload photographs directly from your computer (or send them by email) and offer a number of options for page layout including thumbnail views and the opportunity to add captions. Many offer a basic service free of charge and a number of additional, charged, options that include a greater hosting capacity and an enhanced range of designs. Registration for these services is a simple matter of visiting the host website and signing up. Although the site will often resize photographs automatically, greater control is possible by undertaking this task yourself before uploading images and, as smaller files are being uploaded, the process will be quicker. For most images a file size of about 800 x 600 pixels and a resolution of 72ppi works best.

■ Copyright

One of the potential risks of publishing photographs on the internet is that of image theft, and there are several accounts of photographers seeing CDs containing their photographs on sale at rallies or on other people's internet sites.

With a few exceptions the creator of a photograph is the owner of the copyright, and use of any image without the authority of the copyright-owner is an offence. It is possible to minimise the risk of your photographs being abused in this way by only posting small files to web sites, which will be of limited use for anything other than viewing on a computer monitor. Another approach is to apply a watermark to the image, which clearly states ownership of the copyright. Some photo-sharing websites offer this service, or alternatively you can add a suitable

Photo-sharing sites such as Fotopic and Flickr provide a quick and easy way of getting images on line without the effort of designing a website.

message using the 'Add text' function of your image-processing software.

With Photoshop Elements this is achieved by selecting the 'text' tool – this will then make it possible to draw a text box within the image. The font style and colour are selected from within the Options bar.

Text is added as a new layer so it is possible to vary its transparency by using the Opacity slider – there is a trade-off to be made between ensuring that your photographs are not unlawfully used by others and detracting from the viewing pleasure of the vast majority of people by adding an overly

intrusive watermark. As ever, it's a matter of personal choice. There are a number of alternative styles of text that can be selected from within the 'Text options' bar.

▪ Scanning images

Although digital photography has now practically eclipsed film, it has only been

left and below **When posting images to websites it is advisable to add a declaration of copyright to avoid the risk of photographs being unlawfully used by third parties.**

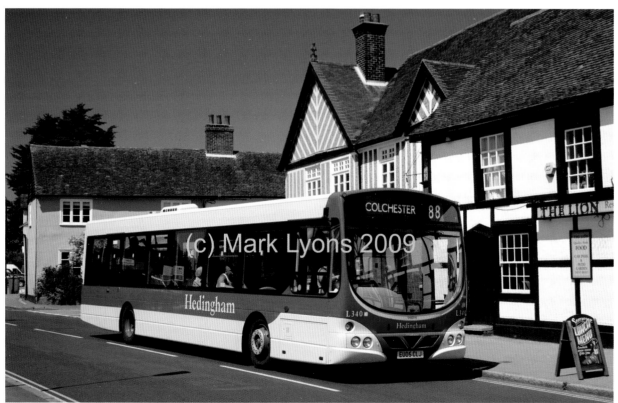

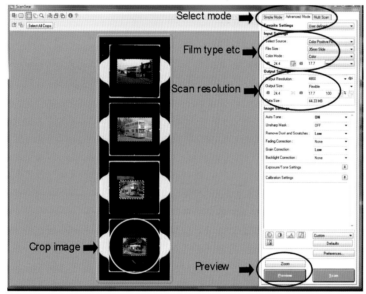

around in a meaningful sense for a few years. Many photographers will have hundreds, if not thousands, of slides, prints and negatives that they wish to share with others in the same way as digital images. Scanning provides just such a route to bring your photographs into the digital domain, where they can be edited to improve them just like any other digital photograph. This facility is particularly useful with old images, which may have deteriorated over time.

Depending upon the type of scanner it is possible to scan printed images only, negatives and transparencies only, or both. As a rule, where available it is preferable to scan original negatives rather than prints.

Most image-editing software will allow the user to import images directly from the scanner for editing; alternatively, the software supplied with the scanner can be used to capture images, which are then saved for subsequent editing.

Each scanner model is different, and it is important to refer to your photo scanner's manual for detailed instructions. The examples shown here were scanned using a Canon flatbed scanner, which has inserts for scanning film strips and mounted slides.

top, above and right
Scanning offers the chance to convert slides, prints and negatives to digital format. Slides can be scanned using either a specialised film scanner or, as in this example, a flatbed scanner with a slide insert.

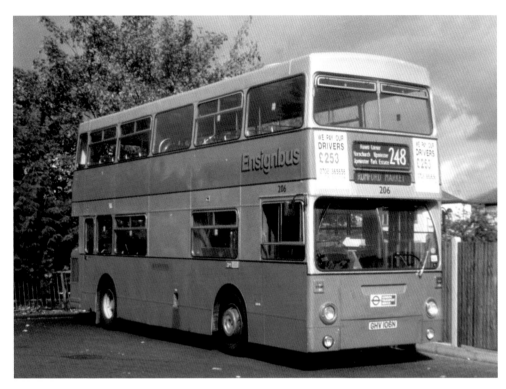

To scan images using editing software, select 'File' and 'Import' from the Menu bar before choosing the name of the scanner. This will open the scanner's software, which will handle the mechanics of actually capturing the image. As can be seen, there are options for 'Simple' and 'Advanced' scanning. The 'Simple' mode will lead the user through a step-by-step process, with relatively little control over settings, although it is not really suitable for anything other than basic functions. Selecting the 'Advanced' tab will offer several choices to the user, including the film type and the size of image that is sought.

Having chosen the desired settings, clicking the 'Preview' button will initiate a low-resolution scan that is displayed in the image window. At this stage it is possible to deselect those images that you do not wish to scan and crop those that you do. When this is complete, click the 'Scan' button to initiate a full scan.

Once scanning is complete the user is offered a choice of either opening the editing program or making more scans. Selecting the former option will complete the importing of the images into the editing software, from where they can be manipulated in the same way as any other digital image. Once you are happy with the result, the file can be saved.

There are a few key steps to ensure the best possible quality of scans:

■ Ensure that both the scanner surfaces and film are free of dust and fibres, as these will be magnified greatly in the final image – a good-quality blower or compressed air are perfect for this.

■ Scan at the right resolution. When scanning your photo slides and negatives, it is crucial to scan at the right resolution to get a high-quality digital image or print later on. While scanning at a higher resolution takes a bit more time and creates larger image files, the quality and detail of your scan will be much greater. Conversely, scanned files can be massive and there is little to be gained by scanning, for example, prints at a very high resolution. As a general rule prints do not need to be scanned at a higher resolution than 600ppi while negatives may require 4,000ppi to show all their detail.

■ Use the scanner software to crop images before carrying out the final scan – this will reduce the time taken and the file size.

■ Ensure that the correct source and film size are selected.

Even though some scanners can capture several slides or negatives at a time, it is still potentially a time-consuming activity. It is therefore worth thinking carefully before starting to scan every slide or negative in your collection.

top right and right
Where possible it is preferable to scan negatives rather than prints. Most scanners will allow the user to scan a strip, then select those that are to be edited.

right Reading Transport 101, the undertaking's first MCW Metropolitan, is seen at St Mary's Butts in 1982.

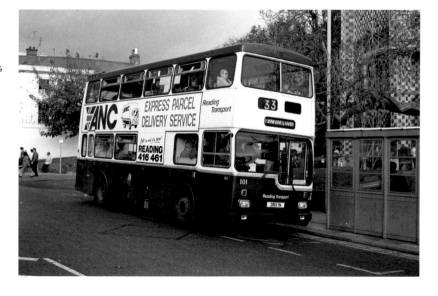

EPILOGUE

One of the most enjoyable aspects of bus and coach photography is being able to use it as an excuse to visit different locations with a sense of purpose. Since I started taking digital photographs in early 2004 the scene has changed dramatically: the Routemaster era finally drew to a close in London, the number of municipal operators continued its long decline, and there has been significant investment in new vehicles including the use of alternative fuels. All of this has been captured for posterity. Looking more widely, fashions have continued to evolve and features previously thought of as permanent, such as Woolworths, will not form the backdrop to photographs taken in the future. Ever-increasing volumes of traffic and the relentless spread of street furniture conspire to make finding good locations more of a challenge. In addition, the increasing paranoia around security will continue to be used by some as an excuse to try and limit the legitimate activities of all photographers.

above Although the corporate livery standards and central buying policies of the big bus groups have brought uniformity to much of the country, there is still a reasonable amount of variety to be found. In 2009 First Glasgow introduced the first examples of Alexander Dennis' three-axle Enviro500 to service in the UK. Just after six o'clock on the evening of 25 June 2009 its 38212 is seen turning from Nelson Street into Commerce Street to the south of the city. Midsummer brings particularly long days to north-west Britain and sun is still fairly high in the sky at this time of day as evidenced by the length of the shadows. The location is somewhat off the beaten track and was identified using a combination of local maps and aerial imagery from the internet.

Some people have claimed that the spread of the big groups has made the contemporary UK bus scene less interesting. This is not an assessment with which I would agree. Although the corporate colour schemes and national vehicle buying policies of Arriva, FirstGroup and Stagecoach have brought homogenous standards to many towns and cities there is still a remarkable amount of variety out there. Furthermore, some of the big groups, notably Go-Ahead and Transdev, continue to allow their subsidiaries a large amount of autonomy when it comes to both liveries and vehicle purchases. Even the London scene, said by many to be red and boring, arguably has far more of interest now than in the 1950s when almost the entire bus fleet was made up of RTs and RFs. Finally, there is still a vibrant independent sector with well established operators including The Delaine and Safeguard being joined by recent entrants such as Western Greyhound.

As far as photography is concerned it is clear that, although the evolutionary curve has begun to flatten out, the development of digital cameras, computers and image processing software will continue. In addition to the launch of new products this process will also, undoubtedly, lead to both lower prices and improved ease of use.

It is clear that the bus scene in the UK continues to hold much of interest and I look forward to the next round of developments with eager anticipation. I will certainly be out with my camera to capture them for future generations.

above Trent Barton has long been an operator with a strong enthusiast following. In recent years it has focussed very strongly on route branding of its vehicles, although a generic red livery is also in use, providing the photographer with a wide variety of subject matter. Perhaps the most dramatic scheme is that applied to six Mercedes-Benz Citaros delivered in the summer of 2009, as carried by the first of the batch, 801, seen in Collyer Rd, Calverton. The dark, highly-reflective livery makes it a challenge to photograph. For this image a polarising filter was used and slightly over-exposed to retain detail in the dark body of the bus.

left Growing concern about vehicle emissions is leading to pressure on manufacturers to develop hybrid buses. The first such vehicles have already entered service with London operators where, it is planned, by 2012 all new buses will use this method of propulsion. London United HDE3 is seen here passing through Ham on 23 May 2009, clearly showing the modified livery carried by these buses in the capital. During 2010 hybrid buses will enter service in a number of towns and cities thanks to funding from the Government's Green Bus Fund.

above As we have seen, the last few years have seen tremendous changes both in the bus industry and the photographic world. Deregulation and the selling-off of state and municipal operators have led to the growth of the big groups with which we are all so familiar, while the advent of digital photography has led to the virtual demise of film as a photographic medium. Amidst all of this change some islands of stability remain. White Bus Services has operated a service linking Windsor and Ascot using roads through Windsor Great Park not open to public vehicles since the 1930s. On 21 February 2009 its YJ57 EHV, a 2007 Optare Tempo, was captured passing through the park at 11.08. An exposure of 1/640th second at f6.3, with a polarising filter, was used. The image was processed using Adobe Camera RAW software – the contrast between the bright white livery of the bus and the darker elements of the vehicle's windows meant that the ability to recover highlight and shadow detail in a RAW image was essential.

INDEX